Gainsborough and Reynolds in the British Museum

Gainsborough and Reynolds in the British Museum

The drawings of Gainsborough and Reynolds
with a survey of mezzotints after their
paintings and a study of Reynolds' collection
of Old Master drawings

Catalogue of an exhibition at the Department of Prints
and Drawings in the British Museum, 1978

by Timothy Clifford, Antony Griffiths and Martin Royalton-Kisch

Published for the Trustees of the British Museum
by BRITISH MUSEUM PUBLICATIONS LIMITED

© *1978 The Trustees of the British Museum*

ISBN 0 7141 0766 2 cased
ISBN 0 7141 0767 0 paper

Published by British Museum Publications Ltd,
6 Bedford Square, London WC1B 3RA

Designed by Roger Davies

Printed in Great Britain

Text set in 10 on 12 Point Monophoto Times New Roman and
printed by Ashdown Printing Services Ltd

Plates printed by Balding and Mansell Ltd,
London and Wisbech

Contents

Preface

The exhibition, which has been given the generalised title of *Gainsborough and Reynolds*, falls into three distinct sections, and this division is reflected in the three parts of this catalogue, each of which has its own author and introduction.

The first section is devoted to drawings by the two artists, with the inclusion of a few works by other masters who are closely related to them. The exhibits comprise approximately two thirds of the drawings by Gainsborough and Reynolds in the Department's collection. The second part, which shows prints, mainly mezzotints, after their paintings, is even more rigorously selected from many hundreds of potential exhibits. The choice has been made in the first place among the finest impressions of the most attractive prints which are available in the collection. The attempt to provide an historical or iconographical survey has come second. The third and final section of Old Master drawings which once belonged to Reynolds has likewise been chosen on grounds of quality from the total, roughly three times greater, of such drawings owned by the Department. The numbering of the catalogue entries for each section begins with a new century; thus the first part begins at 1, the second at 101 and the third with 201.

The exhibition is heterogeneous, but we hope that this will not offend anyone. Its extension beyond a simple display of drawings by the two artists will, we trust, make it of wider interest, and gives an opportunity to show objects which have not been seen by the public for many years.

The authors express their acknowledgements in their individual prefaces, but would like at this point particularly to thank Lady Julia Percy who devoted much time as a voluntary assistant in the Department to helping with this exhibition, and Nicholas Turner, Assistant Keeper in the Department, for preparing the catalogue entries for most of the Old Master drawings.

Thomas Gainsborough

1727	Baptised at Sudbury, Suffolk, on 14 May, son of a cloth merchant.
1740	Moves to London. Apprenticed to Hubert-François Gravelot.
1746	Marries Margaret Burr. Has his own studio in London by this time.
1748	Birth of his first daughter, Mary. Gives his painting of *The Charterhouse* to the Foundling Hospital. Returns to Sudbury after the death of his father and subsequently settles at Ipswich.
1752	Birth of his second daughter, Margaret.
1755	First London commission: two chimney-piece landscapes for the Duke of Bedford.
1759	Moves to Bath where he remains until 1774.
1761	Exhibits at the Society of Artists in London.
1768	A founder member of the Royal Academy.
1769	Exhibits at the first Royal Academy Exhibition.
1772	Gainsborough Dupont, his nephew, becomes his apprentice.
1773	After a disagreement with the Royal Academy over the hanging of his pictures, he sends nothing to its Exhibitions for three years.
1774	Moves to London, where he remains for the rest of his life.
1781	Exhibits portraits of the King and Queen at the Royal Academy.
c.1782	Tours the West Country with Gainsborough Dupont.
1783	Tours the Lake District. At about this time he constructs his peep-show box to display his transparencies.
1784	After a further disagreement over the hanging of his pictures he refuses to exhibit at the Royal Academy again. He holds the first of his annual exhibitions of his work at his studio.
1788	Dies on 2 August, and is buried in Kew Churchyard.

Sir Joshua Reynolds

1723	Born at Plympton, Devonshire, on 16 July, son of the Reverend Samuel Reynolds.
1740	Moves to London. Apprenticed to Thomas Hudson.
1743	Ends his apprenticeship and moves to Plymouth Dock. Sets up as a portrait painter.
1745/6	Returns to Devonshire after the death of his father.
1747–49	Working in London and Devonshire.
1749–52	Italian journey. Sails from Plymouth on 11 May 1749, in the *Centurion*, commanded by Commodore Keppel. After travelling via Lisbon, Gibraltar and Algiers, arrives at Port Mahon, Minorca on 18 August. Suffers a riding accident which disfigures his lip and delays his departure for Italy.
1750–52	In Rome.
1752	Visits Naples. Returns to England via Florence, Bologna, Venice and Paris.
1753–59	Settles in London and establishes his reputation as the leading portrait painter in England. The first prints after his portraits are made. Meets Samuel Johnson, Edmund Burke and Edmond Malone.
1760	Exhibits at the newly-founded Society of Artists. Moves to a house in Leicester Square where he lives for the rest of his life.
1764	Founds the *Literary Club*. Its 12 members include Johnson, Goldsmith and Burke.
1768	Foundation of the Royal Academy, with Reynolds as President. Visits Paris in the autumn.
1769	Delivers the first of the Discourses. Knighted by George III.
1771	Visits Paris to view the auction of the Thiers-Crozat collection.
1773	Receives the honorary degree of Doctor of Civil Law at Oxford University. Elected Mayor of Plympton.
1781	Visits Flanders and Holland with Philip Metcalfe. They make an excursion to Düsseldorf.
1785	Visits Brussels to view the auction of paintings brought on to the market by the suppression of monasteries under Joseph II.
1788	Devotes the Eighth Discourse to a discussion of Gainsborough.
1789	Suddenly loses the sight of his left eye in July. Paints little thereafter.
1790	A disagreement with the Royal Academy leads to his temporary resignation both as President and Member. Delivers the Fifteenth and last Discourse on 10 December.
1792	Dies on 23 February, and is buried in St Paul's Cathedral.

Works referred to in abbreviated form

B	Adam Bartsch, *Le Peintre-Graveur,* 21 vols, Vienna, 1803–21.
BB	Bernard Berenson, *The Drawings of the Florentine Painters,* amplified edition, II, Catalogue, Chicago, 1938.
Cotton 1859	William Cotton, *Sir Joshua Reynolds' Notes and Observations on Pictures,* London, 1859.
CS	J. Chaloner Smith, *British Mezzotinto Portraits,* 4 vols, London, 1883.
Discourses	Sir Joshua Reynolds, *Discourses on Art,* ed. Robert R. Wark, 2nd ed., New Haven and London, 1975.
F	J. Frankau, *John Raphael Smith, his life and works,* London, 1902.
G 1903	G. Goodwin, *James McArdell,* London, 1903.
G 1904	G. Goodwin, *Thomas Watson, James Watson, Elizabeth Judkins,* London, 1904.
Gainsborough Letters	Mary Woodall (ed.) *The Letters of Thomas Gainsborough,* 2nd ed., London, 1963.
Graves and Cronin	Algernon Graves and William Vine Cronin, *A History of the Works of Sir Joshua Reynolds P.R.A.,* 4 vols., London, 1899–1901.
H	John Hayes, *Gainsborough as Printmaker,* London, 1971.
Hamilton	E. Hamilton, *The Engraved Works of Sir Joshua Reynolds,* London, 1884.
Hayes	John Hayes, *The Drawings of Thomas Gainsborough,* 2 vols, London, 1970.
Hind	Arthur M. Hind, *Catalogue of Drawings by Dutch and Flemish Artists preserved in the Department of Prints and Drawings in the British Museum,* I–IV, London, 1915–31.
JCR	J. C. Robinson, *Descriptive Catalogue of Drawings by the Old Masters, forming the collection of John Malcolm of Poltalloch Esq,* 2nd ed., London, 1876.
Kenwood 1977	Lindsay Stainton, *Gainsborough and his musical friends,* exhibition catalogue, Kenwood, London, 1977.
L *(Suppl)*	Frits Lugt, *Les Marques de Collections de Dessins et d'Estampes,* Amsterdam, 1921; *Supplément,* The Hague, 1956.
LB	Laurence Binyon, *Catalogue of Drawings by British Artists and Artists of Foreign Origin working in Great Britain, preserved in the Department of Prints and Drawings in the British Museum,* 4 vols, London, 1898–1907
Leslie and Taylor	Charles Robert Leslie and Tom Taylor, *Life and Times of Sir Joshua Reynolds,* 2 vols, London, 1865.
Lugt, *Ventes*	Frits Lugt, *Repertoire des Catalogues de Ventes Publiques . . . vers 1600–1825,* The Hague, 1938.
Malone	Edmond Malone, *The Works of Sir Joshua Reynolds,* 4th ed., 3 vols, London, 1809.
Northcote	James Northcote, *The Life of Sir Joshua Reynolds,* 2nd ed., London, 1819.
P	A. E. Popham, *Catalogue of Drawings by Dutch and Flemish Artists preserved in the Department of Prints and Drawings in the British Museum,* V, London, 1932.

P and G	Philip Pouncey and J. A. Gere, *Italian Drawings in the Department of Prints and Drawings in the British Museum. Raphael and his Circle,* 2 vols, London, 1962.
P and P	A. E. Popham and Philip Pouncey, *Italian Drawings in the Department of Prints and Drawings in the British Museum. The Fourteenth and Fifteenth Centuries,* 2 vols, London, 1950.
Popham	A. E. Popham, *Italian Drawings in the Department of Prints and Drawings in the British Museum. Artists working in Parma in the Sixteenth Century,* 2 vols, London, 1967.
Reynolds Letters	Frederick Whiley Hilles (ed.), *The Letters of Sir Joshua Reynolds,* Cambridge, 1929.
Russell	C. E. Russell, *English Mezzotint Portraits and their States,* London, 1926.
V and C	A. de Vesme and A. Calabi, *Francesco Bartolozzi,* Milan, 1928.
W	A. Whitman, *Valentine Green,* London, 1902.
Waterhouse 1941	Ellis Waterhouse, *Reynolds,* London, 1941.
Waterhouse 1958	Ellis Waterhouse, *Gainsborough,* London, 1958.
Waterhouse 1973	Ellis Waterhouse, *Reynolds,* London, 1973.
Whitley	William T. Whitley, *Thomas Gainsborough,* London, 1915.
Whitley Papers	Notes in MS and typescript on artists, collected by William T. Whitley and preserved in the Department of Prints and Drawings, British Museum.
Wilde	J. Wilde, *Italian Drawings in the Department of Prints and Drawings in the British Museum. Michelangelo and his Studio,* London, 1953.
Woodall	Mary Woodall, *Gainsborough's Landscape Drawings,* London, 1939.

* *An asterisk beside the catalogue number denotes an illustration in the plates section.*

1
Drawings by
Gainsborough and Reynolds

'If ever this nation should produce genius sufficient to acquire to us the honourable distinction of an English School, the name of Gainsborough will be transmitted to posterity, in the history of the Art, among the very first of that rising name.'[1] So wrote Sir Joshua Reynolds in tribute to his great rival as a portraitist, Thomas Gainsborough. The occasion was one of Reynolds' annual addresses to the Royal Academy students in which he lectured about such aspects of the fine arts as the philosophy of 'genius' and the 'great style', with especial reference to those two great protagonists, Michelangelo and Raphael. This address, Reynolds' *Fourteenth Discourse,* consisted of a most sensitive and elegantly written obituary of an artist whose own approach to painting and drawing was not only diametrically different from his own but who had also committed what Reynolds regarded the cardinal sin by not visiting Italy. In spite of this Reynolds wrote:

For my own part I confess I take more interest in, and am more captivated with, the powerful impression of nature, which Gainsborough exhibited in his portraits and in his landskips, and the interesting simplicity and elegance of his little ordinary beggar-children, than with any of the works of that [Roman] school, since the time of Andrea Sacchi, or perhaps, we may say Carlo Maratti . . . I am well aware how much I lay myself open to the censure and ridicule of the academical professors of other nations, in preferring the humble attempts of Gainsborough to the works of those regular graduates in the great historical style. But we have the sanction of all mankind in preferring genius in a lower rank of art, to feebleness and insipidity in the highest.[2]

That during Gainsborough's life-time there was intense rivalry between the two artists there can be no doubt. Both were competing for the same market and, indeed, on several occasions they painted portraits of the same sitters, for example Mrs 'Perdita' Robinson, Madame Baccelli, Colonel Banastre Tarleton, David Garrick, and Mrs Siddons. In 1784 Gainsborough withdrew all his pictures from the Royal Academy, because he considered that they

were not hung sympathetically, and never again exhibited there. Reynolds on the other hand used the Academy exhibitions to reinforce his pre-eminence, annually sending up to a dozen canvases. An anecdote is often told that Gainsborough painted *The Blue Boy* (now at the Huntington Library, California) to show that Reynolds' warning in the *Eighth Discourse* that it was folly to use cold colours, especially blue, for the principal masses of a picture, need not always be heeded.[3] Even if the story is in fact impossible because *The Blue Boy* seems to have been painted some years before the delivery of the *Eighth Discourse*, it serves as evidence for the competitive spirit and strained atmosphere between these two men. Yet both admired the other's talents and Gainsborough, dying, wrote to Reynolds a letter of great poignancy which clearly shows this:

> I am just to write what I fear you will not read after lying in a dying state for 6 months. The extreme affection which I am informed of by a Friend which Sir Joshua has expresd induces me to beg a last favor, which is to come once under my Roof and look at my things, my woodman you never saw, if what I ask (now?) is not disagreeable to youd feeling that I have the honor to speak to you. I can from a sincere Heart say that I always admired and sincerely loved Sir Joshua Reynolds.[4]

Reynolds' approach to art was essentially intellectual, and his readiness to embrace the world of artistic theory made him an ideal President of the Royal Academy, a position which has always required greater intellectual than executive powers. In the moments when he was not painting, collecting or travelling, he enjoyed the company of the members of 'The Club', among whom were such outstanding literary figures as Goldsmith, Boswell, Burke and Garrick; the prime object of its foundation, Reynolds said, had been to provide occasions to encourage and enjoy Dr Johnson's conversational brilliance. Although Garrick was also a close friend of Gainsborough, Gainsborough in general avoided literary men and all forms of serious conversation, preferring the company of musicians like Abel, J. C. Bach, and Giardini, actors, painters and members of the *demi-monde*. His friend William Jackson wrote:

> His conversation was sprightly, but licentious–his favourite subjects were music and painting, which he treated in a manner peculiarly his own. The common topics, or any of a superior cast, he thoroughly hated, and always interrupted by some stroke of wit or humour ... so far from writing, (he) scarcely ever read a book–but, for a letter to an intimate friend he had few equals, and no superior. It was like his conversation, gay, lively–fluttering round subjects which he touched, and away to another.[5]

The letters of both artists have been collected and published and show the truth of Jackson's observations. Yet, although

Gainsborough's letters often lack the penetration of Reynolds', they show him to have been more seriously interested in aesthetics and other intellectual pursuits than Jackson would have us believe.

Gainsborough has often been explained as an untutored genius, a natural artist, bored by the drudgery of face painting and aching to escape to paint 'landskips' and play his viol da gamba (as he himself said in one letter).[6] Even Reynolds was inclined to such a view, yet it is obviously simplistic. In fact we may suspect that Gainsborough was not even much of a musical performer; John Christian Bach was driven into an exasperated outburst when he called on Gainsborough at Schomberg House and found him playing the bassoon: 'Pote it away, man; pote it away,' he shouted, 'do you want to burst yourself, like the frog in the fable.'[7]

Gainsborough clearly wanted to present an image of himself as an untutored genius of a type we would now call 'romantic'; in his letters he often referred to his 'genius'. But this could only be part of the truth. Behind even the finest and most extravagant paintings of the Bath and London periods lay the discipline of Gravelot's teaching, the intense study of such Flemish paintings as Gainsborough had seen in England (particularly those of Van Dyck) and an only lightly veiled borrowing from the antique. Gainsborough was certainly conversant with ancient sculpture and frescoes, even if only in reproduction. In a painting now at Worcester, Massachusetts, he posed his daughters, pencils and portfolios in hand, before a cast of the Flora Farnese; the pose of *Madame Baccelli* derives from a plate in *Le Pitture Antiche d'Ercolano*; the pose of David Garrick in the destroyed Stratford-on-Avon full length (see 168), from an antique Apollo; the *Girl with Pigs* from a celebrated antique relief of the 'Conquered Province' on the Capitol; and the *Musidora* from a Renaissance bronze by Adrien de Vries.

Gainsborough so much acted the part of the Romantic genius unfettered by academic precepts and the use of learned pictorial quotations that biographers have readily accepted his own assessment of himself and so have been in danger of misunderstanding certain aspects of his real achievement. After he left Suffolk in 1759, Gainsborough settled in Bath and later in London, and here he became so urbanised that his landscapes gradually underwent a metamorphosis and by the 1770s and 80s, they had developed into complex abstract constructions with great attention to rhythms, masses, voids, tones, and textures—a far cry from the Dutch realist approach of his early Suffolk days.

The germ of this analytic approach to nature can be found in Gainsborough's work at an early stage, and both Reynolds[8] and Jackson[9] tell us that he made studies in the studio from model landscapes prepared from pieces of cork and glass, lumps of coal

and vegetables. Such an idea is very foreign to the main English tradition of topographical landscape drawing, and may well have been suggested to him by his master Gravelot, whose practice of drawing figures from articulated dolls he certainly followed (see 23).

Informing Gainsborough's landscape imagery of the later 1760s and 1770s was an increasing awareness of what was later in the century to be codified as the 'Picturesque'. That Gainsborough's experiments with landscape composition anticipated the *Observations* of William Gilpin and the *Essays* of Uvedale Price is particularly fascinating if we bear in mind that Gainsborough was a frequent guest of Sir Robert Price's at Foxley in the 1760s. This suggests that many of the ideas found in the works of Sir Robert's son Uvedale may have been in reality memorised from earlier discussions on landscape aesthetics held between the Prices, father and son, and Gainsborough. Uvedale, after Gainsborough's death, wrote that he went on 'frequent excursions with him into the country' and observed that Gainsborough was

of a lively and playful imagination, yet at times severe and sarcastic: but when we came to cottage or village scenes, to groups of children or to any objects of that kind which struck his fancy, I have often remarked in his countenance an expression of particular gentleness and complacency.[10]

Gainsborough's letters, his drawings, and prints testify to his fascination with experiments in technique and his preoccupation with materials and media. Gainsborough appears to have experimented with a form of monotype (see 62). He was one of the first artists to attempt soft ground etching (see 31, 34, 49 ff) and made one of the earliest English aquatints (see 28). He was very particular about his drawing paper and wrote to James Dodsley, the bookseller in Pall Mall:[11]

Sir,–I beg you to accept my sincerest thanks for the favour you have done me concerning the paper for drawings. I had set my heart upon getting some of it, as it is, so completely what I have long been in search of. The mischief of that you were so kind as to enclose is not only the small wires but a large cross wire ... which the other has none of, nor hardly any impression of the smallest wire. I wish, Sir, that one of my landskips, such as I could make you upon that paper, would prove a sufficient inducement for you to make still further inquiry. I should think my time well bestowed, however little the value you might with reason set upon it.

He wrote a long letter to William Jackson of Exeter on 29 January 1773 in which he explained his technique for applying

white heightening on his varnished drawings using Bristol chalk in an ingenious manner:[12]

You may acquaint your Friend that you tried your strength with me for the secret, but the *fixing the white chalk* previous to tinging the Drawing with waterColors, you find I am determined never to tell anybody; and here you'l get off, for no Chalk is used, and so keep it close for your own use.

Nothing of this type of fascination for technical experiment appears in Reynolds' correspondence and neither is it apparent from the drawings themselves. Reynolds was above all a theoretician and an academic teacher who was more exercised by a picture's subject matter and its 'correct' treatment, by concepts of 'High Art', by the nature of genius, by neo-Platonic theories of the ideal and by the status of the artist in society. Thus, while there are, thanks to recent scholarship, relatively few attributional problems for the student of Gainsborough's drawings, the problems of the connoisseurship of Reynolds' drawings are enormous.

Reynolds could indeed draw well, but too often his efforts are, frankly, coarse and inept. This is curious for an artist who was one of the most distinguished collectors of drawings in the history of English connoisseurship. The principal reason for this was that he composed after the Venetian manner *alla prima*, drawing with the brush directly on to the canvas. Thus an exhibition of X-rays of Reynolds' portraits and compositions should form a more fitting complement to a display of Gainsborough's graphic work.

Reynolds seems hardly ever to have drawn for pleasure. Few of his drawings in fact appear to have been made for their own sakes, and few played any part in his creative process. Many are copies after the works of other masters, where he stored away ideas which might later be useful in his own paintings. His lack of training as a draughtsman was a constant source of regret, as we know from all his early biographers:

... he had real cause to lament the want of a better education in his profession. The basis of all superior Art is ability in drawing the human figure, and knowledge of its anatomy. The valuable days of his youth, the season when it is best, if not alone acquired, passed without his attaining this, the most essential part of youthful study. The want of this acquirement he felt throughout his life; for, owing to this neglect, he never had professional strength to attempt to execute works which required great power of the hand over form, without exposing his deficiency.[13]

As a painter Reynolds set little store by autograph finish and was content in his vast portrait practice to relegate draperies, and perhaps much more beside, to studio assistants like Peter Toms and Giuseppe Marchi. Gainsborough, by contrast, is not known to

have employed any such studio assistance and set great store by his autograph touch, which he referred to as his 'pencillings' and his critics called 'daubs'. Reynolds' compositions are often the result of clever borrowing principally from the Old Masters and the Antique (what Horace Walpole approvingly described as 'wit'), while his concepts of form, even in his most richly Rembrandtesque manner, continue to be defined by line. Gainsborough on the other hand, who as a draughtsman was a master of line, became progressively more fascinated by fleeting impressions of flesh and fabric, and by abstract interior nuances of light and shade.

The attribution of drawings to Reynolds can be hazardous as his work is rarely, if ever, signed and of very uneven quality. The bases for the attributions in this catalogue are (a) autograph inscriptions, (b) a firm provenance from the artist's studio, (c) an undeniable rôle in the process of creation of an autograph painting, (d) apparently reliable early attributions, (e) close stylistic parallels with drawings from any of these four categories. From this a picture of Reynolds' artistic development emerges and, where gaps in it appear, other less securely documented drawings may be inserted tentatively that may further improve our understanding of the artist's work.

Among the earliest drawings attributed to Reynolds, with undeniably insufficient evidence, are a group of studies in pen and brown ink principally after portraits by Sir Godfrey Kneller. These are small studies drawn with a nervous outline, the schematic faces often indicated with crosses and the draperies cursorily shown by untidy scribbles. The drawing style, which is reminiscent of John Vanderbank and some Hogarths, is just the sort of thing which we would expect that Reynolds was doing as a youth in the studio of Thomas Hudson. Something of the same idiosyncrasy of line seems to recur in much later autograph pen drawings like, for example, the study of a little girl, called *Comedy* in the Ashmolean Museum, Oxford.[14]

With the two notebooks (see 6 and 7) we are on firm ground, for these were both made in Italy by Reynolds in 1752 and passed by descent from the artist to his niece, the Marchioness of Thomond, appearing in her sale at Christie's, 26 May 1821. These small volumes with their wealth of pencil annotations and often crabbed little studies, provide a mass of information about the artist's movements and reactions to the architecture, paintings, sculpture, countryside, and day to day life of mid eighteenth-century Italy. Some of the pages are particularly sensitive and show the artist at his most relaxed, observing the gnarled trunk of an olive tree, a small street fountain, or a pretty girl adjusting her garter. Around these undeniably autograph drawings can be associated other loose

sheets of similar style and period like the fine red chalk study of *Ariadne in Naxos* (see 87), that belonged to Reynolds' friend in Italy, the painter Nathaniel Hone.

There follows an elegant pen and brown ink and brown wash sheet of studies for a portrait of a lady (see 88) which is covered with autograph notes and belonged, with other autograph drawings, to the Edgcumbe family, some of his most important patrons. A similarly reliable provenance is afforded by two academical studies that were in the collection of Richard Payne Knight and were bequeathed by him to the British Museum in 1824 with attributions to Reynolds.

It is more difficult to be sure that the coloured chalk study of 'Perdita' Robinson (see 91) is autograph but, in spite of the rubbed condition, the quality seems high and it does vary from all the known oil portraits of the sitter, which suggests that it is not a copy. The initials JR bottom right may indeed be a signature.

Particularly weak are the two studies in red chalk of pictures by Reynolds formerly at Ampthill in the possession of the Earl of Upper Ossory (see 93, 94). The drawings, lacking in assurance, appear to be records of the paintings but at this stage of our understanding it would be risky to say whether Reynolds made them in an off moment or whether they were drawn by another hand. There can be no doubt about the two studies for the *Infant Hercules* (see 95) because not only is the line comparable with other apparently autograph sheets but they are evidently studies for the picture commissioned from Reynolds by the Empress of Russia and exhibited at the Royal Academy in 1788. The portrait drawing of Miss Theophila Gwatkin (see 96), which has a direct provenance from the sitter, must again be authentic, even if its sentiment appears rather mawkish.

Much more work will need to be done on Reynolds as a draughtsman before a really coherent picture of his achievement emerges. The British Museum is fortunate to possess the largest collection of drawings by Gainsborough and one of the largest groups of drawings attributed to Reynolds. The showing of the major part of these two collections alongside each other will draw attention to the relatively neglected aspect of Reynolds' draughtsmanship, and may encourage a more serious examination of this side of his art.

But the comparison is, it must be admitted, less than kind to Reynolds. This is an inevitable result of the two artists' different use of drawing. Reynolds' hesitating and diffident approach has been described. Gainsborough, on the other hand, relished the opportunities that drawing afforded and made huge numbers during his life. Hayes' catalogue includes 878, and more are continually turning up. Of these drawings very few indeed can be

connected with paintings, and most were intended as finished compositions in their own right. The abundance and type of this production is quite exceptional in England in the eighteenth century for a painter (as opposed to a professional draughtsman such as Rowlandson); its quality, although variable, can be very high. The Museum is fortunate in possessing many of Gainsborough's finest drawings, and can thus demonstrate that, at his best, he can bear comparison with the greatest draughtsmen of his period in any country.

TIMOTHY CLIFFORD

Notes to Introduction

1 Discourses, p. 248.
2 Discourses, p. 249.
3 Whitley, pp. 372–8.
4 Gainsborough Letters, p. 127.
5 William Jackson, *The Four Ages, together with essays on various subjects,* London, 1798, pp. 160 and 183.
6 Gainsborough Letters, p. 115.
7 *Reminiscences of Henry Angelo,* London, 1828, I, pp. 185–6.
8 Discourses, p. 250.
9 William Jackson, *op. cit.,* pp. 167–8.
10 Uvedale Price, *Essays on the Picturesque,* London, 1810, II, p. 368.
11 Gainsborough Letters, p. 59.
12 Gainsborough Letters, p. 177.
13 Joseph Farington, *Memoirs of the Life of Sir Joshua Reynolds,* London, 1819, pp. 21–2.
14 Published by K. T. Parker in *Old Master Drawings,* V, 1930–1, pp. 75–8.

Hubert François Bourguignon, called Gravelot
1699–1773

Born in Paris; came to London in 1733 where he remained until 1745. Painted conversation and subject pictures, but was best known as a designer and book illustrator. In 1740 the young Gainsborough became Gravelot's pupil in Covent Garden. Gravelot was the leading member of the group of French artists who introduced the sophisticated *rocaille* style into England. In 1745 he returned to Paris where he died twenty-eight years later.
Literature V. Lanckoronska, 'Gravelot in London', *Philobiblon,* X, 1938, pp. 97–113; Y. Bruand, 'Hubert Gravelot et l'Angleterre', *Gazette des Beaux-Arts,* CV, 1960, pp. 35–44; H. Hammelmann and T. S. R. Boase, *Book Illustrators in Eighteenth Century England,* New Haven, 1975, pp. 38–46.

1 Sheet of studies including a sportsman with a fowling piece, an étui, various heads and ornaments
Etching. 160 × 92 mm
1858–4–17–354

This sheet illustrates the characteristics of Gravelot's French style, combining gracefully drawn figures with a masterly understanding of rococo ornament. Although Gravelot worked in England principally as a book illustrator, he also specialised in designing snuff boxes, cane handles, watch cases and étuis (cf. B. Watney, 'Origins of designs for English ceramics of the 18th century', *Burlington Magazine,* CXIV, 1972, pp. 825f., and F. J. B. Watson, 'An historic gold box by Moser', *ibid,* CXVII, 1976, pp. 26–9, where what appears to be a Gravelot drawing for a box has been wrongly attributed to Moser). It is likely that the young Gainsborough assisted his master in the design of such *objets de virtù*.

2 A triangular panel of *rocaille* ornament decorated with putti, animals, fruit and flowers

Pen and brown ink, brown and grey wash, the vegetation tinted in colours. 238 × 371 mm (the lower corners cut)
Signed bottom right in brown ink: *H. Gravelot delin.*
Provenance Dr J. Percy (L 1504) (sale, Sotheby's, 12 May 1890, lot 535, purchased by the Museum). 1890-5-12-91

The exact purpose of this design is not known. It may have been intended as a pattern for embroidery. The shape suggests a stomacher, but if so one would have to assume that the sheet has been cut at the bottom.

3 Design for a decorative frame to enclose a portrait of Sir William Temple

Pen, brush, grey ink wash over traces of pencil. 371 × 229 mm (irregular)
Signed or inscribed bottom centre: *F. H. Gravelot inv. & delin.* An alternative design for the upper part of the cartouche is attached on a separate piece of paper.
Provenance C. M. Cracherode Bequest. Gg. 1-471

The *Morning Chronicle* in its obituary of Gainsborough on 8 August 1788 stated that the artist 'became pupil to Mr Gravelot, under whose instruction he drew most of the ornaments which decorate the illustrious heads, so admirably engraved by Houbraken'. The surviving drawings for these cartouches are of uneven quality and were clearly drawn by different artists, not one of whom can be identified with Gainsborough (see John Hayes, 'The Ornamental Surrounds for Houbraken's Illustrious Heads', *Apollo*, LXXXIX, 1969, Supplement). Gravelot's accomplished treatment of *rocaille* with its 'S' and 'C' scroll interlaces may have influenced Gainsborough's later compositions with their underlying rococo structure. In the portrait of *Mr and Mrs Andrews* (National Gallery, Waterhouse 18), the interlaced scrolling of the garden seat is far more exaggerated than in any garden furniture of the period and shows Gainsborough's enthusiasm for these fashionable forms.

4 Sir William Temple (1628-99); the frame after Gravelot, the head after Sir Peter Lely (1618-80)

Etching and engraving by Jacob Houbraken (1698-1780). 372 × 235 mm
1868-8-22-6714

Sir William Temple, statesman and author, was one of the leading supporters of the policy of protestant alliances, sometime Ambassador in Brussels and The Hague, and patron of Jonathan Swift. This engraving, with the decorative frame designed by Gravelot's studio (see 3), was used as an illustration to Thomas Birch, *The Heads of Illustrious Persons in Great Britain,* London, 1743-52 (A. Ver Huell, *Jacobus Houbraken et son oeuvre,* Arnhem, 1875, pp. 99-124, No. 67).

Francis Hayman
1708-76

Born at Exeter where he first trained as an artist; came to London and worked as a scene painter for Drury Lane. He became known as one of the most distinguished history painters of his day but also painted portraits and conversation pieces, and designed book illustrations. With Hogarth and others he executed a large series of paintings to decorate the supper boxes at Vauxhall Gardens, an undertaking in which the young Gainsborough probably collaborated. From about 1742-6 Hayman worked with Gravelot illustrating books. Like Hogarth, Wilson, Gainsborough and others he gave a specimen of his work, in his case the *Finding of Moses,* to the Foundling Hospital. He was a founder member of the Royal Academy.
Literature Lawrence Gowing, 'Hogarth, Hayman and the Vauxhall Decorations', *Burlington Magazine,* XCV, 1953, pp. 4-19; *Paintings, Drawings and Prints by Francis Hayman,* exhibition catalogue, Kenwood, 1960; Hans Hammelmann and T. S. R. Boase, *Book Illustrators in Eighteenth-Century England,* New Haven, 1975, pp. 49-55.

5 Illustration to Samuel Richardson's *Pamela: Pamela hides in the woodshed*

Etching by Gravelot after Francis Hayman. 132 × 178 mm
1867-3-9-1408

6 Illustration to Samuel Richardson's
Pamela: Pamela kneels before her master.

Etching by Gravelot after Francis Hayman.
130 × 179 mm
1875–7–10–5044

Nos. 5 and 6 are taken from the first volume of
Samuel Richardson's novel: *Pamela: or, Virtue
rewarded . . . in four volumes . . . sixth edition,
corrected. And embellished with copper-plates
designed and engraved by Mr Hayman and Mr
Gravelot . . . 1742.* The style is closely paralleled in
Gainsborough's early work, in which elegant doll-
like figures in the French rococo taste similarly
disport themselves in landscapes.

Thomas Gainsborough
1727–88

7 Landscape with a couple sketching on a
river bank

Pencil. 190 × 152 mm
Provenance Bought from Colnaghi, 1868.
1868–3–28–315
Literature Hayes 95

The type of river landscape suggests that this study
was drawn in Suffolk. The foreground foliage
recalls *Cornard Wood* (National Gallery, Water-
house 828), and the figures *Mr and Mrs Robert
Andrews* (National Gallery, Waterhouse 18). Both
of these oil paintings date from *c.*1748. The
placing of elegant figures in a landscape setting is
strongly reminiscent of compositions by Gravelot
and Hayman. Late 1740s.

John Boydell
1719–1804

Born at Dorrington, Shropshire, came to London
aged twenty-one where he was apprenticed to the
engraver W. H. Toms. Specialised in reproductive
engraving after compositions by Rosa, Vernet,
Wilson and West, but made his fortune in a publi-
cation of *Views of England and Wales.* He had a
reputation as a liberal patron of talented artists
and, *c.*1789, started his 'Shakespear Gallery'. This
was a series of pictures commissioned by Boydell
illustrating the works of Shakespeare. The Gallery
was opened to the public and the compositions
were engraved for Boydell's splendid illustrated
edition of the *Works of Shakespeare.* In 1791
Boydell, who had become a very rich man and an
alderman, was Lord Mayor of London.

8 Wooded landscape with a fisherman

Line-engraving by John Boydell after Thomas
Gainsborough. 253 × 350 mm
1872–4–13–335
Literature Hayes under 76

First published in 1747 by Boydell as the fourth of
a series, and later republished by him as plate 92
in *A Collection of Views in England and Wales,*
London, 1790. The original drawings for this and
others of the series are lost. The design is curious
and more primitive than Gainsborough's drawings
and paintings of *c.*1748. The conventional com-
position and the contrived foliage with a layered
tonal effect which reveals little dependence on
Dutch prototypes are unusual; while the figures,
especially the couple on the far bank, lack much
of the dainty elegance usually associated with
Gainsborough's master, Gravelot. The vision
seems markedly cruder than in the painting of
Three figures at the foot of a woody bank (Mellon
Collection, Waterhouse 872) which Hayes dates
*c.*1744–6. The stylistic disparity with Gains-
borough's early documented work is even more
marked in others of the Boydell series, which
suggests that though published in 1747, they were
after studies made perhaps as early as 1744–5.
Mary Woodall (pp. 10–11 and pl.2) compared the
print with a painting attributed to Gainsborough
in the collection of Mr Ivan Cobbold; the latter
however, to judge from a photograph, is by
Thomas Smith of Derby (d. 1767).

Jacob Van Ruysdael
1628–82

9 Wood scene with a fallen silver birch

Line engraving by Pierre Etienne Moitte
(1722–80) after Ruysdael. 272 × 308 mm
1850–8–10–403

Ruysdael's influence on Gainsborough was par-
ticularly marked during the later 1740s and early
1750s. *Cornard Wood* at the National Gallery
(Waterhouse 828) is the classic essay in this
manner, but many other landscapes like *Drink-
stone Park* at São Paulo (Waterhouse 826) and
Estuary with church, cattle and figures at Ipswich
(Waterhouse 838) reveal the same indebtedness.
Gainsborough copied a large painting by Ruysdael
of a *Forest scene* (Louvre) in a drawing now in the
Whitworth Art Gallery, Manchester (Hayes 80).

Thomas Gainsborough

* **10** Wooded landscape with gypsies round a camp fire

Etching. 472 × 421mm (image size)
1877–6–9–1774
Literature H 2

The etching records a lost picture by Gainsborough that was painted *c.*1753–4 for an Ipswich patron (Waterhouse 887). An earlier and radically different version of the composition was slashed by Gainsborough in a temper and left unfinished; this was given by the artist to his friend Joshua Kirby and it is now in the Tate Gallery (Waterhouse 864; H plate 33). It has not previously been observed that a study for the head of the donkey is in the British Museum (Oo 2–14, Hayes 857).

This impression shows the plate as it was left by Gainsborough, with all the lines etched. It was later reworked with the graver by J. Wood and published in March 1759, and again republished in 1764, this time by Boydell. Hayes states that 'no impressions of the original etching by Gainsborough are now known', which can only mean that in the state here exhibited the plate has already been reworked with a graver. This is incorrect, for there is no trace of any such reworking. Since Hayes' book was published, an impression of an unknown earlier state, before the addition of some horizontal lines to the sky, and shading in the upper foliage of the tree, has been sold at Christie's (30 July 1975, lot 316).

11 Wooded landscape with a church, cow and figure

Etching. 103 × 155 mm
1878–12–14–158
Literature H 1

The fourth and last state as published by Joshua Kirby in his book: *Dr Brook Taylor's Method of Perspective made easy*, Ipswich, 1754, fig. 72. A copy of this print by the young J. M. W. Turner of *c.*1790–1 is in a sketch book at the Princeton Art Museum (H fig. 32).

12 Burdock leaves
Verso Man in a tricorne hat with his hands on his hips

Black chalk and stump. 138 × 186 mm
Inscribed *verso* in pencil bottom left: *59* and *J* in pencil.
Provenance Sir J. C. Robinson (sale, Christie's, 21 April 1902, lot 130 together with No. 13); G. Salting Bequest. 1910–2–12–256
Literature Hayes 86

The use of large burdock leaves for foregrounds was a compositional device much used by Dutch seventeenth-century artists; a notable example is the *Landscape with sportsmen and game* by Adam Pynacker (1621–73) at Dulwich. Gainsborough, who presumably drew these leaves from nature, used them for the foregrounds of such paintings as *The Peasant with Donkeys* (Major A. F. Clarke-Jervoise, Waterhouse 871). The male figure on the *verso* with his arms akimbo and pointing his right foot appears to be dancing. The pose is most unusual for Gainsborough, and the sketch may be connected with the decorations at Vauxhall, where many dancing figures appeared. Professor Gowing has mentioned Gainsborough's possible rôle as an assistant in this project ('Hogarth, Hayman and the Vauxhall Decorators', *Burlington Magazine,* XCV, 1953, pp. 4–19). Late 1740s.

13 Study of trees
Verso A wooded lane

Black chalk and stump. 140 × 189 mm
Provenance John Lowndes; Sir J. C. Robinson (sale, Christie's, 21 April 1902, lot 130 together with No. 12); G. Salting Bequest.
1910–2–12–257
Literature Hayes 85

Both *recto* and *verso* appear to be studies from nature made in the later 1740s.

* **14** A man holding a Claude glass

Pencil. 184 × 138 mm
Provenance Gainsborough sale, Christie's, 11 May 1799, lot 85 (a sketchbook), bought R. Payne Knight, by whom bequeathed in 1824. Oo. 2–27
Literature Hayes 10

This is presumed to be a self-portrait and dates from the late 1740s or early 1750s. It was evidently drawn from the life and shows the artist using a darkened mirror known as a 'Claude glass', which served to assist the composition of a landscape by reducing the detail and lowering the tone

of the scenery reflected. Thomas West in his *Guide to the Lakes,* London, 1780 explained: 'The person using it ought always to turn his back to the object that he views . . . It should be suspended by the upper part of the case, holding it a little to the right or left (as the position of the parts to be viewed requires) and the face screened from the sun.'

Gainsborough in his paintings frequently posed gentlemen seated on grassy mounds, as in the portrait of *John Plampin* (National Gallery, Waterhouse 546) and the *Browne Family* (Houghton, Waterhouse 86).

15 Study of a sheep

Pencil. 150 × 196 mm
Provenance As for No. 14. Oo. 2–15
Literature Hayes 856

A study from life. Hayes describes the animal as a goat, but it appears to be a sheep. Early to mid 1750s.

16 Farm buildings near a pond

Pencil. 149 × 193 mm
Provenance As for No. 14. Oo. 2–52
Literature Hayes 212

A study from nature which was worked up for the *Landscape with farm buildings, figures and cows* in the Mellon Collection (not in Waterhouse, Hayes pl. 321). Both drawing and painting appear to date from the mid 1750s.

17 A young girl seated

Pencil. 197 × 149 mm
Provenance As for No. 14. Oo. 2–21
Literature Hayes 820

A study for the girl with a basket of eggs to the centre of the *River scene with figures* at St Louis (Waterhouse 834). In the painting the position of the left arm is different. A similar figure appears in the *Rustic Courtship* at Montreal (Waterhouse 844). Mid 1750s.

* 18 Study of willows

Pencil and wash. 153 × 186 mm
Provenance As for No. 14. Oo. 2–9
Literature Hayes 138

In this sheet, as in many of his earlier pencil drawings, Gainsborough has fixed the black lead with a thin wash, the grey tone presumably consisting of particles of soft lead redistributed by the wash. The practice was used later by a fellow East

Anglian, John Crome (1768–1821). The subject, which was probably drawn from nature, is reminiscent in *motif* of some Van Dyck drawings. Late 1740s.

* 19 Trees with a pool in the foreground

Pencil and wash. 148 × 193 mm
Provenance As for No. 14. Oo. 2–6
Literature Hayes 127

A study from nature. Both the subject and composition are reminiscent of Ruysdael, and may be compared with *Cornard Wood* (National Gallery, Waterhouse 828) and the *Woody landscape with a seated figure* (Tate Gallery, Waterhouse 853). Late 1740s.

Hubert François Bourguignon, called Gravelot

(For biographical notice, see before 1.)

20 A young woman walking to the left, looking back over her left shoulder

Black chalk heightened with white on buff paper. 442 × 224 mm
1963–7–16–6

This study by Gainsborough's master anticipates very closely certain drawings by Gainsborough himself, such as the study of Mary Gainsborough (see 30). Gravelot's sophisticated and theatrical French style was subtly transformed by Gainsborough into something more realistic and characteristically English.

Attributed to Arthur Devis

1711–87

21 Mrs Lee

Coloured chalks. 610 × 450mm
Provenance J. P. Heseltine (sale, Sotheby's, 27 May 1935, lot 49); H. S. Reitlinger.
1977–12–10–12

This recently acquired study bore an incorrect attribution to Joseph Highmore (1692–1780). It resembles portraits in oil by Gravelot, Hayman and the young Gainsborough, but the landscape, predominantly in shades of grey-green, is uncharacteristic of any of these artists. Dr John Hayes has suggested most plausibly the present attribution (see, for example, S. H. Pavière, *The Devis Family of Painters,* Leigh-on-Sea, 1950,

plates 13, 15, 17). Gainsborough, during his early period working in Suffolk, and Devis, working in Lancashire, both had a very similar approach to portraiture in the late 1740s, with stiff doll-like figures, brightly lit and painted with minute attention to details of costume, posed in a rural setting.

Attributed to Thomas Gainsborough

22 A woman seated holding a fan
Black and coloured chalks on blue paper.
286 × 200 mm
1907–5–15–25
Literature Hayes 26

This bold drawing is difficult to parallel in the work of Gainsborough. It is evidently a life study for an unidentified portrait, and is dated by Hayes *c.*1755–65 on the basis of costume and coiffure. The author could be foreign, perhaps a Netherlandish or French artist.

Thomas Gainsborough

*** 23** A standing woman holding a fan
Pencil with grey wash. 358 × 220 mm (trimmed at all four corners)
Provenance Miss L. Stephanoff. 1895–7–25–3
Literature Hayes 21

Probably drawn from an articulated doll. Gainsborough evidently used dolls as the basis for many of his portrait studies in the late 1750s and 1760s. Later he used them for his painting of *The Mall;* William Jackson stated that 'all the female figures in his Park-scene he drew from a doll of his own creation' (*The Four Ages,* London, 1798, p. 167). A doll that belonged to Gainsborough was later acquired by Collins (Whitley, p. 231), and Gravelot had three dolls which were sold together with their wardrobes in his posthumous sale, Paris, 1773. A doll which belonged to L. F. Roubiliac (1702–62) is now in the London Museum.

This drawing lacks its corners; presumably it was once pasted down by the corners and later torn from its mount. Other drawings suffering the same fate and presumably having a provenance from the same album are known such as Nos. 24, 25 and 37 (see also Hayes 17, 18, 19, 22 and 24). Several in the series are known to have descended through Gainsborough's wife to his daughter Margaret and then either to Henry Briggs or, through Sophia Lane, to Richard Lane. The costume and hair style in this drawing suggest a date in the later 1750s or early 1760s.

24 A seated woman holding a fan
Pencil. 355 × 215 mm (trimmed at all four corners)
Provenance Miss L. Stephanoff. 1895–7–25–2
Literature Hayes 20

Probably studied from the same articulated doll as No. 23. The area of soft tone in the shadows at the lower right has been made by smudging the lead and not by applying wash as is usually the case with Gainsborough's drawings of this type.

*** 25** Mrs Philip Thicknesse
Blue, yellow and brown watercolour over pencil.
335 × 256 mm (trimmed at all four corners)
Provenance H. H. Gilchrist. 1894–6–12–11
Literature Hayes 16; Kenwood 1977, No. 16

Philip Thicknesse (1719–92) was Gainsborough's friend and patron first at Ipswich and later at Bath. He also wrote the first biography of Gainsborough, published in 1788. The drawing is a study for the portrait of his wife, née Anne Ford (1737–1824), painted in 1760 (Cincinnati, Waterhouse 660). In the painting the pose is very similar, but a small table with a pile of music replaces the sofa to the right, and in place of the landscape background is a viol and bow hanging on the wall; the cat is also omitted. William Hoare and Cipriani also made studies of Mrs Thicknesse holding musical instruments which are now respectively in the British and Ashmolean Museums. In the present drawing she is posed with a cittern or English guitar (see Kenwood 1977, No. 22).

*** 26** Landscape with winding track and cottage
Watercolour. 61 × 87 mm
Inscribed *verso* in brown ink: *Bath–*
Mr Gainsborough Given me by Mr Saml. Collins, miniature Painter, who had it of
Mr Gainsborough.
Provenance Given by the artist to Samuel Collins; C. M. Cracherode Bequest. Gg. 3–389
Literature LB 15; Woodall 475 (as 'doubtful'); Hayes p. 89, pl. 446 (as 'too coarse for Gainsborough himself')

The attribution of this drawing, which was doubted by Woodall and rejected by Hayes,

deserves reconsideration. According to a note on the back in Cracherode's hand, the drawing had been given by the artist to Samuel Collins, a miniature painter. Collins, who was a native of Bristol, worked at Bath but removed to Dublin *c.*1762/3 where he died in October 1768. His chief claim to fame was as the master of Ozias Humphrey. Collins was certainly an acquaintance of Gainsborough whom he introduced to the musician William Jackson ('Autobiography of William Jackson', *The Leisure Hour,* May 1882, p. 276). Gainsborough also apparently painted a portrait of him (G. C. Williamson, *Ozias Humphrey,* London, 1918, p. 221). If the inscription is to be believed, this drawing must date from between October 1759, when Gainsborough arrived in Bath, and 1762/3, when Collins left Bath for Dublin. This does not necessarily mean that it was drawn in 1760 (*pace* Woodall p. 58).

Woodall associated this drawing with a small study attributed to William Marlow in the British Museum (Gg. 3–396), also from Cracherode's Bequest. But Marlow's drawing is similar only in size, and, as Miss Woodall admits, 'the actual shape of the tree is quite different and the linear conventions employed often differ from those which are most characteristic of Gainsborough'. Although the size of the present drawing is unusual for Gainsborough, the composition, palette, pointillist foreground and feathery convention for foliage all appear in his work *c.*1760. The provenance is one of the soundest for any Gainsborough drawing. Perhaps the artist gave this miniature landscape in return for a miniature portrait by Collins. In a similar way John Bacon (1740–99) exchanged a profile marble portrait of Mason Chamberlain (d. 1787) for his own portrait painted on canvas (both now in the National Portrait Gallery). This exquisite small landscape is of considerable importance if it can be accepted as Gainsborough's work, for it must date from 1759–1762/3, and there are few watercolour landscapes that can be dated with this degree of accuracy.

*** 27 Open landscape with cows**

Watercolour, varnished. 187 × 236 mm
Provenance C. M. Cracherode Bequest.
Gg. 3–390
Literature Hayes 326

The delicate underlying palette of pink, buff, grey and blue is unfortunately distorted by a dense film of yellow varnish.

The vision is clearly influenced by the paintings of Aelbert Cuyp (1620–91). Dated by Hayes in the early 1770s, and associated with a drawing in the Cleveland Museum of Art (Hayes 325) and one of a landscape with a drover and horses in Mrs U. Studdart's collection (Hayes 321); the latter he dates in the later 1760s. The present drawing was engraved by Thomas Rowlandson in his *Imitations of Modern Drawings,* London, 1784–8. It appears to date from *c.*1760 or a little later (see 26) and Mrs Studdart's drawing may also date from the same period. It was later used as the model for Gainsborough's aquatint (see 28), but was clearly not made specifically for it.

*** 28 Three cows on a hillside**

Aquatint with dry-point. 126 × 202 mm
1872–6–8–283
Literature H 3

Aquatint executed by the sugar-lift process with additional work in dry-point; this impression is printed in grey. Hayes observes that 'the effect of sunlight and strong shadow achieved in the drawing [see 27] is totally lost'. If Hayes dating in the early 1770s is correct, this must be one of the earliest aquatints made in Britain.

*** 29 A woman in a chip hat**

Black chalk and stump heightened with white on grey-green paper. 449 × 345 mm
Verso A youth, a study after Van Dyck
Inscribed in pencil in a recent hand on the old mount: *CATHERINE*
Provenance Agnew; 2nd Viscount Rothermere; Miss J. E. Wilson Bequest. 1960–11–10–2
Literature Hayes 36 (*recto*) and 37 (*verso*)

The costume suggests a date of *c.*1765–70. The drawing on the *verso* appears to be a copy of a lost Van Dyck drawing: compare, for example, Van Dyck's study for *Ferdinand, Cardinal Archduke of Austria* (1845–12–8–1) which belonged to Jonathan Richardson, Thomas Hudson and Sir Joshua Reynolds. The drawing on the *recto* was evidently *en suite* with a drawing now in the Ashmolean (Hayes 30) and No. 30.

*** 30 Mary Gainsborough**

Black chalk heightened with white on grey-green
paper. 447 × 344 mm
Inscribed in pencil in a recent hand on the old
mount: *MARY*
Provenance As for No. 29. 1960–11–10–1
Literature Hayes 35

A companion drawing to No. 29. Comparison
with portraits in oil of Mary Gainsborough
suggests that this study represents the artist's
daughter. The hair-style and costume suggest a
date of *c*.1765–70.

**31 A wooded landscape with country cart
and figures**

Soft ground etching and aquatint. 253 × 320 mm
(trimmed)
1852–7–5–228
Literature H 6

The original drawing for the subject in black chalk
is in the Whitworth Art Gallery, Manchester
(Hayes 407). A unique impression of the print
before the aquatint was added on top of the soft
ground etching is at Christchurch Mansion,
Ipswich. The impression exhibited here is printed
in grey and pasted on a contemporary wash line
mount. The reprints by Boydell in 1797 seem to
be printed in brown. The soft, broad handling of
the chalk in the Whitworth drawing suggests a date
in the mid to late 1770s, to which period this soft
ground etching must also belong.

**32 Wooded landscape with figures and
cottages**

Watercolour over pencil, heightened with white.
202 × 248 mm
Provenance E. Cheney (sale, Sotheby's, 29 April
1885, lot 324, bought Colnaghi for the Museum)
1885–5–9–1640
Literature Hayes 254

The style is unusual, but the drawing seems to
date from the mid 1760s. The closest parallel is
with the *Wooded landscape with horseman* in the
Fogg Art Museum, Harvard (Hayes 259).

Sir Peter Paul Rubens
1577–1640

**33 Rocky landscape with waggon by
moonlight**

Line-engraving by Schelte a Bolswert
(1586–1659) after Rubens. 336 × 455 mm
1891–4–14–1277

This engraving is after a landscape by Rubens
which, in Gainsborough's day, was at Houghton
Hall, Norfolk; it was later bought by Catherine
the Great and is now in the Hermitage. Such
landscapes, so broadly conceived with undulating
linear rhythms and so vigorously dramatic, exer-
cised a strong influence on Gainsborough's
landscape paintings of the 1760s onwards. The
artist wrote to his friend David Garrick and sought
him 'to call *upon any context* any day after next
Wednesday at the Duke of Montagu . . . only to
see his Grace's Landskips by Rubens' (n.d.
Gainsborough Letters No. 27).

Thomas Gainsborough

*** 34 Wooded landscape with two country
carts and figures**

Soft ground etching. 297 × 392 mm (trimmed)
1866–12–8–355
Literature H 9

The plate was published on 1 February 1780.
Since this impression is trimmed one cannot tell
whether it bore this lettering, but it is certainly
earlier than the Boydell reprint of 1797. There is a
related drawing, which shows only one cart, in the
collection of Earl Spencer (Hayes 462).

*** 35 A wooded landscape with a boy
reclining in a cart**

Pen and brown ink with grey and brown wash.
176 × 221 mm
Provenance J. E. Preston. 1896–5–11–2
Literature Hayes 307

Dateable in the late 1760s or early 1770s. The
motif of the boy sleeping in the cart with the cart
seen at the same angle recurs in an unpublished
drawing by Gainsborough in the Warde collection
at Squerryes Court, Westerham.

36 Woman seated playing the harp

Black chalk and stump and white chalk on buff
paper. 369 × 271 mm
Provenance C. Fairfax Murray, from whom
purchased. 1890–10–13–2
Literature Hayes 34

Gainsborough painted Lady Clarges seated playing
the harp in the late 1770s (see 38); as Hayes
observes, the costume and hair style in the draw-
ing, though loosely indicated and indistinct,
suggest a somewhat earlier date of c.1755–65. The
technique comes close to the drawing of a *Woman
seated beside a plinth* in the Pierpoint Morgan
Library (Hayes 39), dateable c.1765–70.

* **37** A music party

Red chalk and stump. 241 × 324 mm
Inscribed *verso* in grey ink: *Portraits (of Himself,
his two Daughters, and Abel) by Gainsborough*
and in the same hand and ink *To W. Mulready
Esq. RA from his obliged servant Richd. Lane*
Provenance Among the drawings left by the artist
to his wife, which descended through Margaret
Gainsborough either to Henry Briggs or, through
Sophia Lane, to Richard Lane (1800–72); given
by Richard Lane to William Mulready;
possibly Mulready sale, Christie's,
28 April 1864, lot 91; W. Ward. 1889–7–24–371
Literature LB 1; Hayes 47; Kenwood 1977,
No. 18

The use of red chalk is unusual for Gainsborough
although it was often employed by his competitor
in Bath, the portraitist William Hoare (1706–92).
The darting line with rapid hatching is character-
istic of Gainsborough at his most fluent and is
very similar to his handling of oil paint when
laying in portraits: compare *4th Earl of Abingdon*
(Waterhouse 5) and *1st Earl Cathcart* (Waterhouse
124).

Various attempts have been made to identify the
members of the party. Hayes tentatively suggested
that the scene was the Linley house in Bath, in
which case the characters could be Mrs Linley at
the harpsichord and Elizabeth and Thomas
Linley, senior, singing. This hypothesis was
further elaborated in the Kenwood catalogue,
where the violinist was cautiously identified with
Thomas Linley, junior (b. 1756), an infant prodigy
on the violin, who was already leading the Bath
orchestra at the age of eleven.

This theory drew much of its plausibility from
the misreading of the donor's signature on the
verso as Linley. In fact it is of Richard Lane, who
was Gainsborough's great nephew, and inherited

eight portraits of Gainsborough, his wife and
family (Waterhouse 274, 275, 279, 290, 291, 293,
297 and 299). He also seems to have owned a
group of drawings identifiable by their trimmed
corners (see 23, 24 and 25). This makes it more
likely that the identification on the *verso* follows a
family tradition and is substantially correct. It
does, however, require emendation: as Binyon
pointed out, the violinist cannot be Abel because
his instrument was the viol da gamba. Binyon
thought he might rather be Felice de' Giardini (for
whom see Kenwood 1977, No. 3). The costume
and hair style suggest a date for the drawing in the
middle or later 1760s.

* **38** Study for the portrait of Lady Clarges

Black chalk and stump heightened with white on
grey prepared paper. 317 × 260 mm
Provenance Miss L. Stephanoff. 1895–7–25–4
Literature Hayes 50

The surface is badly rubbed and abraded. For
another drawing in the same technique and on the
same paper, see 43. This is a composition study
for the portrait of Louisa Clarges (1760–1809),
formerly in the collection of Mrs Stella Hotblack
(Waterhouse 149), that was probably painted
c.1777 at the time of her marriage, but left un-
finished. The painting is far more formal than the
drawing and the alterations were presumably
made at the sitter's request. Such portraits as those
of *Henry, 3rd Duke of Buccleuch* with his arms
around a pet dog (Waterhouse 88), and *Mrs Philip
Thicknesse* posed casually with her cittern (see 25)
were criticised at the time as being unduly
informal. In the painting of Lady Clarges the dog
has been replaced by a column and curtain, while
the left side and top of the harp are shown, so
removing the sitter further from the picture plane.
The frivolous private glimpse of a lady plucking
her harp, listened to by her dog, was transformed
in the painting into something recalling Italian
seicento images of St Cecilia.

Alexander Runciman
1736–85

Born in Edinburgh, he was apprenticed to a coach
painter and later, at Glasgow, studied landscape
painting. In 1766 he went to Rome with his
brother John (b. 1744) and there met Barry and
Fuseli. He returned to Edinburgh in 1771 where
he was appointed Master of the Trustees'
Academy and Manager in 1773. He is chiefly
remembered for his series of decorative paintings
for Sir John Clerk at Penicuik House.

39 Thisbe fleeing from the lion

Black chalk, grey, brown, yellow and pink wash
heightened with white on brown paper.
210 × 270 mm
Signed in black chalk in the bottom right corner:
AR
Provenance Purchased from the H. L. Florence
Fund. 1944–7–26–1

The drawing is pasted onto a contemporary lined
mount. The style and technique are so similar to
certain drawings by Gainsborough (such as 41)
that this would appear to be an experiment by
Runciman in Gainsborough's manner. It is likely
that he saw drawings by Gainsborough when he
was in London in 1772. The subject of the draw-
ing is taken from Ovid's *Metamorphoses*.

Thomas Gainsborough

40 Cattle drinking at a mountain stream

Black chalk, brush with brown and grey wash
heightened with pink, white and yellow chalk on
greyish buff paper. 216 × 308 mm
Provenance Colnaghi; E. J. Blaiberg Bequest.
1970–9–19–97
Literature Hayes 338

Formerly varnished, presumably by the artist.
Dated by Hayes in the early 1770s. Drawings of
this type appear to have influenced Runciman (see
39).

* **41** Woman with a rose

Black chalk and stump heightened with white on
grey-green paper. 466 × 330 mm
1855–7–14–70
Literature Hayes 29

A costume study, perhaps from an articulated
doll. Dated by Hayes on the basis of costume
c.1765–70. The iconography suggests that this
may have been a study for a marriage portrait.

* **42** A seated woman

Black and white chalks on grey paper.
313 × 234 mm (trimmed at all four corners)
Provenance Miss L. Stephanoff. 1895–7–25–1
Literature Hayes 51

A study from the life. The costume and hair style
suggest a date *c*.1775–80. The soft broad chalk
work with generous diagonal hatching are charac-
teristic of Gainsborough's manner in the later
1770s: compare, for example, the *Landscape with*

a horse and cart at the Whitworth Art Gallery,
Manchester (Hayes 407). The effect is similar to
that of soft ground etching, a technique with which
Gainsborough was experimenting at this date.

* **43** Coast scene with figures and boats

Black chalk and stump heightened with white on
grey prepared paper. 279 × 370 mm
Inscribed in pencil on the *verso: This is a
Gainsborough–and belonged to / the late William
Pearce Esq: of Cadogan Place / one of his
intimate friends. He gave it / to Mr Marsh (?) and
Mr M to me / F S H.*
Provenance William Pearce, who gave it to a
Mr Marsh (?), who in turn gave it to F. S. Haden;
R. P. Roupell (sale, Christie's, 14 July 1887, lot
1332 bought *Riggell*); A. Kay (sale, Christie's,
23 May 1930, lot 20 bought *Agnew*); presented
by Gerland and Colin Agnew. 1930–6–14–1
Literature Hayes 431.

Possibly connected with a visit to the Devonshire
coast that Gainsborough was intending to make in
the summer of 1779 (Gainsborough Letters, No.
62). The style and technique are very similar to
those in the drawing of *Lady Clarges* (see 38)
which can be dated *c*.1777. The composition is
close to two sea pieces in the *Peepshow* (Victoria
and Albert Museum, Waterhouse 974, 976) of
c.1783 and the *View of the mouth of the Thames*
(Melbourne, Waterhouse 964), which was exhibi-
ted at the Royal Academy 1783.

44 George, 1st Duke of Montagu (1712–90)

Pastel (in a simulated oval). 271 × 227 mm
Provenance Anon. sale, Dowell's, Edinburgh,
11 March 1950, lot 23 (as of an unknown sitter);
Colnaghi; presented by the National Art
Collections Fund. 1951–1–29–1
Literature Hayes 41

The portrait is in its original carved gilt frame.
The Duke is shown wearing the star and ribbon of
the order of the Garter to which he was appointed
in 1762. It is a small scale replica, showing the
head and shoulders only, of the oil portrait
painted in 1768 and now belonging to the Duke of
Buccleuch (Waterhouse 490). The pastel was
probably made at the same time.

45 Wooded landscape with a cottage

Black chalk and stump heightened with white on
grey-blue paper. 176 × 217 mm
Provenance G. Salting Bequest. 1910–2–12–252
Literature Hayes 414

The convention of drawing foliage with scalloped
edges is reminiscent of works by Gaspar Poussin
(1615–75) and Jan van Bloemen, called Orizzonte
(1662–1749). There is another similar drawing by
Gainsborough in the collection (1910–2–12–253),
not in this exhibition. Mid to late 1770s.

* **46** Wooded landscape with herdsman and
cows

Black chalk heightened with white chalk on
grey-blue paper. 354 × 317 mm
Provenance Sir J. C. Robinson (sale, Christie's,
21 April 1902, lot 117); G. Salting Bequest.
1910–2–12–251
Literature Hayes 434

Probably drawn in the mid to later 1770s. The
grey-blue sheet of paper has faded to buff, except
round the edges.

John Baptist Claude Chatelain
1710–71

Draughtsman and engraver, born probably in
Paris. He came early to England and was much
employed by Boydell as an engraver of landscapes.
His drawing style was strongly influenced by
Gaspar Poussin, many of whose compositions he
engraved.

47 View on a river

Black chalk, the sky and background drawn in
pencil. 221 × 338 mm
1872–10–12–3276
Literature LB 5

The technique and foliage convention, deriving
from the Italian landscape tradition, provide an
interesting parallel to some of Gainsborough's
drawings of the 1770s, with which this type of
Chatelain has sometimes been confused.

48 Wooded landscape with an oak tree

Pen and Indian ink, with grey and brown wash.
186 × 232 mm
Provenance I. Williams Bequest. 1962–7–14–20

On a contemporary wash line mount. The style
and type of motif are reminiscent of Gains-
borough's landscape drawings of the 1770s.

Thomas Gainsborough

49 Wooded landscape with figures and cows
at a watering place

Soft ground etching with aquatint. 276 × 347 mm
1866–12–8–356
Literature H 7

Soft ground etching in grey with light aquatint in
the sky and elsewhere. This impression belongs to
the set of twelve reprints of Gainsborough's plates
which was published by Boydell in 1797. Eleven
of the original copper plates have recently been
acquired by the Tate Gallery. The print is almost
identical in composition with Gainsborough's oil
of *The Watering Place,* which was exhibited at the
Royal Academy in 1777 (National Gallery,
Waterhouse 937), but lacks the herdsman on
horseback and the two goats.

50 Wooded landscape with a peasant
reading a tombstone, rustic lovers and a
ruined church

Soft ground etching. 297 × 394 mm (trimmed)
1852–7–5–262
Literature H 10

Printed in grey. This impression belongs to
Boydell's edition, published 1 August 1797. The
etching had previously been published by
Gainsborough on 1 February 1780. In subject and
composition it is related to the painting *The
Country Churchyard* (Waterhouse 942) exhibited
at the Royal Academy in 1780.

51 Wooded landscape with a herdsman
driving cattle over a bridge, rustic lovers and
a ruined castle

Soft ground etching. 300 × 394 mm (trimmed)
1852–7–5–229
Literature H 11

Printed in grey and pasted down onto a contem-
porary wash line mount. It is in the second state;
the first state is lettered bottom right: *Publish'd as
the Act directs, Feby. 1st. 1780.* An oval drawing in
the Witt collection, Courtauld Institute of Art
(Hayes 498), is a study for a large landscape
exhibited at the Royal Academy in 1791
(Michaelis Collection, Waterhouse 959). Both are
closely related in composition to the print. The
print was republished by Boydell in 1797.

52 Wooded landscape with riders
Aquatint. 182 × 243 mm (trimmed)
1852–7–5–243
Literature H 14

A second state, printed in brown, as published by
Boydell in August 1797. Hayes draws attention to
the stylistic resemblance to such drawings of the
later 1760s as those in the Louvre (Hayes 289) and
the Mellon Collection (Hayes 303), but discounts
the possibility that the aquatint dates from the
same period. Although the print is close to an oil
sketch in the Witt Collection, Courtauld Institute
of Art (Hayes 724) which belongs to the mid
1780s, it could well date, like the *Three cows on a
hillside* (see 28), from the early 1770s. It seems
likely that Gainsborough's aquatints were all done
in a batch at much the same date, while his soft
ground etchings belong a little later and his pure
etchings rather earlier.

**53 Wooded river landscape with shepherd
and sheep**
Soft ground etching with aquatint. 256 × 344 mm
(trimmed)
1852–7–5–270
Literature H 13

Soft ground etching with light aquatint in the sky
and elsewhere; this impression is printed in grey.
The original copper plate is now in the Tate
Gallery, although this print was not included in
Boydell's publication in 1797. The soft ground
drawing at the centre on the right failed to transfer
to the plate; the gap was later disguised by the
aquatint wash. Dated by Hayes to the mid 1780s,
although possibly as early as the middle or later
1770s (cf. H 6 and 8).

*** 54 Wooded landscape with a waggon in a
glade**
Watercolour and gouache over black chalk
indications. 237 × 317 mm
Stamped monogram in gold bottom left: *TG*
Verso: tree and hilly background
Provenance W. T. Green. 1899–5–16–10
Literature Hayes 282 (*recto*), 253 (*verso*).

Although the technique of full watercolour is
unusual for Gainsborough, the drawing is clearly
by him. Both the *recto* and *verso* of this very
beautiful sheet are dated by Hayes in the early to
mid 1760s. The highly sophisticated technique
shows an obvious debt to Van Dyck and perhaps
also to William Taverner (1703–72). The gilded
stamped monogram was presumably applied by
Gainsborough himself.

Sir Anthony Van Dyck
1599–1641

Van Dyck was the most celebrated pupil of
Rubens, under whom he studied in Antwerp.
From 1632 until his death, he worked mainly in
England for Charles I and his court, primarily
painting portraits.

55 Study of fields
Watercolour and body colour on blue paper.
240 × 389 mm
Inscribed in brown ink bottom right hand corner:
A Vandyck
Provenance H. Oppenheimer (sale, Christie's,
10 July 1936, lot 236); presented by the National
Art Collections Fund. 1936–10–10–22
Literature A. E. Popham: 'Acquisitions at the
Oppenheimer Sale', *British Museum Quarterly,*
XI, 1936, pp. 128 f.

This drawing belongs to a group of landscape
sketches inscribed in an old hand with the name of
Van Dyck. The attribution is generally accepted,
as is the suggestion that the drawings date from the
artist's years in England. Most of them have been
in English collections since the seventeenth
century and evidently influenced the landscape
draughtsmen of the generation of Skelton and
Taverner, and – even more strongly – Gains-
borough.

**56 A mounted rider with a herdsman driving
a flock**
Black chalk and wash, brush and brown ink, with
white heightening. 344 × 295 mm
Provenance Uvedale Price (sale, Sotheby's, 4 May
1854, lot 279); Dr H. Wellesley (sale, Sotheby's,
10 July 1866, lot 2360); R. Johnson (L 2216); H.
Oppenheimer (sale, Christie's, 14 July 1936, lot
320A); F. Lugt. 1936–10–10–23
Literature Hayes, p. 58

There is an old inscription on the verso: *Vandyck,
thought so by Mr West. It was a very favorite
drawing of Gainsborough's.* Gainsborough would
have seen the drawing in the collection of Uvedale
Price, and there are certain affinities with his own
drawings, notably in the use of wash over black
chalk. The attribution to van Dyck is no longer
accepted, and the drawing is now placed as
anonymous Flemish of the seventeeth century.

Thomas Gainsborough

57 Wooded landscape with figures on horseback and a cottage

Grey wash and oil on brown prepared paper.
216 × 392 mm
Provenance C. M. Cracherode Bequest.
Gg. 3–392
Literature Hayes 511

The device of a diagonal tree-trunk slanting into the composition right of the centre was one often employed by Gainsborough who borrowed the idea from artists like Jan van Goyen (1596–1656) and Herman Saftleven (1609–85). The colouring is also reminiscent of van Goyen. This type of mature Gainsborough is difficult to date precisely. Hayes favours the early 1780s, but the subject and composition are strongly reminiscent of the two versions of the *Peasants going to market* in the Royal Holloway College and at Kenwood (Waterhouse 911 and 912) which appear to date from the early to mid 1770s.

58 Wooded landscape with a covered cart passing through a ford

Black chalk with grey and white oil paint on brown paper, varnished. 228 × 318 mm
Provenance E. C. Innes (sale, Christie's, 13 December 1935, lot 27); E. J. Blaiberg Bequest. 1970–9–19–99
Literature Hayes 666

A study for *A country cart crossing a ford* owned by Mrs H. Scudamore, and now on indefinite loan to the Victoria and Albert Museum (Waterhouse 948). This painting has always been considered as a companion to *The cottage door with a girl with pigs* (Waterhouse 1001), and both paintings were purchased from the artist by Wilbraham Tollemache, later Earl of Dysart. The latter picture was bought *c.*1786, but Waterhouse thinks that the first picture must be several years earlier.

59 Wooded landscape with herdsmen and cows

Aquatint. 277 × 349 mm
1930–8–21–7
Literature H 20

This impression comes from the 1797 series of reprints published by Boydell; the lettering is printed on a separate plate below. Printed in grey, and dateable to the later 1780s.

60 Wooded landscape with a herdsman and cows

Aquatint with soft ground etching.
278 × 347 mm
1867–2–8–265
Literature H 19

Aquatinted by the sugar-lift process, with much use of soft ground etching which produces the granular texture like chalk. This impression comes from Boydell's series of reprints. Mid to later 1780s.

Francesco Zuccarelli
*c.*1702–88

Zuccarelli was a pupil of Anesi in Florence and of G. B. Morandi in Rome. After establishing his reputation in Venice, he worked in England from 1752–62. He returned again in 1765, and in 1768 was elected a founder member of the Royal Academy. In 1771 he went back to Venice where he became President of the Venetian Academy. His landscape paintings, influenced by Dutch and Italian painters, have always been popular, although they display little variety.

61 Italianate landscape with figures and distant castle

Brush and brown ink wash over pencil indications. 192 × 282 mm
Signed or inscribed bottom left corner in black ink: *F2.F.* On *verso* in brown ink: *A10*
1863–1–10–4

Zuccarelli's mottled 'tortoise-shell' wash seems to have exerted an influence on certain drawings by Gainsborough (compare 62).

Thomas Gainsborough

62 Hilly landscape with a shepherd and sheep

Brown wash over brown chalk or oil.
200 × 267 mm
Signed in brown ink with initials *TG* outside a gold tooled arabesque border
1859–8–6–428
Literature Hayes 585

The drawing belongs to a series of distinctive brown wash landscapes on mounts decorated with similar arabesque tooling in gold. They appear to

have been mounted and signed by Gainsborough himself. Of one of this group in the Huntington Library, San Marino (Hayes 584), Robert Wark noted that 'the lines and some of the washes have a matt appearance as if blotted or perhaps printed by some monotype process', (*Gainsborough and the Gainsboroughesque,* exhibition catalogue, Huntington Library, 1967–8, No. 9). Hayes suggests that the peculiar grained effect may have been produced by combining wash with a brown oil colour outline offset from another sheet. But if the lines were produced by offsetting, one would expect the shading to run in a 'left-handed' direction, diagonally from top left to bottom right, which it does not. The process has yet to be explained.

63 Wooded landscape with figures on horseback

Brown wash over brown chalk or oil.
200 × 267 mm
Signed in brown ink with initials *TG* outside a gold tooled arabesque border
1859–8–6–427
Literature Hayes 586

From the same group of drawings as No. 62.

*** 64** Coastal scene with shipping, figures and cows

Grey and brown wash and oil, varnished.
217 × 302 mm
Dated on *verso* 1788
Provenance C. M. Cracherode Bequest.
Gg. 3–391
Literature Hayes 728

Engraved by Thomas Rowlandson and included in his *Imitations of Modern Drawings* of *c.*1788. Gainsborough's drawing probably dates from the same time.

65 Wooded landscape with figures and cows

Grey wash, heightened with white, over an offset outline. 252 × 309 mm
Provenance C. F. Abel (sale, Christie's, 13 December 1787); J. Thane; C. M. Cracherode Bequest. Gg. 3–393
Literature Hayes 679

Engraved by Thomas Rowlandson and published by J. Thane, 21 May 1789, as having been formerly in the collection of Charles Frederick Abel. Three other Gainsborough landscape drawings from Abel's collection were engraved by Rowlandson and published by Thane (Hayes 680,

681, 682). The composition and foliage convention of an outline of loose scallops suggest a date in the 1780s, somewhat later than Gainsborough's full length portrait of Abel (Huntington Library, Waterhouse 1).

66 An open landscape with buildings, horses and figures

Grey, green and pink watercolours, heightened with white (oxidised) and varnished.
210 × 296 mm
Provenance J. H. Anderdon; formerly pasted into his grangerized copy of Edwards' *Anecdotes of Painters,* No. 295; presented 1869. 1972. U. 520
Literature Hayes 506

Probably dates from the early 1780s.

*** 67** A rocky wooded landscape with figures on horseback

Black chalk and stump, and white and brown chalk, on grey-blue paper. 229 × 322 mm
Provenance G. Salting Bequest. 1910–2–12–258
Literature Hayes 671

This broadly handled composition reveals the influence of Gaspar Poussin (1615–75). Mid 1780s.

*** 68** Open landscape with figures on horseback

Black chalk and grey wash heightened with white on buff paper. 211 × 297 mm
Provenance A. Kay (sale, Christie's, 23 May 1930, lot 45); presented by Percy Moore Turner through the National Art Collections Fund. 1930–6–14–2
Literature Hayes 800

Probably dates from the middle to later 1780s.

69 An Italianate landscape with figures on horseback crossing a bridge

Black chalk and stump heightened with white.
277 × 370 mm
Provenance Agnew; R. W. Lloyd Bequest. 1958–7–12–345
Literature Not in Hayes

A bold drawing of the mid 1780s showing a marked debt to Gaspar Poussin. These chalk drawings are rarely found in such pristine condition.

70 A woman seated with three children

Black chalk and stump with some red chalk on
buff paper, heightened with white. 394 × 298 mm
Inscribed (? signed) lower left: *T. Gainsborough.*
An inscription bottom right in brown ink is now
difficult to read: *Sketch given by D . . .*
Provenance W. Esdaile; possibly Esdaile sale,
Christie's, 20 March 1838, lot 673, brought in;
H. Vaughan Bequest. 1901–1–4–1
Literature Hayes 839

Gainsborough's name is said by Hayes to be
inscribed 'in a later hand', but it seems to have
been written in exactly the same grey chalk as the
draughtsman used in the left background. The
flesh tints and the mother's underskirt have been
lightly tinted with red chalk.

This study is probably made from the life, and
is related in theme to the 'Cottage Door' subjects,
which begin in 1778. The generous treatment of
mass and interlocking forms is also found in *The
Woodcutter's Return* of 1782, belonging to the
Duke of Rutland (Waterhouse 960), and in the
background of *The Harvest Waggon* of 1784/5 at
Toronto (Waterhouse 993). The group recalls the
traditional allegorical representation of Charity, a
subject also painted in 1784 (Waterhouse 988).

**71 Study for *The Haymaker and Sleeping
girl at a stile***

Black chalk. 225 × 354 mm
Provenance Among the drawings left by the artist
to his wife, which descended through Margaret
Gainsborough either to Henry Briggs or through
Sophia Lane to Richard Lane; Henry J. Pfungst,
by whom presented through the National Art
Collections Fund. 1906–7–7–1
Literature Hayes 847

Engraved in the same direction by Richard Lane
and published 1 January 1825. A preparatory
study for the painting in the Museum of Fine Arts,
Boston (Waterhouse 815), painted in the later
1780s, in which the format has been changed from
horizontal to vertical. The subject is curious, and
is reminiscent of Gainsborough's youthful rococo
works. The wire lines of the paper are much in
evidence, which would certainly have distressed
the artist (see introduction).

72 A lady walking to the right

Black chalk and stump heightened with white, on
buff paper. 495 × 314 mm
Inscribed on a label formerly pasted on the back
of the frame: *This drawing was given by
Gainsborough to Mr Pearce Chief Clerk of the
Admiralty, & by him to me. He had left it to me
in his will, but in the year 1834 chose rather to
give it to me & he accompanied it with the
following written account of the drawing
'Gainsbro' once told me that King George III
having expressed a wish to have a picture
representing that part of St James's Park which is
overlooked by the garden of the Palace–the
assemblage being there, for five or six seasons, as
high dressed & fashionable as Ranelagh–
employed him to paint it. "His Majesty" said
Gainsbro' "very sensibly remarked that he did not
desire the high finish of Watteau, but, a sketchy
picture." & such was the picture produced by
Gainsbro'. While sketching one morning in the
Park for this picture, he was much struck with
what he called "the fascinating leer" of the Lady
who is the subject of the drawing. He never knew
her name, but she was that evening in company
with Lady N . . . field, & observing that he was
sketching she walked to & fro' two or three times,
evidently to allow him to make a likeness. Sir
Thomas Lawrence when he lodged in Jermyn
Street came to my house in Pall Mall for several
successive days, when Lord Derby employed him
to paint Miss Farren, to study this drawing'
William Pearce 1st Feb. 1834'–J. W. Croker
1842.*
Provenance Presented by the artist to William
Pearce, who gave it to J. W. Croker 1834;
Sir F. Leighton (sale, Christie's, 14 July 1896,
lot 256); G. Salting Bequest. 1910–2–12–250
Literature Hayes 59

One of a group of full-length drawings of women
that can be dated *c.*1785 by the large wide hats
(Hayes 58–63). The inscription on the old label of
this drawing (quoted above) has been linked by
Hayes with a notice in the *Morning Herald* of 20
October 1785: 'Gainsborough is to be employed,
as we hear, for Buckingham House on a com-
panion to his beautiful Watteau-like picture of the
Park-scene, the landscape, Richmond water-walk,
or Windsor–the figures all portraits.' The
'Watteau-like Park-scene' must be *The Mall* of
1783, now in the Frick Collection in New York
(Waterhouse 987); the companion painting, for
which this group of drawings was probably
intended as studies, was apparently never finished,
and possibly never even begun. (See John Hayes,
'Gainsborough's *Richmond Water-Walk'*, *Bur-
lington Magazine*, cxi, 1969, pp. 28–31.)

*** 73 A lady walking to the left**

Black chalk and stump on buff paper heightened with white. 484 × 311 mm (trimmed at all four corners and made up)
Provenance Among the drawings left by the artist to his wife, which descended through Margaret Gainsborough and Sophia Lane to Richard Lane; probably Sir Charles Greville; 4th Earl of Warwick (L 2600) (sale, Christie's, 20 May 1896, lot 134); Colnaghi. 1897–4–10–20
Literature Hayes 62

Engraved by Richard Lane in the same direction and published 1 January 1825. Probably a preparatory study for the same picture as No. 72. Other drawings connected with this composition are Hayes 60, 61 and 63. The pose was later used in reverse for the portrait of the *Duchess of Devonshire* in Mrs Mabel S. Ingalls' collection (Waterhouse 195) painted in the late 1780s.

Gaspar Poussin
1615–75

Properly Gaspar Dughet, but adopted the name of his brother-in-law Nicolas Poussin whose pupil he was at the beginning of the 1630s. Lived in Rome, and specialised in painting landscapes, in which he combined the styles of Claude and Poussin.

74 Italianate landscape

Etching and engraving by James Mason (1710–*c*.1780) after Gaspar Poussin.
312 × 400 mm
1877–6–9–1625

Published by Arthur Pond in March 1746. Prints of this kind must have had a great influence on Gainsborough's chalk landscapes of the 1780s (see 75).

Thomas Gainsborough

75 Italianate rocky landscape

Black chalk and stump heightened with white on blue paper. 302 × 420 mm
Provenance G. Salting Bequest. 1910–2–12–260
Literature Hayes 396

The white heightening in the sky to the right has partly oxidised. The composition is based on Gaspar Poussin (see 74).

76 Italianate landscape with a hillside town

Black chalk and stump heightened with white on blue paper. 254 × 320 mm
Provenance J. H. Hawkins; C. H. T. Hawkins (sale, Christie's, 29 March 1904, lot 193); A. Kay (sale, Christie's, 23 May 1930, lot 28); E. J. Blaiberg Bequest. 1970–9–19–98
Literature Hayes 542

77 Rocky wooded landscape with a waterfall, cattle and a mountain

Black chalk and stump heightened with white on prepared paper. 226 × 320 mm
Provenance G. Salting Bequest. 1910–2–12–259
Literature Hayes 804

A fine landscape of the later 1780s, reminiscent of the paintings of Salvator Rosa (1615–73).

*** 78 The Duke and Duchess of Cumberland with Lady Elizabeth Luttrell**

Black chalk and stump heightened with white chalk on buff paper. 432 × 316 mm
Provenance W. F. Mercer; Anon. (=Mercer) (sale, Christie's, 19 April 1869, lot 209); Sir J. C. Robinson (sale, Christie's, 21 April 1902, lot 106); Colnaghi. 1902–6–17–6
Literature Hayes 58

A study for the oval portrait in the Royal Collection painted in the mid 1780s (Waterhouse 178). An earlier compositional study, horizontal in format, is in the Royal Collection (Hayes 57). The costume, in particular the polonaise dress and the forward tilt of the ladies' hats, indicates a date *c*.1783–5.

Sir Joshua Reynolds
1723–92

*** 79 An artist's studio with a painter(?) standing behind a painting of a woman**

Pen and brown ink. 147 × 151 mm
Provenance Lord Northwick (sale, Sotheby's, 1 November 1920, lot 454, bought for the Museum). 1920–11–16–30

This study is difficult to interpret: it might represent either an artist in his studio holding a paint brush and standing behind a full-length portrait of a lady, or two paintings stacked one upon the other with the further one's edges defined at the bottom but not at the sides or top. The pose of the nearer portrait is closely related to *Mary, Countess of Essex* by Sir Godfrey Kneller

(1646–1733), one of the set of 'Hampton Court Beauties' (Oliver Millar, *The Tudor, Stuart and early Georgian pictures in the collection of Her Majesty the Queen,* London, 1963, cat. 354, pl. 152); mezzotints of this painting were published by John Faber, junior, and John Simon. The portrait of the *Countess of Essex* does not however have a landscape background as in this drawing. The further portrait (if we assume that is what it is) might represent *Frances, Lady Middleton* posed as a shepherdess with a crook, another of Kneller's 'Hampton Court Beauties' (Millar, *op. cit.,* cat. 357, pl. 158).

Reynolds does not seem to have used this particular drawing, but in his portrait of *Thomas and Martha Neate with their tutor Mr Needham,* signed and dated 1748 (Waterhouse pl. 10) the pose of Martha Neate is based on another of Kneller's 'Beauties', *Carey, Countess of Peterborough* (Millar, *op. cit.,* cat. 355, pl. 157), a fact which might imply that he made other studies of the Hampton Court series.

The drawing style, with schematic heads marked with a cross to indicate the disposition of the features, though little employed by Kneller, was a distinctive device especially favoured by Sir James Thornhill (1675/6–1734) who may have derived it ultimately from the drawings of Paolo Veronese (*c.*1528–88).Probably drawn *c.* 1744–6.

80 Profile portraits of Lady Elizabeth Southwell and the Rt. Hon. Edward Southwell, after Kneller

Pen and brown ink. 212 × 350 mm
Inscribed in Reynolds' hand above the heads: *Lady Eliz. Southwell* and *Mr Southwell,* and on the reverse: *Sir G. Kneller*
Provenance Lord Northwick (sale, Sotheby's, 1 November 1920, lot 456, bought for the Museum). 1920–11–16–33

Edward Southwell MP, of Kings Weston, Somerset (1671–1730), succeeded his father Sir Robert as Vice-Admiral of Munster and Secretary of State for Ireland on 27 June 1701. In 1708 he was appointed Clerk to the Privy Council. His first wife, Lady Elizabeth Cromwell, daughter of the Earl of Ardglass, died in childbirth in 1709. Kneller's original portraits which are here copied are now lost. A few of Reynolds' early portraits can be related to profile studies after Kneller; examples are *Mary Kendall* of 1744 and *Rev. Samuel Reynolds* of 1746 (Waterhouse plates 1 and 2). Probably drawn *c.*1744–6.

81 A three-quarter portrait of a lady, after Kneller

Pen and brown ink. 158 × 104 mm
Inscribed in the artist's hand in brown ink: *S. Gofray Knellar*
Provenance Lord Northwick (sale, Sotheby's, 1 November 1920, lot 455 [with one other], bought for the Museum). 1920–11–16–31

This demure portrait of a lady in a landscape, her hands clasped, leaning on a rock, is very similar to Kneller's portrait of *Frances, Countess of Salisbury in Mourning* of 1695 (Marquis of Salisbury; see *Sir Godfrey Kneller,* exhibition catalogue, National Portrait Gallery, 1971, No. 67) which was mezzotinted by John Smith (CS 221). Probably drawn *c.*1744–6.

* 82 A recumbent lady, after Kneller

Pen and brown ink. 124 × 150 mm
Inscribed in Reynold's hand in brown ink at the bottom: *Sʳ Godfry Knellar*
Provenance Lord Northwick (sale, Sotheby's, 1 November 1920, lot 455 [with one other], bought for the Museum). 1920–11–16–32

The pose seems to derive from *seicento* Italian paintings of the Magdalen lying in the desert, but a close parallel is also found in Gherardini's figure of *Night* in the Palazzo Corsini in Florence, a figure that a few years later Reynolds himself was to copy in one of his Italian sketchbooks (see 84, folio 61 *verso*). The original Kneller composition has not been traced. Probably drawn *c.*1744–6.

* 83 Self-portrait

Black chalk and stump heightened with white on blue paper. 411 × 274 mm
Inscribed by the artist in black chalk lower left: *Rome May 1750*
Provenance Purchased from Mr J. D. Reigh. 1897–6–15–1
Literature LB 1 (as by John Astley); *Portrait Drawings XV-XX Centuries,* exhibition catalogue, Department of Prints and Drawings, British Museum, 1974, No. 167.

Reynolds shared Rembrandt's fascination with self-portraiture and, in many of his paintings, imitated Rembrandt's compositions and technique. This drawing was formerly believed to be a portrait of Reynolds at the age of twenty-seven by John Astley (*c.*1730–87), a fellow-pupil in Hudson's studio who was also in Rome in 1750. The features are clearly those of Reynolds, although idealised by the omission of the scar on

his lip which he received in 1749 and which remained with him for the rest of his life. The intent gaze suggests a self-portrait and in style the drawing is very similar to an earlier self-portrait drawing in the same technique which belongs to Viscount Harcourt (John Steegman, 'Portraits of Reynolds', *Burlington Magazine,* LXXX, 1942, pp. 33–4, plate IIb). The strong similarity in handling to portrait drawings by Kneller (eg. 1870–10–8–2382) demonstrates the strength of his influence on Reynolds even at this comparatively late date.

*** 84** Sketchbook, opened at folio 15: A lady seated tying her garter

Provenance By descent from the artist to the Marchioness of Thomond (sale, Christie's, 26 May 1821); Richard L. Gwatkin; Miss Theophila Gwatkin. 1859–5–14–305
Literature LB 12

The book contains notes and sketches made at Florence and on the journey from Florence to Rome in 1752; most are of Old Masters.

85 Sketchbook, opened at folio 13: Studies from the Palazzo del Te, Mantua

Provenance As for No. 84. 1859–5–14–304
Literature LB 13

The book contains notes and sketches, mainly from paintings and sculpture, made on the journey from Florence to Venice and in Venice. Reynolds travelled by way of Bologna, Modena, Parma, Mantua, Ferrara and Padua in 1752.

Reynolds spent two very profitable years in Italy, returning not only with a hugely enriched repertory of motifs, ideas, and poses stored in his memory and in his sketchbooks, but also with a far deeper understanding than most of his contemporaries of the principles underlying the works of the Old Masters. He studied them all, noting their excellencies and their characteristics, but his paintings after his return to England are of no school but his own.

His approach to the 'great masters' can be best summed up in his own words from Discourse XI: 'Whoever should travel to Italy and spend his whole time there only in copying pictures . . . would return with little improvement . . . It is not by laying up in the memory the particular details of any of the great works of art, that any man becomes a great artist, if he stops without making himself master of the general principles . . . he must consider their works as the means of teaching

him the true art of seeing nature. When this is acquired, he may then be said to have appropriated their powers . . . the great business of study is to acquire a mind . . . to which all nature is laid open, and which may be said to possess the key of her inexhaustible riches.'

86 Three studies of a child supported by his mother's hands

Black chalk on blue paper. 229 × 161 mm
Inscribed in pencil bottom left: *Sir J. Reynolds*
1911–5–17–23

The coarse graphic style is closely related to drawings in Reynolds' Italian sketchbooks. The inscription is in a hand that appears on other apparently authentic Reynolds drawings such as the study for *Lady Elizabeth Keppel* of 1761/2 in the Victoria and Albert Museum (reproduced, *Burlington Magazine,* LXXX, 1942, p. 41). These studies were probably not made from life but copied from earlier pictorial sources not yet identified. The artist perhaps recalled this *aide mémoire* in later paintings of mothers with their children, like *The Duchess of Marlborough with her daughter* of *c.*1764–5 at Blenheim and *Mrs Richard Hoare with her son Henry* of *c.*1767–8 in the Wallace Collection (Waterhouse plates 99 and 123). Perhaps drawn at the beginning of the 1750s.

87 Ariadne in Naxos

Red chalk. 184 × 268 mm
Inscribed *verso* in brown ink, a draft of a letter:
'*Caris^{mo}: Amico è Pron Stimatis^{mo}: Firenze 8 Gennaio 1752 Per non aver pratica nello scrivere Italiano mi è convenuto contro mià voglia indugiare fin à desso a avere il piacere di Scrivergli fin à tanto . . .*'
Provenance N. Hone (L 2793); P. Sandby (L 2112); presented by the Earl of Cawdor. 1846–5–9–1
Literature LB 6

The drawing style is similar to many pages in Reynolds' Italian sketchbooks. This study, after an unidentified Italian painting, is drawn on the back of a draft letter in what Binyon believed to be the hand of the painter Nathaniel Hone (1718–84). The draft is dated from Florence on 8 January 1752, a time when Reynolds was in Rome and Hone certainly still in Italy, where he had been for two years. Portrait drawings of Hone are to be found in one of Reynolds' Italian sketchbooks (cat. 84, folios 71 *verso* and 72 *verso*).

* **88** Two studies for the portrait of a lady and one of an upturned head

Pen, brown ink and wash. 200 × 153 mm (the corners trimmed)

Inscribed in the artist's hand *verso* with a draft passage: . . . *Genius that seem to be necess- / entire comprehension the other of / of Genius is like a General or he who / Army, who without attending the minu- / -ations of individuals, takes considers only / Great Masses, and sees distinctly / to an ordinary or inexperienced observer / -ears all confusion–a union of Contrasts / necessary– Courage & Calmness- / other Genius is the power of seeing a diff- / -ere other people see none this is necessary / -rds expressing the passions, both of thes- / are acquired by practice / -tter artist than another mer- / practical.*

Provenance By descent to Sir R. Edgcumbe; Parsons & Sons. 1913-4-15-14

Literature Lord Ronald Sutherland Gower, *Sir Joshua Reynolds, his Life and Art,* London, 1902, p. 124, repr.; F. W. Hilles, *The Literary Career of Sir Joshua Reynolds,* Cambridge, 1936, pp. 129–131.

This sheet has the corners trimmed and a double border line in brown ink like a *Study for a child's head,* also formerly in Sir Robert Edgcumbe's collection (Gower, *op. cit.,* repr. facing p. 125). The 'undress' costume of the sitter to the right could date from the late 1750s or early 1760s, but the hair style points more strongly to the early 1760s. The type resembles Reynolds' portrait of *Miss Louisa Poyntz* of 1759 (Althorp; Waterhouse pl. 58).

The Edgcumbe family, who owned this sheet, were important patrons of Reynolds at the time this drawing was made. Commodore Edgcumbe and Miss Henrietta Edgcumbe sat to him in 1756, the 2nd Lord Edgcumbe in 1759 and 1760, the 3rd Lord Edgcumbe in 1761, and his wife, Emma, in 1762.

The draft on the reverse is of particular interest. Theories on art, and particularly the nature of genius, had always fascinated Reynolds as can be seen in his later Discourses. He read very many authors on this subject, often copying out sections from them or making random notes of his own ideas. He certainly wrote much more than he published (see Hilles, *op. cit.*). This passage is probably a draft for an essay never published, perhaps for *The Idler,* Dr. Johnson's magazine; to which he contributed three essays on art between 1759 and 1761. Probably drawn *c.*1759–62.

* **89** A man's head inclined to the left
Verso: Nude man, holding a staff in one hand, and with the other supporting a picture of the infant St John with a lamb

Black chalk. 470 × 294 mm

Provenance R. Payne Knight Bequest. Oo. 5–17*

Literature LB 9

The drawings on both sides were done from the life from a model posed in the studio. Reynolds in his First, Second and Twelfth Discourses strongly recommended this practice to students as a means to progress: 'a habit of drawing correctly what we see . . . will give a proportionable power of drawing correctly what we imagine.'

Reynolds always regretted that he himself had never acquired this skill, a deficiency which, as his contemporary Joseph Farington remarked, meant that he 'never had the professional strength to attempt to execute works which required great power of his hand over form' (Malone I, pp. CXLIf.). Perhaps drawn in the 1750s.

* **90** Academical study of Hercules striding to the left

Black chalk heightened with white on yellow prepared paper. 471 × 294 mm

Provenance R. Payne Knight Bequest. Oo. 5–17

Literature LB 8

This drawing, the previous study, and a further drawing of a *Nude stooping down and pulling on a rope* (not exhibited, LB 7), may represent an attempt by Reynolds to improve his drawing skill in later life; but it is also possible that he executed the drawing of *Hercules* to illustrate the theories on the beauty of the human figure that he propounded in his 3rd Discourse of 1770. He argues that in the human figure there are various types of beauty: the muscular beauty of Hercules, the activity of the gladiator, the delicacy of Apollo, and that 'perfect beauty must combine all the characters which are beautiful in that species' (Discourses, p. 47).

91 Portrait study of Mrs Robinson ('Perdita') for the picture called 'Contemplation'

Coloured chalks on pale buff paper.
152 × 125 mm
Stamped with initials at lower right: *JR*
Provenance W. T. Brooks. 1887–7–22–19
Literature LB 2; *Wallace Collection Catalogue of Pictures and Drawings,* London, 1968, p. 273.

This may be an original study, although much rubbed, for the portrait of *Mrs Robinson as Contemplation,* probably painted in 1784 and now in the Wallace Collection. The Wallace Collection portrait is one of several sketches, versions and replicas not one of which corresponds precisely with the above drawing. No other drawings by Reynolds quite like this are known, but the quality is high.

Mrs Mary Robinson, née Darby (1758–1800) was a celebrated actress and in the role of Perdita in December 1779 attracted the attention of the Prince of Wales whose mistress she became. Although she was left by the Prince in 1782, her friends obtained for her from him a pension of £500 a year. Both Gainsborough and Romney also painted her portrait (both now likewise in the Wallace Collection).

*** 92 A girl with a mask**

Black chalk heightened with white on blue paper.
292 × 204 mm
Provenance Mr Manson, partner in Messrs Christie, Manson and Woods; Frank T. Sabin. 1907–5–15–26

Probably related to the pen drawing in the Ashmolean Museum of a girl with a mask, known as *Comedy.* Andrew Wilton observed that the Ashmolean drawing is probably connected with the portrait of *Mary Meyer as Hebe* (see 133), (*Royal Academy Draughtsmen 1769–1969,* exhibition catalogue, Department of Prints and Drawings, British Museum, 1969, No. 39).

The gesture and facial expression are derived ultimately from Leonardo; but the more immediate source was probably Correggio, to whom Reynolds continually refers in his Discourses, and in whom the mysterious ambiguity of Leonardo is transformed into the sweetness and innocent mischief found in this drawing.

93 A nymph and cupid

Red chalk. 208 × 284 mm
Inscribed *verso* in pencil: *Sketch by Sir Joshua Reynolds for his picture of Nymph and Cupid, now in Mr Fitzpatrick's possession. (Wellesley Collection) March 1867 F. T. Palgrave.*
Provenance Dr H. Wellesley; F. T. Palgrave; Marquis of Breadalbane (sale, Christie's, 4 June 1886, part of lot 27, bought for the Museum). 1886–6–9–35
Literature Sir Walter Armstrong, *Sir Joshua Reynolds,* London, 1900, p. 204, repr.; LB 4; *Royal Academy Draughtsmen 1769–1969,* exhibition catalogue, Department of Prints and Drawings, British Museum, 1969, No. 40

This rather weak drawing is apparently a study for a painting of *Venus and Cupid,* which was exhibited at the Royal Academy in 1785 and purchased by the Earl of Upper Ossory (Waterhouse p. 76); this was a later version, with alterations to the landscape, of a painting of a *Nymph and Cupid* of *c.*1759, known in an engraving by Samuel Reynolds. Both pictures differ from the drawing in which the head of Venus falls to one side while she supports herself on her arm with her wrist turned backward; in the paintings her arm follows the contours of her body without supporting anything. If by Reynolds (see 94), probably drawn *c.*1779–85.

94 Study for the portrait of Lady Gertrude Fitzpatrick

Red chalk. 338 × 284 mm
Inscribed along the bottom in pencil: *Sketch for the picture of Gertrude Fitzpatrick, by Sir J. Reynolds Wellesley Collection*
Provenance As for No. 93. 1886–6–9–34
Literature Sir Walter Armstrong, *Sir Joshua Reynolds,* London, 1900, p. 205, repr.; LB 3

This study is apparently a first idea for the portrait of *Lady Gertrude Fitzpatrick* sitting on the ground and holding a bunch of grapes on her lap. The portrait of Lady Gertrude, who was the daughter of the second Earl of Upper Ossory was painted in 1779 and now belongs to Lord Glenconner (Waterhouse p. 70). The drawing is in the same technique and has the same provenance as No. 93. Both drawings are so feeble and the detail studies so meaningless that one is tempted to consider that both may have been early records by another hand of the paintings which were then together in Lord Ossory's collection at Ampthill.

95 (a) Study for *The Infant Hercules*

Pencil, brush and brown wash on grey paper.
195 × 174 mm
1887–3–1–17
Literature LB 5a

* (b) Study for *The Infant Hercules*

Pencil, brush and brown wash heightened with
white on grey paper. 195 × 186 mm
1887–3–1–16
Literature LB 5b

Hercules in (a) is seated frontally. In (b) he leans
over to the right in his cradle. In 1786 Reynolds
received a commission from the Empress
Catherine II of Russia for an historical picture, the
subject to be of his own choosing. He finally
decided on the Infant Hercules overcoming the
serpents 'in allusion to the great difficulties which
the Empress of Russia had to encounter in the
civilisation of her Empire' (Northcote II, p. 215).
The painting, which was exhibited at the Royal
Academy, 1788 (167), is now in the Hermitage,
Leningrad (Waterhouse p. 80). Reynolds after-
wards painted a single figure *Infant Hercules* of
which several versions exist. Neither of the present
drawings represents the figure in the attitude
finally adopted for either the large or small
picture. Another drawing for this painting,
inscribed *First idea of the Infant Hercules* is in the
collection of Mrs R. A. Lucas (Luke Hermann,
'The Drawings of Sir Joshua Reynolds in the

Herschel Album', *Burlington Magazine,* CX,
1968, pp. 650–58, pl. 6).

The final figure of Hercules can be traced back
to a painting of the Christ Child by Carlo Maratta
(1625–1713), which Reynolds also used as a
model for his related painting of *The Infant
Jupiter.* An engraving after Maratta's painting
appears among the group of prints in Nathaniel
Hone's painting *The Conjuror,* which satirised
Reynolds' practice of borrowing motifs from the
Old Masters (Martin Butlin, 'An Eighteenth
Century Art Scandal, Nathaniel Hone's *The
Conjuror',* Connoisseur, May 1970, pp. 1–9).

* **96** Portrait study of Miss Theophila
Gwatkin, for the picture called 'Lesbia'

Black, white and coloured chalks and stump.
458 × 305 mm
Inscribed or signed bottom right corner in pencil:
JR
Provenance By descent from the mother of the
sitter Theophila Palmer (Mrs Gwatkin); Laura C.
Gwatkin, wife of General Steel. 1902–2–12–1
Literature LB 1

Study for the picture painted in 1786 of a girl
holding a dead bird in her lap, called *Lesbia,* from
Catullus' poem. It was engraved by Bartolozzi in
1788. The painting was offered Sotheby's, 6 July
1977, lot 24 from Lord Glenconner's Collection
(Waterhouse, pl. 294). Theophila Gwatkin was the
daughter of 'Offy' Palmer, Sir Joshua's favourite
niece. Drawn 1786.

11
Prints after
Reynolds and Gainsborough

Of all the various styles of engraving, Sir Joshua Reynolds considered that of mezzotinto as the best calculated to express a painter-like feeling, particularly in portraits; and I have often heard him declare, that the production of M' Ardell would perpetuate his pictures when their colours should be faded and forgotten. Fortunate are those collectors who can boast of proof-impressions from the portraits of Sir Joshua: they of themselves form a brilliant school of Art, not only for the grace displayed in their attitudes, but also for the grandeur of their chiaroscuro, and for the delightful portions of landscape with which many of them are embellished.

These words were written in 1828 by the then Keeper of the Department of Prints and Drawings, J. T. Smith.[1] The same idea can be found in writings by Reynolds' contemporaries. Sir Robert Strange wrote in 1775:

'No body knew better, or has more experienced, than Sir Joshua Reynolds the importance of engraving . . . Since the memorable aera of the revival of the arts, in the fifteenth century, I know no painter, the remembrance of whose work will depend more on the art of engraving than that of Sir Joshua Reynolds.'[2]

But Strange and Reynolds were wrong; the paintings are remembered, while, with the growth of photomechanical reproductive processes, the mezzotints have been forgotten.

The present exhibition of some of the finest of the mezzotints will show that the neglect is undeserved; indeed, the mezzotint is the only area in which British printmaking can hold its own with the finest work of continental Europe. This catalogue has, however, a different purpose; it seeks to give an historical outline of the subject and to define, so far as is possible, the relationship between the painter and his engravers. It will be almost entirely concerned with Reynolds, since there is no comparable link in the case of Gainsborough.

Every student of the subject builds on the foundation of John Chaloner Smith's catalogue of portrait mezzotints.[3] This great work provides the basic catalogue of the engravers' works; its

deficiency is that, in accordance with the well-established British tradition of collecting only portrait prints, its listing of subject prints is far from complete. In a few cases it has been superseded by catalogues of the complete works of individual engravers. The historian of Reynolds can also rely on Edward Hamilton's invaluable catalogue of Reynolds' engraved works. The best general book on English mezzotints is A. Whitman's *The Masters of Mezzotint,* London, 1898, and there is a useful twelve-page introduction by W. G. Rawlinson to the illustrated catalogue of the exhibition of *English Portrait Mezzotints* held at the Burlington Fine Arts Club in 1902.

Mezzotint is a distinctive print-making process. At the time of its invention in the mid seventeenth century the only intaglio (i.e. carrying the ink in the recessions made in a metal, usually copper, plate) processes in use were line-engraving and etching. The mezzotint differs from these in being a tonal and not a linear process, and in being worked negatively, from dark to light. The procedure is not complicated: the copper plate is first 'grounded' – that is, it is systematically worked over with a spiked rocking tool until it is thoroughly roughened; if inked in this state, it will print a rich black. The engraver then smooths out ('scrapes') graduated highlights with a burnisher; the more burnished the area is, the less ink will it hold and thus, when the plate is printed, the design will emerge from the basic blackness. The other intaglio tonal processes, stipple and aquatint, were developed in the course of the eighteenth century, but mezzotint remained the only one to work from dark to light.

An engraved plate produces a reversed printed image. In the later eighteenth century reproductive mezzotints were always printed in the same direction as the original painting, and so it follows that the design had to be engraved on the plates in reverse. Although the evidence is not good,[4] it seems that in our period the standard procedure was to make a reduced copy on tracing paper from the original painting, to the exact size of the copper-plate. The drawing was squared and an identical grid was drawn in chalk on the grounded plate; each square was identified by numbering the grid vertically and horizontally. The design then had to be scraped onto the plate in reverse, using the grid to establish the proportions and the design seen from the back of the tracing paper to help in the reversal. The engraver would also have had, if possible, the original painting in front of him.[5] As the work proceeded he would have printed numerous trial proofs to check the effects; few of these now survive. When finally finished, the lettering was added by a specialist writing engraver while the printing was entrusted to a professional printer. The latter was a highly

skilled craftsman; a good printer could substantially prolong the life of a plate, while a clumsy one could ruin it.

The mezzotint was invented in Germany in the middle of the seventeenth century, and soon was introduced to England. It rapidly achieved a success here which it did not retain on the Continent, and as a result came to be known there during the early eighteenth century as *la manière anglaise*.[6] A central figure of this early period was not an engraver but the painter Sir Godfrey Kneller (1646–1725). The huge numbers of prints after his portraits were not produced by chance. John Smith, the most important mezzotinter of the period, actually lived in Kneller's house for some time;[7] his great rival was John Simon, and Vertue tells us that 'for some time when Smith differed with Sir G. Kneller the other was caressed by him and did many good works'.[8] Smith retired many years before his death in 1742, but the tradition was continued by John Faber the younger (? 1695–1756). When he published two prints of Sir Robert Walpole and the Prince of Wales in 1742, Vertue observed: 'No sooner is a picture painted by any painter of any remarkable person but presently he has it out in print'.[9]

But contemporaries saw signs of decline. Vertue tells us that George White, in the 1720s, was alarmed at being asked to engrave after indifferent paintings 'which he knew must inevitably appear defective in all his prints'.[10] Part of the cause of the trouble must have been the low quality of portrait painting in the years after Kneller's death; the best mezzotinter will never be able to make a fine print of a bad painting. But there is also the evidence of the Frenchman Rouquet, who in 1755 published a book entitled *The Present State of the Arts in England.* Chapter XVII is entitled *Of Mezzotintos* and is so important that it must be quoted in full:

This kind of engraving is very much upon the decline in England. Mr Smith, who lived in Sir Godfrey Kneller's time, did admirable things this way. It costs the artist, and consequently the purchaser, but very little; and it is generally used in portraiture. Painters of some reputation, as well as those who have none, equally strive to signalize themselves this way; they engrave one or more of their portraits in Mezzotinto, under different sorts of pretences, while their real motive is to make themselves known. But the engraver takes everything that offers, so that he is as often the publisher of ignorance as of abilities. Besides, this kind of work is so very incorrect at present, that bad painters have a very good opportunity of imputing their own inabilities to the ignorance of the engraver. But the painter's name is at the bottom of the plate, he reads it with a secret satisfaction, as he runs thro' the collections in printsellers' shops; this is a public testimony of his existence, which in other respects is perhaps very obscure; and that is all he wanted.

But even as Rouquet was writing, signs of a revival were visible. Vertue devoted one of his latest notes in 1751 to 'Mr McArdell who has lately succeeded very well in Mezotint scraping . . . he came from Ireland a few years ago–his parents living in Dublin dealers in the linnen trade–he lately went over to see them and being return'd finds full employment and well paid for his works'.[11] McArdell had in fact first come to London in 1747 with his master John Brooks. Brooks was himself of little importance, but his pupils and the other Irishmen attracted to London dominated the mezzotint trade for the next twenty-five years.[12] McArdell himself chose to engrave many prints after earlier artists like Rubens and van Dyck, and by doing so raised his quality dramatically.[13] But the standard of portrait painting was also improving, and some of McArdell's earliest plates were scraped after fine paintings by Allan Ramsay and Thomas Hudson.

Reynolds returned from Italy at the end of 1752 and in 1753 set up in London; the first mezzotints after his paintings were published in the following year by McArdell. It is significant that none had been made from the many portraits he had painted before he went to Italy; and it is also significant that the first to appear were by McArdell, the best engraver of the period, and that what was probably the first of them bore the publication line: 'Published by J. Reynolds according to act of Parliament 1754' (see 101). This shows that Reynolds was doing what Rouquet would lead us to expect–publicising himself by means of the print. In this aim he was immediately successful, and in the years up to his death in 1792 he was kept continuously in the public eye by a constant succession of mezzotints after his most important paintings.

The statistics of this production are remarkable. The first catalogue of engravings after his paintings, published in the *Gentleman's Magazine* of 1784, lists 319 prints by thirty-eight engravers.[14] The second catalogue by William Richardson, published in 1794, reaches a total of seven hundred, but this includes some duplicates.[15] Hamilton's catalogue has a total of 529 paintings engraved, but many of these were engraved more than once. Even if we reduce these totals by excluding prints made after Reynolds' death, piracies, book illustrations and suchlike, we may still hazard the guess that over four hundred 'authorised' engravings were issued between 1754 and 1792–an average of about ten a year. To put this in perspective, the equivalent total for Gainsborough is about forty-five, for Romney about 105[16]; no contemporary would seem to go above this number. As Northcote observed: 'The prints from his works . . . certainly form the most numerous collection of portraits that have ever been engraved after the works of one artist'.[17]

Nevertheless, since Reynolds must have produced over two thousand paintings, by no means every one can have been engraved. The choice in fact seems to have been largely determined by the paintings shown at the Royal Academy. Most of these regularly appeared as prints within a year or two of exhibition, and by investigating the engravers who received these prize commissions we can discover Reynolds' preferences.

In the course of his career, Reynolds seems to have made regular use of about twenty engravers. They can conveniently be divided chronologically into three groups. The earliest, from about 1754 to 1775, was of the already mentioned Irishmen: McArdell and Houston, followed by Fisher, James Watson and Dixon. In the same period we find several non-Irish rivals using a similar manner: Spilsbury, Finlayson and Marchi. The middle period, from about 1770 to 1783, saw the production of what have come to be regarded as the classic mezzotints after Reynolds: the series of *Beauties* by Valentine Green, the textural virtuosity of Thomas Watson and his partner Dickinson, and the varied effects of John Raphael Smith. To these years also belong the works of Doughty and Jacobe. Finally, the series is continued from 1783 to Reynolds' death by Hodges, Grozer and Jones, who serve as the link with the next generation of engravers who worked principally after Sir Thomas Lawrence. Unfortunately, in the context of this exhibition, which includes none of the original oil-paintings, it is impossible to attempt to analyse the differing approaches of the mezzotinters to their task. This must await some future occasion on which mezzotints and paintings can be hung alongside each other.[18]

We have seen in the passages quoted at the beginning of this introduction that Reynolds greatly preferred reproductions of his paintings to be done in mezzotint. In the early part of his career exceptions are very rare, and are always in line engraving, at this stage the only alternative process. These were almost invariably published by John Boydell whose declared ambition in his earlier years was to raise the quality of line-engraving in England.[19] Although line-engraving continued occasionally to be used for prestige prints (see 161 and 162), the real challenge to the mezzotint came from a quite unsuspected quarter – the newly invented stipple. This seems to have been developed by William Wynne Ryland (1733–83) out of the crayon manner he had learnt in Paris in the later 1750s.[20] Although, significantly, the only print by Ryland himself after Reynolds was a mezzotint, the series of stipples he made after Angelica Kauffmann between 1774 and his execution for forgery in 1783 were a *succès fou* and firmly established the new vogue.[21] The first stipple after Reynolds is by Thomas Watson in 1779 – a reduction of the *Mrs Sheridan as St*

Cecilia which his partner Dickinson had engraved three years earlier in mezzotint. The number of stipples steadily increased, and by 1792 it is probable that there were almost as many stipples as mezzotints being published. The original success of stipples lay in the field of 'furniture' prints (that is, prints intended to be framed and hung), for which they were very suitable because they could easily be printed in colours or coloured after printing. It is not surprising therefore, that the process tended to be used for Reynolds' fancy pictures, or those portraits which had a fancy element. The mezzotinters met the challenge in various ways: of the three in our last group above, Grozer and Jones both made stipples themselves, while Hodges, when he wished to, could adapt his manner of mezzotinting to resemble the stipple (see 153). On the other hand, Haward could reproduce in his stipples much of the effect of the mezzotint (see 160).

The following sections attempt to describe in greater detail the workings of the business. I first describe the print market, and then attempt to elucidate the inter-relationship of Reynolds and his engravers.

The market

Publishers

In order to secure copyright under the terms of the Copyright Act of 1735, every print published had to carry a publication line giving the name and address of the proprietor together with the date of publication.[22] The proprietor was the publisher and the copyright was vested in him. It is reasonable to assume that he was also always the owner of the copper plate. Four types of publication can be distinguished.

1. The plate is published by the artist (this term is here used as opposed to 'engraver' to refer invariably to the painter after whose picture the engraving is made). In the case of Reynolds the only print so published is the Charlotte Fitzwilliam (see 101), and it was in general unusual for portrait mezzotints to be published in this way. The situation was however quite different with line engravings after history paintings, where painters regularly turned publisher to get a share of the large profits which engravings could bring in.

2. The plate is published by the engraver. This is the most common procedure with the prints after Reynolds, and with English mezzotints in general, in the earlier years.

3. It could be published by a third party—a printseller. Such a dealer could be an engraver who dealt in prints as a sideline (e.g.

Ryland), but was more usually a professional like Boydell (although he too started as an engraver). In many cases we find a popular plate published jointly by the engraver and one or more dealers. In the liquidations of stock after dealers' bankruptcy, a half or third share of a plate is sometimes offered at auction. The dealers became increasingly important towards the end of the eighteenth century, and by the time of Reynolds' death most prints were published by them.

4. Occasionally plates have no publication line. This sometimes means that they are piracies (e.g. many of the mezzotints by Spooner or Purcell). Sometimes however the plate was private and was never published. A private plate was usually commissioned by the sitter or his family, who paid the engraver a flat fee and acquired the actual plate. Impressions from this would then be presented to the sitter's friends (see 104).

Prints were sold in the first place by the publisher at his address. They could also be acquired at 'the printsellers of London and Westminster' (as a typical advertisement of the period states) as well as those of the provinces; these must have been able to buy the prints at wholesale prices. Outside the shops of the dealers, there were opportunities to see mezzotints in the exhibitions at the Society of Artists. The Royal Academy was much less generous, and only allowed its associate engravers to show one or two prints a year.

Engravers were excluded from membership of the Academy in 1769. As a sop, places for six associate engravers were established in 1770, but since such membership was nominal rather than real it was boycotted by most engravers. The often ferocious controversy was only ended in 1853 when two Academician engravers were admitted to full membership. Reynolds himself was firmly against admittance:

The fact was that Sir Joshua Reynolds held the ingenuity of able engravers in high consideration; but would not admit that works purely imitative should be classed with original productions or that the professors of the former were entitled to the distinction granted to the latter, which requires more profound study and greater powers of mind.[23]

This attitude was a logical consequence of the well-established doctrine that the idea behind a painting was important, not its execution, and was shared by most of his fellow academicians.

Prices

Portrait mezzotints were usually made in three fairly standard sizes: head (about 12 × 10 in.), half-length (about 17 × 13 in.), or

whole-length (about 25 × 15 in.). In the early years the usual prices for these were 2s., 5s. and 10s. 6d. But prices went up very quickly. In May 1770 Horace Walpole wrote to Horace Mann: 'Another rage is for prints of English portraits. I have been collecting them for thirty years, and originally never gave for a mezzotinto above one or two shillings. The lowest is now a crown; most from half a guinea to a guinea.'[24] Mezzotints were not usually published by subscription; this was only necessary with the much slower and more expensive process of line engraving. The only exception that concerns Reynolds is Valentine Green's series of 'Beauties of the Present Age' (see 134).

We know very little about the amounts paid to mezzotinters. Vertue tells us that George White in the 1720s was being paid 15 to 20 guineas a plate – but this was 'above double what any other person had had before'.[25] The only figure I have found for a mezzotint after Reynolds is the £70 that Macklin paid Dunkarton in 1790 for the plate of Lord Lifford (CS 29).[26] Stipples and line-engravings were much more expensive (see 156 and 162), but printed very many more impressions before wearing out.

Mezzotint plates could only produce a limited number of good impressions before becoming badly worn. William Carey, writing in 1832, stated that 'from two to three hundred are the most that can be taken off, and then it is often necessary to refresh the ground and restore the lights during the progress of the printing.'[27] Such reworkings were regular (for an extreme example see 170) and must have greatly extended the life of a plate. Nevertheless if the demand for a print was expected to be enormous, the mezzotint was not a sensible medium to choose.

To judge from the number of impressions surviving, it was a regular practice long before 1754 to sell mezzotints either before letters, or with scratched letters (see 118). The reason for this will be obvious to anyone who has seen a worn mezzotint; with no other class of print is it more important to see an early impression, and the issuing of a number (presumed to be limited) of proofs was intended to guarantee the buyer of one an impression of the desirable quality. The advertisements in the press do not usually give a separate price for proofs, but it was normally one and a half times or twice the price of the ordinary edition. The only case I know in which the number of proofs was specified is Valentine Green's Düsseldorf Gallery, where they were advertised as limited to fifty at twice the price of an ordinary lettered impression. But the auction catalogues of dealers going out of business suggest that the number of proofs printed was often much higher. During the course of our forty years the market became increasingly sophisticated and complicated; by the 1780s it is usual to find mezzotints published in four or even more states.

Buyers

The market for portrait mezzotints was undoubtedly larger than we might now suppose. There was a craze for collecting English portraits (cf. the quotation from Walpole above), fed by Granger's *A Biographical History of England from Egbert to the Revolution . . . adapted to a methodical catalogue of engraved British heads*, 1769–74, and its successor by Bromley published in 1793. At the bottom end of the market we find numerous mezzotints listed in the catalogues of firms like Bowles and Sayer at 6d. or 1s. each.[28] At the top end there were the large-scale collectors like Horace Walpole (see 169), Lord Braybrooke and the Earl of Essex.[29] The 1784 catalogue addresses itself to the collectors of prints made from 'our modern Raphael'–referring to Reynolds–and so there was already a recognisable breed of collectors of his engraved works.

In the late eighteenth century English prints were exported in vast numbers to the Continent.[30] Although this trade seems to have been largely in line-engravings or fancy, usually stippled subjects, portrait mezzotints were certainly appreciated and bought (see 168), but for their beauty rather than through any interest in the sitter: Walpole found McArdell taking the letters out of one of his plates because the French preferred not to know who the sitter was.[31] Some plates of foreign sitters were also lettered in the appropriate language (see 148), while a further aspect of continental interest is the emigration of various mezzotinters (Dickinson, Hodges). A remarkable exhibition of prints after Reynolds imported from Boydell in England was held in Philadelphia in 1786.[32]

Reynolds' own collection is described by Northcote:

He kept a portfolio in his painting room, containing every print that had then been taken from his portraits; so that those who came to sit had this collection to look over, and if they fixed on any particular attitude, in preference, he would repeat it precisely in point of drapery and position; as this much facilitated the business and was sure to please the sitters' fancy.[33]

Fine collections of prints after Reynolds were also formed by Nollekens[29] and Lawrence.[34]

Relation of Reynolds with his engravers

Every time an engraving was made there were three interested parties: the painter, the engraver and the owner of the painting. In the case of Reynolds the last would usually be the sitter;

occasionally it was a print publisher. Almost invariably a portrait was only engraved once; the exceptions can usually be explained as special cases. Copyright law gave the publisher copyright in a design; piracies could be and were prosecuted. Copyright at this stage did not subsist in the original painting.[35] There is a reliable tradition that Reynolds never charged copyright fees; the first to do so was Sir Thomas Lawrence.[36] Similarly there was never any question that the owner of the painting had any copyright, or ever charged fees. But he would almost invariably have given his permission for it to be engraved; this is seen in Reynolds' letter to Keppel (see 130) and would be necessary if the painting was lent to the engraver while the print was being made. In one case we know that the owner objected to the appearance of the engraving; the difficulty was circumvented by leaving the name of the sitter off the plate.[37]

In many cases we can be sure that the sitter or owner chose the engraver. This presumably happened with almost every private plate, and can often be inferred where a portrait is engraved by someone who is not one of Reynolds' usual engravers. It is also probably true whenever a process other than mezzotint was used. One documented case is Bartolozzi's stipple of Lord Mansfield (see 156). All paintings commissioned from Reynolds by print publishers would have been engraved by men chosen by the publisher (see 158).

In one instance we know that the engraver wrote to Reynolds asking to be allowed to engrave a picture.[38] This very important case concerned Valentine Green who wanted to engrave *Mrs Siddons as the Tragic Muse,* (see 160). The seven letters of the correspondence have often been published, and we need only pick out the salient points.[39] Green's original letter stated that he had already received the agreement of Sheridan (obviously the owner) to borrow the painting to engrave, and added 'it certainly is almost the only portrait, without the particular support of the party, which an engraver could venture on in the hope of being rewarded for his trouble'. Reynolds, in his reply, said that if the choice of engraver depended on him, he would remember Green's first application: but he thought that Mrs Siddons wanted the print to be engraved, not mezzotinted; moreover the picture, being only just begun, might turn out not to be worth making a print from. Reynolds was correct and the painting was given at Mrs Siddons's request, to the stippler Haward; Green thought that Reynolds had double-crossed him and sent a furious letter which elicited a cutting reply. Green never engraved another picture by Reynolds. From this fascinating correspondence we learn that the decisive voice lay with the owner or sitter, and that only if they stood aside did the decision revert to the painter. Further, it reveals that, even

if we take Green's words with a pinch of salt, it was not unknown for the sitter to subsidise the engraver; this is otherwise undocumented.[40] A final interesting fact emerges from Green's second letter:

It was my intention . . . to have the plate executed in whatever manner yourself, Mrs Siddons or Mr Sheridan might determine on . . . and to have commissioned any artist that might have been mentioned, to have done it. You are not to be informed that this practice is common, and that by that means the proprietorship of that plate would have been equally secured to me, as if I myself had done it.

This explains the frequency of the engraver's turning publisher, and, incidentally, supports the conclusion that the ownership of a plate did indeed rest with the publisher.

The third, remaining category is where Reynolds chose the engraver. In one case we have a document to prove that this happened: a letter from Reynolds to Keppel in 1779 saying that he had sent his portrait to the engraver without Keppel's leave (see 130). The engraver in this case was Doughty, who, like Marchi, had worked in Reynolds' studio. Both were only occasional mezzotinters; and since they hardly ever engraved after any other artist and since many of their prints were of members of Reynolds' circle, it may confidently be assumed that it was Reynolds who gave them these commissions. We know that McArdell was very close to Reynolds; Reynolds painted his portrait and Northcote tells a story in which he calls on Reynolds to ask his advice.[41] With other mezzotinters we can only argue from the regularity with which they engraved his paintings. This may seem a very weak argument; it can however, I believe, be strengthened by a supporting consideration. The majority of Reynolds' sitters would have been delighted to publicise their portraits by a print, but very few would have known anything about the practical side of the print business. It is surely reasonable to suppose that they turned the whole matter over to Reynolds. And one would not expect evidence for such procedures to have survived.

The final question, and the one which is crucially important, is how much Reynolds supervised the work of the engravers. The evidence is tantalisingly scrappy. A press notice in 1787 announced: 'Sir Joshua Reynolds' finished picture of Melancholy, which was exhibited at the Royal Academy last year, is engraving by a self-taught female artist, under the immediate inspection of the Knight'.[42] C. R. Grundy quotes from a letter of James Ward, written in 1848 to his son about altering plates: 'It makes me so afraid of little alterations, one little thing begets another, until the change is of a new picture. I remember when a boy, how often this was the case with Sir Joshua Reynolds, to the annoyance of J. R.

Smith and my brother'.[43] But no writer has ever mentioned seeing one of these corrected proofs. Indeed Rawlinson, in his introduction to the Burlington Fine Arts Club catalogue, states that Lawrence's corrected proofs are regularly found, Hoppner's occasionally, and Romney's very rarely; Reynolds' are not mentioned. Much of the difficulty is that touched proofs are regularly seen in which it is evident that the markings are due to engraver rather than artist. Nevertheless we have succeeded in finding one touched proof in which we are sure that the correcting hand is Reynolds' (see 109). This is the only proof touched by Reynolds that I know, and the question must arise whether it is representative of a whole lost class or not. I think it is. No engraver would bother to keep corrected working proofs unless there were a market for them; the print market rapidly became more sophisticated in the late 1780s and 1790s, but before this date I do not think that touched proofs would have been saleable. The other, and stronger, argument is from the uniformly high quality of the mezzotints made after Reynolds' paintings. This argument has already been put forward by A. Aspland:

It cannot be doubted that Reynolds examined those trial proofs and corrected them. It would be otherwise impossible for so many scrapers to have done such fine work. Turner, by the same means, educated unrivalled line and mezzotint engravers. Were it not known that such was the practice of these two masters, it would naturally be inferred by the inferiority of those engravers who worked after the death of the artists, and who had not the advantage of their instruction.[44]

This is not to argue that Reynolds supervised every engraving, but rather that his occasional supervision had the effect of raising standards and keeping the mezzotinters on their mettle.

Gainsborough

We have already observed that the number of prints made after Gainsborough's paintings is very much smaller than of those made after Reynolds'. But they provide an interesting comparison and contrast. The small group of line-engravings in the exhibition made after early landscapes belongs to a different tradition of printmaking, and does not enter into the discussion here. The portrait mezzotints were done by a motley assortment of engravers. The only 'official' mezzotinter we can find is Gainsborough Dupont, who published four prints during his uncle's life and three more after his death (three others are undated, and three more were never finished). The most striking feature of all these prints is their very low quality. One has to admit that Gainsborough's style

of painting was an engraver's nightmare; this is shown by Dean's heroic failure (see 169). Gainsborough must have realised that the mezzotint could do his reputation no good. But equally significant was his complete lack of interest in publicity; from 1784 he abandoned the Academy exhibitions, and *a fortiori* he was hardly likely to bother about mezzotints.

Curiously, whereas Reynolds never personally made a print in his life, Gainsborough is responsible for twenty-one of the most remarkable English prints of the eighteenth century. These have been very fully discussed in a recent book by John Hayes, and are catalogued in this exhibition in the section devoted to Gainsborough's drawings.

ANTONY GRIFFITHS

Notes to Introduction

My colleagues in the Department have given me much help. I would also like to thank David Alexander and Richard Godfrey who both most kindly read and criticised an early draft of the introduction. David Alexander has also checked the engravers' biographies and given me invaluable information and suggestions.

1 J. T. Smith: *Nollekens and his times,* ed. W. Whitten, London 1920, II, p. 223.
2 Sir Robert Strange: *An enquiry into the rise and establishment of the Royal Academy,* London, 1775, pp. 2–3.
3 See general bibliography. A supplement was published by C. E. Russell. The information about states given in this catalogue occasionally tacitly adopts Russell's corrections, as well as the manuscript annotations in the Department's copy of Chaloner Smith.
4 Cf. Rawlinson's introduction to the 1902 Burlington Fine Arts Club catalogue. The process of squaring here described is seen in an album of preparatory drawings in this Department by William Sharp. These are for line engravings, but some remarks by William Carey about Dixon show that the process was similar for mezzotints: 'Our artist thought in his outset that he might dispense with the usual mode of reducing his subject by squares and supposed his eye sufficiently correct to reduce it from the original picture'–with predictably disastrous results. (*Arnold's Library of the Fine Arts,* IV, 1832, p. 14).
5 There is a great deal of evidence for this happening and it would seem to be almost invariable practice.
6 The earliest use of this expression that I know is in the introduction to the *Cabinet de Boyer d'Aguilles,* Paris, 1744, àpropos of plates 100 and 101, which were described as being engraved 'à la manière noire d'Angleterre'.
7 The earliest source I can find for this is Walpole's biography of Smith in the *Anecdotes of Painting in England.*
8 Vertue Note Books III, Walpole Society, 1934, p. 14.
9 Vertue III, p. 109.
10 Vertue III, p. 60.
11 Vertue III, p. 159.
12 David Alexander: The Dublin Group, Irish mezzotint engravers in London 1750–1775, *Quarterly Bulletin of the Irish Georgian Society,* XVI, 1973, pp. 72–93.
13 This important point was made by David Alexander, op. cit., p. 75.
14 Reprinted by Graves and Cronin, pp. 1583–93.
15 Northcote, II, p. 280.
16 H. P. Horne: *Catalogue of engraved portraits and fancy subjects painted by Thomas Gainsborough and George Romney,* London, 1891.
17 Northcote, II, p. 280.
18 Richard Godfrey in his forthcoming history of the English print has put forward the fascinating suggestion that Reynolds' style of painting was affected by the possibilities and demands of the mezzotint.
19 An advertisement from a newspaper of 22 May 1769 (Victoria and Albert Museum Library album of press-cuttings) describes Boydell's collection of 53 prints after paintings in British collections as having been 'undertaken to encourage and improve the art of engraving'. T. Balston's article on Boydell in *Signature,* 8, 1949, pp. 3–22, is totally inadequate on his earlier career.
20 Cf. F. Harvey: Stipple engraving as practised in England 1760–1810, *Print Collectors Quarterly,* XVII, 1930, pp. 49–71. But the subject needs much more investigation.
21 Almost all the known information about Ryland is assembled by Horace Bleackley: *Some distinguished victims of the scaffold,* London, 1905, pp. 107–111.
22 The act is reprinted by R. Paulson: *Hogarth, his life, art and times,* II, New Haven, 1971, pp. 489–90.

23 J. Farington: *Memoirs of the life of Sir Joshua Reynolds,* London, 1819, p. 62.
24 Quoted by Leslie and Taylor, I, p. 357. The 1784 catalogue gives the price of every print listed.
25 Vertue III, p. 60.
26 This is given by a cutting among the Whitley Papers in the Department library.
27 *Arnold's Library of the Fine Arts,* IV, 1832, p. 73.
28 Their catalogue for 1775 has been issued in a facsimile reprint by Holland Press, 1970.
29 J. T. Smith (op. cit. in note 1), I, p. 316.
30 This is the most startling phenomenon in the history of the English print, but has never been investigated. There is an abundance of evidence.
31 H. Walpole: *Anecdotes of Painting in England,* ed. F. W. Hilles and P. B. Daghlian, V, 1937, p. 215.
32 R. Brimo: *L'Évolution du goût aux États-Unis d'après l'histoire des collections,* Paris, 1938, p. 33.
33 Northcote I, p. 83.
34 Mezzotints after Reynolds stamped with Lawrence's collector's mark (L 2446) are common.
35 The whole subject is very complicated, and I hope to discuss it in a separate article.
36 Catalogue of the Burlington Fine Arts Club exhibition 1902, p. 22. For Lawrence, cf. J. Pye: *Patronage of British Art,* 1845, p. 243 note 52.

37 C. Wilkin's stipple of Lady Cockburn (National Gallery). Cf. Graves and Cronin, pp. 182 and 1283.
38 When John Raphael Smith applied to Northcote to engrave two of his paintings, he offered different terms depending on the likely popularity of the subject. Cf. W. Hazlitt: *Conversations with James Northcote,* in his *Collected Works,* VI, ed. A. R. Waller and A. Glover, 1903, p. 404.
39 The only complete publication is in *The Literary Gazette and Journal,* 1822, pp. 85–6. The important passages are in Reynolds' *Letters* and in W. T. Whitley: *Artists and their friends in England 1700–1799,* II, 1928, pp. 3–13.
40 There are also the cases where a print is dedicated by the engraver to a patron, where some reward would have been expected. This, however, was not very common with portrait mezzotints. The only print dedicated by Reynolds is a special case (see 120). cf. also 164. xi
41 Northcote I, p. 231.
42 This print was never published, and I have no idea who is referred to.
43 C. R. Grundy: *James Ward,* 1909, p. XIV.
44 Introduction to the catalogue of an exhibition of mezzotints after Reynolds at the Brazenose Club, Manchester, 1874.

Prints after Reynolds

James McArdell

1728/9–65

Born in Dublin. Pupil of John Brooks, whom he accompanied to London about 1746. By 1751 he was publishing his own prints at the 'Golden Head in Covent Garden'. Between 1754 and his early death, he scraped some 230 extremely fine prints after Old Masters and contemporary portraitists; thirty-eight were after Reynolds, who is recorded as saying 'By this man I shall be immortalised'. His portrait of McArdell is now in the National Portrait Gallery.

* **101** Lady Charlotte Fitzwilliam

1754
Mezzotint 326 × 225 mm
Provenance Bequeathed by Lord Cheylesmore.
1902–10–11–3261
Literature CS 67; G 38, second state, with lettering

This is probably the earliest mezzotint after a painting by Reynolds. The sitter was the eldest daughter of Earl Fitzwilliam, and was eight at the time the portrait was painted.

This was the only print published by Reynolds himself; he later handed the plate back to McArdell, and the third state of the plate bears McArdell's address. An entry in Reynolds' sitter book for January 1755 mentions 'Lady C. Fitzwilliam prints' (*Walpole Society.* XLI, 1966–8, p. 116).

102 Lady Anne Dawson as Diana

1754
Mezzotint 376 × 278 mm
Provenance Bequeathed by Felix Slade.
1868–8–22–2095
Literature CS 52; G 35, second state with scratched lettering

The sixth daughter of the Earl of Pomfret, who married Thomas Dawson in 1754 at the age of 21. This portrait was evidently painted on this occasion. Allen Ramsay had earlier painted a marriage portrait of Lady Boyd, also as Diana, of which McArdell published a mezzotint in 1749 (G 9).

103 Mrs Bonfoy

1755
Mezzotint 375 × 275 mm
Provenance Bequeathed by Felix Slade.
1868–8–22–2079
Literature CS 23; G 44, first state, with
scratched lettering

Mrs Bonfoy was the daughter of Richard Eliot, of
Port Eliot, Cornwall; her husband was a captain
in the Royal Navy. Unlike most portrait prints,
this was published without the sitter's name.
Reynolds had painted a group portrait of the Eliot
family in 1746, before his departure for Italy.

104 Horace Walpole

1757
Mezzotint 358 × 254 mm
Provenance Presented by Mr F. W. B. Maufe and
Mrs G. B. Lane. 1950–5–20–324
Literature CS 186; G 63, second state, with
lettering

The famous dilettante, letter-writer and anti-
quarian. Reynolds painted this portrait in 1756–7.
On 9 May 1757 Walpole wrote to Grosvenor
Bedford: 'I shall be much obliged too if you will
call as soon as possible at M' Ardell's in Henrietta
Street, and take my picture from him. I am
extremely angry for I heard he has told people of
the print. If the plate is finished, be so good as to
take it away, and all the impressions he has taken
off for I will not let him keep one. If it is not
finished, I shall be most unwilling to leave the
plate with him. If he pretends to stay for the
inscription, I will have nothing but these words
*Horace Walpole, youngest son of Sir Robert
Walpole, Earl of Orford.* I must beg you will not
leave it with him an hour, unless he locks it up,
and denies to everybody there is any such thing.'
(*Letters,* ed. Paget Toynbee, IV, Oxford, 1903, No.
629).

This proves, what the lack of a publication line
implies, that this was a private plate. This par-
ticular impression has been selected, although of
very poor quality, because it bears an annotation
in a contemporary hand: 'From Mr Horace
Walpole Nov. 12. 1781'. The fact that this is
twenty-four years after the engraving was made
explains the wear of the plate.

105 John Lockhart

*c.*1762
Mezzotint 396 × 280 mm
Provenance Purchased at Colnaghi's sale,
Sotheby's, 15 May 1865, lot 1458, for £1.
1865–6–10–33
Literature CS 121; G 95, first state, before
lettering

The print is undated, but Lockhart is known to
have been sitting for his portrait from 1760–2
(Waterhouse 1941, p. 93). He was a distinguished
sailor, and was promoted admiral in 1779.

106 John, Earl of Rothes

*c.*1763
Mezzotint 507 × 350 mm
Provenance Bequeathed by Lord Cheylesmore.
1902–10–11–3376
Literature CS 157; G 102, first state, before
lettering

The portrait was exhibited at the Society of Artists
in 1763. The sitter was commander-in-chief of the
Forces in Ireland.

Richard Houston
*c.*1721–75

A fellow-pupil with McArdell of Brooks in
Dublin, and came with him to London about
1746. He was 'very idle, capricious and ex-
travagant', and absconded for debt in 1762. Most
of his work was done for the print publishers, and
he never really escaped from them. It is said that
Sayer had him arrested and confined in the Fleet
Prison so that 'he would know where to find him'.
Twenty-two of the 153 mezzotints catalogued by
Chaloner Smith are after Reynolds.

**107 Maria, Countess Waldegrave and
daughter**

1761
Mezzotint 491 × 356 mm
Provenance Bequeathed by Felix Slade.
1868–8–22–2132
Literature CS 121, first state before any
inscription

In the later state, this mezzotint was inscribed with
the date 1761, but has no copyright line. This
would explain why copies of it could be published
by J. Smith (CS p. 1241), James Watson (CS 147,
148) and R. Purcell (CS 75). It cannot, however,
have been a private plate, since it is marked 7s.
6d.

The sitter was the natural daughter of Sir Edward Walpole. She married Earl Waldegrave in 1759, and her daughter was born in March 1760.

The picture was exhibited at the Society of Artists in 1762 as 'A Lady with her child, in the character of Dido, embracing Cupid'. J. A. Gere has pointed out that the type of the child's head may have been inspired by paintings by Bartolomeo Schidone (1578–1615), the Emilian artist who was very popular in the eighteenth century.

108　Harriet Powell

1771
Mezzotint 490 × 357 mm
Provenance Purchased at Sotheby's.
1830–7–14–35
Literature CS 100, first state with scratched inscription

The print was published by Sayer on 1 May 1771, and in its lettered state carries a song of nine lines. The actress is shown in the character of Leonora in Bickerstaffe and Dibdin's opera 'The Padlock'. The portrait was painted in 1769.

Another mezzotint from the same painting by Elizabeth Judkins (CS 4) had been published earlier by Sayer on 1 July 1770 (the Department owns no impression of this). Presumably this was a popular subject; and since Sayer owned the copyright, there was no difficulty in satisfying the demand by making another print.

James Watson

*c.*1739–90

Born in Ireland; in England by the late 1750s, where he is said to have been a pupil of McArdell. Watson was the most prolific of Reynolds' engravers, and the most important in the decade after McArdell's death. Of the two hundred plates catalogued by Goodwin, sixty-one are after Reynolds. The latest of them is dated 1778; after this year he seems largely to have abandoned mezzotinting. His daughter Caroline became a distinguished stipple engraver; Elizabeth Judkins (see 108) was his sister-in-law.

* 109　Nelly O'Brien

*c.*1767
Mezzotint 456 × 352 mm
Provenance Sir T. Lawrence (L 2446); purchased at the Buccleuch sale, Christie's, 8 March 1887, lot 949, for 17 guineas. 1887–4–6–34
Literature CS 67; G 32, working proof

Although this proof was correctly described as having been touched by Reynolds in the Buccleuch sale catalogue, by Goodwin and by Russell, its significance has not been realised as the only known proof corrected by the artist (see p. 40).

An interesting light is thrown on the corrections by some comments that Reynolds made in his 'Journey to Flanders and Holland' of 1781 (Malone, II, pp. 321–3) about an engraving after Rubens by Bolswert: 'This print was undoubtedly done under the inspection of Rubens himself. It may be worth observing, that the keeping of the masses of light in the print differs much from the picture; this change is not from inattention, but design; a different conduct is required in a composition with colours, from what ought to be followed when it is in black and white only. We have here the authority of this great master of light and shadow, that a print requires more and larger masses of light than a picture'. Reynolds' corrections on this print are all similarly concerned with the masses of light and dark; there is no interest in contour or shape.

Nelly O'Brien was a celebrated courtesan.

110　Edmund Burke

1770
Mezzotint 375 × 274 mm
Provenance Sir T. Lawrence (L 2446); bequeathed by Felix Slade. 1868–8–22–2084
Literature CS 20; G 69, first state, before name

The celebrated statesman, orator and author, and intimate member of Reynolds' circle; he was executor to Reynolds' will. The original portrait (Waterhouse 1941, plate 119) is in an oval frame, but has here been adapted to a circle.

111　Dr Johnson

1770
Mezzotint 456 × 330 mm
Provenance Bequeathed by Lord Cheylesmore.
1902–10–11–6444
Literature CS 82; G 70, second state, before name

Samuel Johnson was perhaps Reynolds' closest friend, and was painted by him five times. This is

the second and was exhibited at the Royal Academy in 1770. The original is now at Knole; a replica is in the Tate Gallery. Reynolds' memoirs of Johnson are published by F. W. Hilles: *Portraits by Sir Joshua Reynolds,* 1952, pp. 66–80.

Mrs Piozzi records Johnson's reaction to one of his portraits: 'When Sir Joshua Reynolds had painted his portrait looking into the slit of his pen, and holding it almost close to his eye, as was his general custom, he felt displeased, and told me "he would not be known by posterity for his defects only, let Sir Joshua do his worst". I said in reply, that Reynolds had no such difficulties about himself, and that he might observe the picture which hung up in the room where we were talking, represented Sir Joshua holding his ear in his hand to catch the sound. "He may paint himself as deaf if he chooses (replied Johnson), but I will not be *blinking Sam*".' (*Anecdotes of the late Samuel Johnson,* 1786, p. 248.) Commentators have always linked this story to the portrait type in which Johnson is shown near-sightedly peering at the book he is reading. It appears, however, to be equally applicable (or inapplicable) to this composition.

112 Sir Joshua Reynolds

1770
Mezzotint 458 × 330 mm
Provenance Bequeathed by Lord Cheylesmore.
1902–10–11–6492
Literature CS 123; G 71, first state, before lettering

This is a pair to the portrait of Johnson (see 111), which was published on the same day. A whole series of portraits of members of Reynolds' circle was engraved in 1770 (see 110, 120). Reynolds here has his hand on a portfolio of drawings, possibly by the Old Masters.

113 James Beattie

1775
Mezzotint 354 × 408 mm
Provenance Purchased from the Buccleuch sale, Christie's, 8 March 1887, lot 592, for 4 guineas.
1887–4–6–12
Literature CS 9; G 103, first state, before lettering

A well-known Scottish philosopher and poet. His 'Essay on Truth' was published in 1770; it was a great popular success and earned him an honorary doctorate at Oxford. The book (which Beattie holds under his arm) is an attack on scepticism and on Hume in particular. Reynolds was awarded his honorary doctorate at the same ceremony as Beattie, and was so impressed by him that he presented this picture to him, in which a personification of Truth drives out three demons, identified by Beattie as Prejudice, Scepticism and Folly. Reynolds expressly denied that anyone was personified except Voltaire; contemporaries, however, identified Hume and Gibbon as well. Goldsmith took exception to the painting: 'How could you degrade so high a genius as Voltaire before so mean a writer as Beattie? The existence of Dr Beattie and his book together will be forgotten in the space of ten years, but your allegorical picture and the fame of Voltaire will live forever, to your disgrace as a flatterer' (Leslie and Taylor II, p. 30). The composition derives from a Venetian picture at Hampton Court (E. Mandowsky: *Burlington Magazine,* LXXVII, 1940, p. 196).

Edward Fisher
1722–after 1781

Born in Ireland. Active in London by 1758. Twenty-eight of the seventy-four plates listed by Chaloner Smith are after Reynolds, and date from 1759 to 1777. Reynolds is said to have criticised Fisher's work (see 116), but the large number of his paintings engraved by Fisher proves that he fully recognised his brilliance.

114 David Garrick between Tragedy and Comedy

1762
Mezzotint 401 × 504 mm
Provenance Bequeathed by Felix Slade.
1868–8–22–2099
Literature CS 20, first state, before lettering

Garrick was as conscious as Reynolds of the potential usefulness of prints in keeping him constantly in the public eye. He was painted by all the leading painters, often more than once, and the portraits were all engraved as mezzotints. From Paris in November 1764 Garrick wrote: 'I am so plagu'd here for my prints or rather prints of me – that I must desire you to send me by the first opportunity six prints from Reynolds' picture, you may apply to the engraver he lives in Leicester Fields, and his name is Fisher, he will give you good ones, if he knows they are for me'. (*The Letters of David Garrick,* ed. D. M. Little and G. M. Kahrl, 1963, No. 343.) Walpole recorded in

1761 'Reynolds has drawn a large picture of three figures to the knees, the thought taken by Garrick from the judgement of Hercules' (*Anecdotes of Painting*, v, ed. F. W. Hilles and P. B. Daghlian, 1937, p. 61). The Judgement of Hercules was a traditional subject in western art derived from an allegorical myth by the Greek philosopher Prodicus in which Hercules was offered the choice between Virtue and Vice, personified by two female figures. Walpole makes it clear that this parody of the subject was devised by Garrick himself.

* 115 Granville, Earl Gower

1765
Mezzotint 387 × 278 mm
Provenance Bequeathed by Lord Cheylesmore.
1902–10–11–2135
Literature CS 22, first state, before lettering

The portrait was painted in 1760–1, but only engraved four years later. The scraping of the velvet is particularly brilliant.

116 Lady Sarah Bunbury sacrificing to the Graces

1766
Mezzotint 593 × 366 mm
Provenance Bequeathed by Felix Slade.
1868–8–22–2081
Literature CS 6, first state, before lettering

The fourth daughter of the Duke of Richmond; married Sir Thomas Bunbury in 1762. The portrait (now in Chicago) was painted and exhibited at the Society of Arts in 1765.

Northcote (I, p. 64) describes Fisher as 'that most exact and laborious artist, of whom Mr Reynolds used to say, that he was injudiciously exact in his prints, which were mostly in the mezzotinto style, and wasted his time in making the precise shape of every leaf on a tree with as much care as he would bestow on the features of a portrait'. This mezzotint gives a very clear illustration of what Reynolds disliked. But Fisher's other two prints in the exhibition show little sign of over-elaboration of detail.

John Dixon

before 1740–1811

Trained in Dublin. In London by 1766 when he exhibited at the Society of Artists. Eleven plates, about a quarter of his production, were engraved after Reynolds. In 1775 he married Miss Meriton, a great beauty and widow of Nicholas Kempe, bullion porter to the Mint; the marriage contract stipulated that he should not follow his profession otherwise than for his amusement and he kept to this. In his old age he wrote and had printed a series of pamphlets on the 'Improvement of the Fisheries'. The latest of these was published in 1804.

117 Emma and Elizabeth Crewe

*c.*1767
Mezzotint 505 × 354 mm
Provenance Unknown. Aa 10–43
Literature CS 12, second state, with scratched lettering

The original painting is almost square (Waterhouse 1941, plate 113), and its proportions have been altered in the print. The landscape and tree to the left are completely recast.

118 William, Duke of Leinster

1774
Mezzotint 500 × 354 mm
Provenance Unknown. Aa 2–6
Literature CS 22, first state, with uncleaned margin and scratched lettering

The scratched lettering on this impression reads 'Published according to Act of Parliament, November 15 1774'. The plate was later re-issued with cleaned margin and new scratched lettering with the date 25 April 1775. The final state with engraved lettering is dated 19 May 1775. It is unusual to find such precise dating of the publication of the various states. The portrait was exhibited at the Royal Academy in 1775. A technical peculiarity of this print is the considerable use of drypoint on the waistcoat and the fur of the gown. In this impression the burr is printing to remarkable effect.

Giuseppe Marchi

1735–1808

Born in Rome; brought back from Italy by Reynolds in 1752 to act as his assistant. In the cover of one of Reynolds' ledgers is a draft agreement: 'Nov. 22nd 1764 agreed with Giuseppe Marchi that he should live in my house and paint for me for one half year from this day I agreeing to give him fifty pounds for the same' (*Walpole Society*, XLII, p. 107). Northcote records that he once tried to set himself up as a portrait painter in

Swansea, but failed and returned to assist Reynolds. Thirteen mezzotints by him are known: eight are after Reynolds, all of which belong to the years 1767–73. After Reynolds' death, Miss Palmer, his niece and residuary legatee, continued to pay Marchi's annuity of £100 per annum. (*General Evening Post,* 28 February 1792; cutting among the Whitley papers.)

119 Miss Hester Cholmondeley

1768
Mezzotint 500 × 355 mm
Provenance Purchased from Messrs Smith.
1840–8–8–56
Literature CS 3, first state, before lettering

The pose is a humorous adaptation of traditional representations of Hercules lifting Antaeus.

120 Oliver Goldsmith

1770
Mezzotint 452 × 328 mm
Provenance Bequeathed by Felix Slade.
1868–8–22–2104
Literature CS 7, second state, with scratched lettering

Goldsmith was a member of 'The Club' and a very close friend of Reynolds and Johnson. In 1770 he dedicated his poem 'The deserted village' to Reynolds. Reynolds returned the compliment by dedicating to him the mezzotint of *Resignation* (by Thomas Watson, 1772, G 51), which was described as an 'attempt to express a character in the Deserted Village'. Reynolds' notes about Goldsmith are published by F. W. Hilles: *Portraits by Sir Joshua Reynolds,* 1952, pp. 40–54.

121 Oliver Goldsmith

1770
Pen and ink over wash. 197 × 179 mm
Provenance Purchased from Mr Bennett.
1876–5–10–930
Literature Exhibition of Works by Sir Joshua Reynolds, Birmingham Art Gallery, 1961, No. 91, as by Reynolds

The drawing was acquired as an anonymous copy of Reynolds' painting. At some time after the publication of Binyon's catalogue in 1902, it was attributed to Reynolds himself. It is clearly drawn after the painting, and seems to be related to the mezzotint. One possible explanation is that it was drawn by Marchi as a reduction for the mezzotint, and was then corrected by Reynolds; the pen and ink scribblings are similar to those on the cor-rected proof of Nelly O'Brien (see 109). On the other hand the size of the drawing does not match the mezzotint.

Thomas Watson

1750–81

Not related to James Watson. Born in London, and engraved twenty-four plates (about a third of his production) after Reynolds between 1770 and his early death. From 1779 he was in partnership with William Dickinson as print-seller and publisher. He seems to have made the first stipple after Reynolds (G 37).

122 Mrs Crewe

1773
Mezzotint 480 × 516 mm
Provenance Bequeathed by Lord Cheylesmore.
1902–10–11–6549
Literature CS 10; G 15, third state, before title

Mrs Crewe of Crewe Hall, Cheshire, is shown as St Geneviève, reading the Bible while tending the sheep. The original painting (Waterhouse, 1941, plate 139) is much squarer, and has here been extended at the sides.

Charles Mitchell (*Burlington Magazine,* LXXX, 1942, p. 36) has observed that the pose is derived from a drawing in the Italian sketchbook f. 53r, annotated by Reynolds as being after a painting in the Palazzo Pitti in Florence.

123 Mrs John Parker

1773
Mezzotint 618 × 380 mm
Provenance Bequeathed by Lord Cheylesmore.
1902–10–11–6570
Literature CS 28; G 16, second state, before title

The sitter was the wife of one of Reynolds' oldest friends, John Parker of Saltram near Plymouth (where the picture still hangs). Reynolds was often a guest there, and advised on the purchase of paintings. When she died, tragically, in childbirth in 1775 Reynolds wrote a beautiful obituary (Leslie and Taylor, II, pp. 144–5), which was published in the *Public Advertiser* of 29 December 1775, and reprinted in the *Gentleman's Magazine* of February 1776.

The vase is based on a print of one of the vases painted by Polidoro da Caravaggio (d. 1543?) on the façade of the Palazzo Milesi in Rome (cf. Timothy Clifford: 'Polidoro and English Design'; *Connoisseur,* 1976, pp. 282 ff.).

*** 124** Lady Bampfylde

1779
Mezzotint 632 × 378 mm
Provenance Bequeathed by Lord Cheylesmore.
1902–10–11–6533
Literature CS 2; G 36, second state, before title

The portrait, now in the Tate Gallery, was
exhibited at the Royal Academy in 1777.
Catherine Moore had married Sir Charles
Bampfylde of Poltimore in Devon in 1776. This
has always been regarded as one of the very finest
English mezzotints.

William Dickinson
1746–1823

Born in London; began publishing his own prints
in 1773. In 1779 entered into partnership with
Thomas Watson; after Watson's death in 1781 he
continued as publisher although he made few
further plates himself. The recession after the
French Revolution caused him acute financial
troubles, and he went bankrupt in 1797. He then
emigrated to France, and died in Paris in 1823,
having made several mezzotints there after French
masters.

125 Mrs Pelham

1775
Mezzotint 623 × 380 mm
Provenance Bequeathed by Lord Cheylesmore.
1902–10–11–702
Literature CS 59, second state, with lettering

The painting was in the Academy exhibition of
1774. The lack of a publication line shows that
this was a private plate: when Hamilton wrote, it
was still in the possession of the family.

126 Mrs Sheridan as St Cecilia

1776
Mezzotint 500 × 351 mm
Provenance Bequeathed by Felix Slade.
1868–8–22–2127
Literature CS 74. first state, with scratched
lettering

The portrait, now at Waddesdon, was exhibited at
the Royal Academy in 1775. Miss Linley of Bath
married Sheridan, after eloping with him, in 1773.
She was famous for her soprano voice, so the pose
was obviously suitable. Sheridan, having ordered
the picture, found he could not afford to pay for it.

He finally raised the 150 guineas in 1790, when
Reynolds wrote that it was 'the best picture I ever
painted' (*Letters,* p. 191).

127 Lady Charles Spencer

1776
Mezzotint 507 × 356 mm
Provenance Purchased at Sotheby's.
1830–7–14–42
Literature CS 77, first state, with scratched
lettering

The wife of the son of the Duke of Marlborough.

128 Diana, Viscountess Crosbie

1779
Mezzotint 632 × 378 mm
Provenance Purchased from Messrs Smith.
1838–7–14–51
Literature CS 14, second state, with scratched
lettering

The painting was exhibited at the Royal Academy
in 1779, and is now in the Huntington Library in
California. It was painted in 1777 on the occasion
of the sitter's marriage. The *St James' Chronicle*
sourly commented: 'This may be a good likeness
of a lady of fashion, for the countenance is very
expressive of affectation'.

129 Mrs Mathew

1780
Mezzotint 638 × 380 mm
Provenance Bequeathed by Lord Cheylesmore.
1902–10–11–695
Literature CS 48, third state, with title

The portrait was painted in 1777 and was
exhibited at the Royal Academy in 1778.

William Doughty
1757–82

Born in York; a pupil of Reynolds 1775–8. He
then tried to set up as a portrait painter on his
own account in various places, but failed. In 1780
he married a servant girl of Reynolds and left
England for Bengal; but bad luck still pursued
him, he was captured by the Spaniards, and died
in captivity in Lisbon. Doughty made six mezzo-
tints after Reynolds' paintings in the months from
February 1779 to March 1780; the commissions
may be seen as attempts by Reynolds to help
Doughty in his difficulties. (See J. Ingamells,
Apollo, July 1964, pp. 33–7.)

130 Admiral Keppel
1779
Mezzotint 454 × 327 mm
Provenance Purchased from Messrs Smith.
1840–8–8–78*
Literature CS 3, second state, with engraved
address

Keppel was one of Reynolds' earliest patrons, and
had taken him to Italy in 1749. Seven portraits of
him by Reynolds are known. In 1778 he was in
command of the Channel Fleet at the Battle of
Ushant. The action was indecisive, and Keppel
was court-martialled at the instigation of his
second-in-command, Vice-Admiral Sir Hugh
Palliser. The strong public feeling which the case
aroused was largely political in origin, for
Keppel was closely associated with the leaders of
the Whig opposition party. On 12 February 1779
he was honourably acquitted, and became a public
hero. On the same day Reynolds wrote him a
letter of congratulation (Letters, p. 68), which
concludes: 'I have taken the liberty, without
waiting for leave, to lend your picture to an
engraver, to make a large print from it'. As
mentioned in the introduction, this is the only
documented case of Reynolds' selecting the en-
graver. The print was published on 12th March,
and would clearly have been made as quickly as
possible to catch the immediate interest. A month
therefore was the minimum time necessary to
scrape a plate of this size.

* **131 Dr Johnson**
1779
Mezzotint 454 × 329 mm
Provenance Bequeathed by Felix Slade.
1868–8–22–2113
Literature CS 2, third state, with scratched
lettering

Northcote tells a story about this print: 'Doughty
had engraved in mezzotint Sir Joshua's portrait of
Doctor Johnson very finely indeed, and on his
showing it to Sir Joshua it pleased him exceed-
ingly, and he said, "I would advise you by all
means to stick to mezzotint". Now this remark
disconcerted poor Doughty very much; he made
the mistake of thinking that the remark implied
that he was not likely to succeed as a painter,
though, I believe, Sir Joshua did not mean that.'
(*Conversations of James Northcote with James
Ward,* ed. E. Fletcher, 1901, p. 232.) Johnson
must have watched over this plate. In the second
state Doughty had put *Dr Samuel Johnson.* This
was hastily changed to *Samuel Johnson LLD.*

Johann Jacobe
1733–97

Jacobe was born in Vienna; Austria was then one
of the few European countries with any mezzotint
tradition, and in 1776 Jacobe was appointed,
under Schmutzer, chief instructor in mezzotint
engraving at the Vienna Academy. In 1777–80 he
was sent to London with a government grant for
further study. He produced seven mezzotints
there, four after Reynolds and three after Romney.
The addresses of the earliest prints suggest that he
was instructed by Dickinson; the later ones were
published by Boydell. His second plate was after
Reynolds' portrait of Count Belgioioso, the
Imperial ambassador to London, who was doubt-
less officially concerned with Jacobe's welfare.

132 The Honourable Mary Monckton
1779
Mezzotint 640 × 378 mm
Provenance Bequeathed by Lord Cheylesmore.
1902–10–11–2806
Literature CS 6, first state, with scratched
lettering

The daughter of Viscount Galway, who married
the Earl of Cork in 1786. Fanny Burney wrote in
1782: 'Miss M. is between thirty and forty, very
short, very fat, but handsome; splendidly and
fantastically dressed; rouged not unbecomingly,
yet evidently and palpably desirous of gaining
notice and admiration'. (Leslie and Taylor, II, p.
278). She died in 1840, aged nearly a hundred,
having been well known in society for her
eccentricities. The painting is now in the National
Gallery.

133 Miss Meyer as Hebe
1780
Mezzotint 624 × 380 mm
Provenance Bequeathed by Lord Cheylesmore.
1902–10–11–2805
Literature CS 5, second state, with lettering

Miss Meyer was the daughter of Jeremiah Meyer,
the miniaturist and foundation member of the
Royal Academy. She is shown as Hebe, the cup-
bearer of Zeus, whose attribute is the eagle.
(Reynolds is known to have kept an eagle in his
back yard.) The portrait had been exhibited at the
Academy in 1772 and belonged to Meyer. One
may surmise that Meyer's readiness to help a
fellow German led to the engraving of the picture
after so long an interval.

Walpole noted that the idea of the Hebe was borrowed from a print of Fortune by Goltzius (Leslie and Taylor I, p. 444). A hasty search has failed to identify this.

Valentine Green
1739–1813

A pupil of Robert Hancock in Worcester; published a *Survey of Worcester* in 1764. In 1765 moved to London, where his first mezzotints were published in 1767. In 1774 he was elected one of the engraver associates of the Royal Academy, and was already distinguished before he published his first mezzotint after Reynolds in 1778. In 1782 he dedicated a pamphlet to Reynolds entitled *A Review of the polite arts in France at the time of their establishment under Louis XIV, compared with their present state in England*. But in 1783 a furious quarrel (see p. 38) put an end to their fertile association which had produced nineteen mezzotints in six years. In 1789 he began an extremely ambitious series of prints after pictures in the Düsseldorf Gallery; the wars cut off the continental market, and he went bankrupt in 1799. His final years were spent as Keeper of the British Institution, to which he was appointed in 1805.

134 Lady Jane Halliday
1779
Mezzotint 627 × 383 mm
Provenance Unknown. 1833–7–15–31
Literature CS 61; W 79, first state, with scratched lettering

The daughter of the Earl of Dysart; married John Halliday in 1771. The painting was exhibited at the Royal Academy in 1779, and is now at Waddesdon.

The print was published as a pair with one of Lady Louisa Manners. They were the first of a projected series of six whole length portraits, of 'Beauties of the Present Age, on the plan of those in the Royal Collection at Windsor by Sir Peter Lely and at Hampton Court by Sir Godfrey Kneller'. The price to subscribers was 12s. a print, to non-subscribers 15s. Nos. 135, 136 and 139 belong to the same set.

135 Mary Isabella, Duchess of Rutland
1780
Mezzotint 630 × 386 mm
Provenance Bequeathed by Lord Cheylesmore. 1902–10–11–2360
Literature CS 115; W 103, first state, with scratched lettering

The painting was exhibited at the Royal Academy in 1781, but was later burnt in a fire in 1816. This mezzotint is the only record of the composition. The Duchess later reported that Reynolds had made her try on eleven different dresses before choosing 'that bedgown' (Leslie and Taylor I, p. 248). This print was published as one of the set of *Beauties of the Present Age*.

136 Georgiana, Duchess of Devonshire
1780
Mezzotint 629 × 385 mm
Provenance Unknown. 1978 U 1899
Literature CS 37; W 102, second state, with scratched lettering

The daughter of Earl Spencer, married to the Duke of Devonshire in 1774. The portrait was in the Royal Academy exhibition in 1776; it was purchased by her mother, but was later sold from Althorp to Henry Huntington and is now in California.

The impression here exhibited is so early that the blacks are printing too richly and are distorting the balance of the composition.

* 137 Sir Joshua Reynolds
1780
Mezzotint 481 × 380 mm
Provenance Bequeathed by Lord Cheylesmore. 1902–10–11–2356
Literature CS 110; W 105, second state, with lettering

The self-portrait was painted for presentation to the Royal Academy, where it still hangs. It shows the artist in the robes of his honorary Oxford D.C.L. with a bust of Michelangelo. Reynolds' admiration of Michelangelo is most movingly expressed in the last *Discourse*.

138 The three Ladies Waldegrave
1781
Mezzotint 448 × 583 mm (cut)
Provenance Bequeathed by Lord Cheylesmore.
1902–10–11–2385
Literature CS 133; W 111, state uncertain

The three girls were famous beauties; their father was Earl Waldegrave, while their mother, Maria Walpole, was the illegitimate daughter of Sir Edward Walpole, Horace Walpole's brother. This portrait of his three great-nieces was commissioned by Horace Walpole, and hung in the refectory at Strawberry Hill.

This impression is not particularly good; the shadows have flattened and the contrasts no longer stand out.

139 Mary Amelia, Countess of Salisbury
1781
Mezzotint 638 × 386 mm
Provenance Bequeathed by Lord Cheylesmore.
1902–10–11–2363
Literature CS 116, W 110, first state, with scratched lettering

Daughter of Viscount Hillsborough, married the Earl (later Marquess) of Salisbury in 1733. This portrait was shown at the Royal Academy in 1781, and is still at Hatfield.

John Raphael Smith
1752–1812

Son of the painter John Smith of Derby. Apprenticed to a linen-draper, but soon took up mezzotinting. His career follows the fortunes of the English print. His earliest mezzotints in 1769 were of low quality and aimed at the popular market. But his abilities recommended him to Reynolds, and he scraped forty-one plates after him in the decade 1774–84. From 1780 begins his association with George Morland; he commissioned paintings from Morland, engraved them and made very large profits. As a result he turned print dealer, and employed a large staff of assistants, among whom were the brothers William and James Ward. These engravers were paid a salary by Smith and their plates were published under Smith's name; this explains Smith's apparently colossal productivity. His trade was largely in fancy 'furniture' prints for the French market, and he was in consequence ruined by the Revolution. In 1802, in a fanfare of publicity, he announced his retirement from print-dealing and his future exclusive concentration on portrait-painting. These coloured pastels maintained him to his death. Smith has traditionally, and probably rightly, been regarded as the outstanding mezzotinter of his time.

140 Master Crewe as Henry VIII
1775
Mezzotint 500 × 352 mm
Provenance Unknown. Aa 10–7
Literature CS 47; F 100, second state, with scratched lettering

The portrait is of the eldest son of John Crewe, who was created Baron Crewe in 1806. He was one of Reynolds' most loyal patrons; a portrait of his wife as St Geneviève is shown as No. 122. The portrait is an amusing riposte by Reynolds at the critics who charged him with plagiarism; the pose is borrowed to the last detail from the famous portrait of Henry VIII by Holbein, of which the cartoon is now in the National Portrait Gallery.

141 Mrs Elizabeth Montagu
1776
Mezzotint 505 × 353 mm
Provenance Bequeathed by Felix Slade.
1868–8–22–2118
Literature CS 112; F 246, first state, with scratched lettering

Mrs Montagu was the leading spirit in a group that met for the purpose of 'intellectual conversation' at her house (Montagu House in Portman Square), and which was derisively known as the 'Blue-Stocking Coterie'. She is shown at the age of fifty-six, in the year of her husband's death.

142 Lady Caroline Montagu
1777
Mezzotint 509 × 355 mm
Provenance Bequeathed by Lord Cheylesmore.
1902–10–11–5009
Literature CS 110; F 244, second state, with scratched lettering

The third daughter of the Duke of Buccleuch; the portrait was in the Royal Academy in 1777. It is a very clear example of how good Reynolds was at painting children, and how bad at painting animals.

143 Jonathan Shipley, Bishop of St Asaph

1777
Mezzotint 350 × 250 mm
Provenance Purchased at the Buccleuch sale, Christie's, 8 March 1887, lot 1029, for four guineas. 1887–4–6–37
Literature CS 149; F 316, first state, before lettering

The brother of William Shipley, founder of the Society of Artists. He and his daughter, Georgiana, herself an amateur artist, were both friends of Reynolds. This mezzotint has been selected for its particularly brilliant and life-like character.

*144 Mrs Carnac

1778
Mezzotint 632 × 386 mm (trimmed)
Provenance Sir T. Lawrence (L 2446); purchased from Mr Smith. 1830–6–12–2
Literature CS 31; F 61, first state, before lettering

The wife of General John Carnac; curiously, despite its modern fame, the portrait was never paid for by the family and remained on Reynolds' hands. It turned up in his sale in 1796 and is now in the Wallace Collection.

145 Mrs Musters

1779
Mezzotint 613 × 379 mm (trimmed)
Provenance Bequeathed by Lord Cheylesmore. 1902–10–11–5024
Literature CS 120; F 255, second state, with lettering

The wife of Mr John Musters of Colwick Hall, near Nottingham. The portrait is now at Petworth.

146 Lieutenant-Colonel Tarleton

1782
Mezzotint 640 × 393 mm
Provenance Purchased from Mr Smith. Aa 6–50
Literature CS 161; F 345, second state, with scratched lettering

Tarleton was a captain of cavalry and gained wide fame and the soubriquet 'Bloody Tarleton' for his exploits in the American War of Independence. He returned to England at the beginning of 1782, and was already sitting to Reynolds on 28 January. The painting was shown at the Royal Academy in 1782, and is now in the National

Gallery. Tarleton wears the uniform of his own troop, Tarleton's Green Horse, and lacks the two fingers he lost in 1781.

In 1827 William Carey wrote of J. R. Smith: 'There was a loose bewitching freedom in his best prints which fully expressed all the spirit of the President's pencil. I well remember hearing the latter say, with evident pleasure, looking at a proof of his admirable print of Colonel Tarleton, "It has everything but the colouring of my picture"' (*Ackermann's Repository,* IX, p. 43).

147 Lady Hamilton as a Bacchante

1784
Mezzotint 380 × 277 mm
Provenance Purchased from Messrs Smith. 1840–8–8–116
Literature CS 75; F 167, second state, with open letters

The famous beauty, wife of Sir William Hamilton and mistress of Nelson. Reynolds only made this one portrait of her, unlike Romney who painted her continuously. The print shows two new features: the borderline in aquatint, and the 'open-letter' proof, a new marketing practice which found a great following in the nineteenth century.

As mentioned in the biography of Smith, many of his prints were made by other engravers. This was one such case. 'I saw William Ward at work on that plate from day to day until he had brought it to a proof ready for publication. Nothing could be more charming in its class than that print. Smith, who was always disposed to do justice to merit, expressed his high admiration of it; but he took the tool in hand, worked on the plate for little more than a couple of hours, sent it to the writing-engraver to have his name engraved under it, and published it as his own. This was not deemed by Ward any unfairness; nor is it here noticed as such. It was an act in strict conformity with their special contract.' (W. Carey: *Ackermann's Repository,* IX, 1827, p. 43).

148 Philippe, Duc d'Orléans

1786
Mezzotint 650 × 452 mm
Provenance Bequeathed by Lord Cheylesmore. 1902–10–11–5029
Literature CS 125; F 261, first state, with scratched lettering

The portrait was painted while the Duke was on a visit to England in 1785. It was given by the Duke to the Prince of Wales, and was shown at the

Academy in 1786; later it was burnt in the fire at Carlton House. The print is lettered in French and English, as it would obviously have a large French sale.

The Duke, whose grandfather had been Regent of France during the minority of Louis XV, turned revolutionary in 1789 and adopted the name Philippe Egalité. He voted for the execution of Louis XVI, his cousin, in 1793, but this did not prevent him from being guillotined in turn later that year. His son, Louis-Philippe, ascended the throne as King of the French in 1830.

John Jones
active 1775–97

His earliest prints were published in 1775; his prints after Reynolds began in 1783 and continued after Reynolds' death. There are twenty-three mezzotints, mostly of male sitters, and at least ten stipples, chiefly of fancy subjects. The Department possesses a remarkable series of seven progress proofs of Jones' mezzotint of Miss Kemble, which gives a unique insight into working practices in this period.

149 Sir Abraham Hume

1783
Mezzotint 378 × 278 mm
Provenance Purchased from Molteno and Graves.
1833–6–10–44
Literature CS 40, first state, with scratched lettering

The sitter was a great collector of precious stones and old masters. He was a very close friend of Reynolds, who bequeathed him his choice among his Claudes. The portrait was shown at the Royal Academy in 1783.

150 Lady Caroline Price

1788
Mezzotint 380 × 276 mm
Provenance T. Kirk (L 1623); bequeathed by Lord Cheylesmore. 1902–10–11–2913
Literature CS 64, third, published, state

The wife of Sir Uvedale Price, the author of *An Essay on the Picturesque*.

151 Petersham Meadows from Richmond Hill

1800
Mezzotint 470 × 575 mm
Provenance Purchased from Mr Tiffin.
1848–7–8–215
Literature Not in CS; Hamilton p. 155, first state, before lettering

This print was published long after Reynolds' death, and was described as 'the only landscape painted by that eminent artist'. The painting is dated 1788, and is now in the Tate Gallery. The view is taken from Wick House on Richmond Hill, built for Reynolds by Sir William Chambers in 1771–2. This view was a favourite subject among English painters. Reynolds has, however, transformed it almost unrecognisably into an idealised Claudian landscape.

Charles Hodges
1764–1837

Hodges produced twelve mezzotints after Reynolds between 1784 and 1791. Despite his excellence, his career in England was unsettled and his plates were published by a succession of dealers. He was obviously hit by the recession, for in 1794 he is found in Amsterdam where he worked for the rest of his life. He was there very successful and is sometimes counted by Dutch writers as a member of the Dutch school. He spent as much of his time in Holland in making pastel portraits as in mezzotinting (cf. J. R. Smith). One may deduce that the mezzotinter's training in making reductions of portraits as a preliminary to engraving stood him in good stead for such a practice.

* 152 Lavinia, Countess Spencer

1782
Mezzotint 376 × 276 mm
Provenance Purchased from Messrs Smith.
1840–8–8–104
Literature CS 28, first state, before lettering

The portrait still hangs at Althorp. The manuscript inscription on this impression is particularly interesting; it is clearly dated 2 August 1782, which is nearly two years earlier than the first lettered date of 15 July 1784. Since the portrait was in the Academy exhibition of 1782, there is no reason to disbelieve the date. This print gives an outstanding rendering of fur.

153 Lady Dashwood and child

1784
Mezzotint 355 × 252 mm
Provenance Purchased at the Buccleuch sale,
Christie's, 8 March 1887, lot 708, for 6¹/₂ guineas.
1887–4–6–17
Literature CS 11, first state, with scratched
lettering

This print is exhibited, not for its beauty, but for
its curious method of grounding, which makes it
look very much like a stipple (see p. 34).

154 Henry Hope of Amsterdam

1788
Mezzotint 406 × 288 mm
Provenance Purchased from Messrs Smith.
Aa 8–52
Literature CS 17, first state with open letters

The Hopes, descended from a Scotch family which
settled in Holland in the seventeenth century, were
bankers in Amsterdam. By the middle of the
eighteenth century, they had become the greatest
financiers in Europe. Henry Hope (1736–1811)
was the head of the family. In the notes that he
made of a journey to Holland in 1781 Reynolds
records frequent visits to his collection 'ack-
nowledged to be the first in Amsterdam'.

Thomas Hope of Deepdene (1769–1831), the
collector, patron and propagandist of Neo-
classicism, was Henry's second cousin.

155 Mrs Williams Hope

1788
Mezzotint 406 × 290 mm
Provenance Bequeathed by Lord Cheylesmore.
1902–10–11–2504
Literature CS 18, first state, with open letters

The niece and heir of Henry Hope (see 154). Her
husband, John Williams, who had been a clerk in
the banking house, added the name of Hope to his
own. When the French invaded Holland in 1794
the Hopes moved to England. Joseph Farington
in his Journal for 1797 describes her as 'a very
proud woman, much disgusted at not being more
noticed and distinguished in England than she is.
In Holland she was looked up to as a vice queen
would be'.

Her portrait and that of her uncle were painted,
as they were engraved, as a pair; they are now
lost.

Francesco Bartolozzi
1728–1815

Born in Florence and studied at the Florentine
Academy. In 1748 moved to Venice where he
worked for the publisher Wagner. In 1764
attracted to London by a two year contract to
engrave the drawings by Guercino in the Royal
Collection; on the expiry of this in 1766 he made
a new contract with Boydell. He adopted stippling
as soon as it was introduced, and became its
greatest master. His success was enormous. He
made several thousand plates, with the help of a
large workshop, often after the designs of his
fellow Italian Cipriani. In 1769 he was a founda-
tion member of the Royal Academy. The reces-
sion of the 1790s affected him too; in 1802 he
moved to Lisbon as Professor of Engraving, and
died there thirteen years later.

156 Lord Mansfield

1786
Stipple 483 × 370 mm (trimmed)
Provenance Purchased from Molteno and Graves.
1833–6–10–53
Literature V and C 871, second state, with
scratched lettering and Bartolozzi's address

The portrait is still in the family's possession. It is
mentioned in a letter from Reynolds to the Duke
of Rutland (*Letters,* p. 148): 'I have made him
exactly what he is now, as if I was upon my oath
to give the truth, the whole truth, and nothing but
the truth . . . However, being told by everybody
what a good picture, and how like it is, he is per-
fectly pleased with it, and has ordered a print by
Bartolozzi to be made after it'. Lord Mansfield
was Lord Chief Justice; legally-trained minds
seem to have liked stipples, for Bartolozzi also
engraved Lord Thurlow and Lord Ashburton.
This print was published by Bartolozzi on 24
August; on 19 October it was re-issued in the
lettered state by Macklin. A cutting in the Whitley
papers states that Macklin paid Bartolozzi £500
for the plate.

157 Lady Smith and her children

1789
Stipple 378 × 295 mm
Provenance Unknown. 1830–11–23–18
Literature V and C 1221, third state, before title

The painting, now in the Metropolitan Museum in
New York, was exhibited at the Academy in 1787.
Sir Robert Smith was Member of Parliament for
Colchester. This stipple was published in 1789 as

a pair with that of the *Countess of Harrington and her sons* (Waterhouse 1941, plate 273), a painting of the same date and dimensions.

Richard Earlom
1743–1822

Born in London, and studied drawing under Cipriani. Worked much of his time for Boydell. Earlom was one of the most distinguished mezzotinters of the period, but was unusual in making few plates after contemporary portraitists; most are after subject pictures or Old Masters. Very few of his prints are in stipple, and only three are after Reynolds.

158 Lord Heathfield
1788
Stipple 507 × 382 mm
Provenance Purchased from Mr Evans.
1831–5–31–5
Literature Hamilton p. 36, fourth state, before title

General Eliott was governor of Gibraltar, and had led the heroic and successful defence during a siege by the Spaniards from 1779 to 1783. The painting, which shows Heathfield holding the key of Gibraltar with the defending guns behind him, is now in the National Gallery. It was commissioned by Boydell, and he had it stippled by Earlom. This raised protests in the press: 'Sir Joshua's portrait of Lord Heathfield is now before Earlom, the engraver, of whose ability in mezzotinto this country has not an equal; it is to be stippled on the plan of the new print of the tragic muse' (Victoria and Albert Museum Library, album of press-cuttings). This is an outstanding example of the encroachment of stipples into the territory of the mezzotint. In this case the probable explanation is the popularity of the subject, and the likely demand which could not have been satisfied by a quickly worn mezzotint. Another press comment of November 1788 retailed the information that 'Sir Joshua Reynolds is not entirely pleased with Earlom's plate of Lord Heathfield'.

Francis Haward
1759–97

A student at the Royal Academy schools in 1776, and elected Associate Engraver in 1783. His earliest prints were in mezzotint, but he later changed over, with considerable success, to stipple.

159 The Infant Academy
1783
Stipple 304 × 357 mm
Provenance Bequeathed by Felix Slade.
1868–8–22–2140
Literature Hamilton p. 150, first state, with scratched lettering

Haward's first stipple; one curious feature, if Hamilton is correct, is that this print was never issued in a lettered state. The painting was exhibited at the Royal Academy in 1782. It is now at Kenwood, but is rarely shown because it is almost completely ruined by bitumen–a case where the 'remembrance of the work' does indeed depend on the art of engraving. The print has been chosen to represent a significant class of Reynolds' production, his fancy pictures. Such subjects were usually, after 1780, engraved in stipple.

160 Mrs Siddons as the Tragic Muse
1787
Stipple 633 × 457 mm
Provenance Bequeathed by Felix Slade.
1868–8–22–2128
Literature Hamilton p. 131, second state, before the addition of the Royal arms

Mrs Siddons was the greatest tragic actress of her day, and this is one of Reynolds' finest pictures. It was exhibited at the Royal Academy in 1784, and is now in the Huntington Library in California; a replica is at Dulwich. The row between Valentine Green and Reynolds over the engraving is described in the introduction (see p. 38). One point which emerges from the correspondence is that Sheridan had an interest in the picture; he was Mrs Siddons' manager at Drury Lane and perhaps arranged for the portrait for the same reason as Garrick did his own (see 114), as a discreet form of advertisement. The print was dedicated by Haward to George III, and presented to him in January 1788; such a dedication is an exceptional case of Royal patronage.

John Hall

1739–97

A line engraver, trained by Ravenet in London; in 1785 Woollett's successor as historical engraver to George III. Most of his engravings were of history paintings, especially those of Benjamin West, but some were of portraits.

161 Richard Brinsley Sheridan

1791
Line engraving 522 × 384 mm
Provenance Bequeathed by Felix Slade.
1868–8–22–1476
Literature Hamilton p. 64, third state, open letter proof

In the third state the plate was published by Hall himself; in the fourth and final state the plate was taken over by a consortium of Dickinson, Macklin and Evans, but still carries the same date. Raimbach's story must therefore be emended: 'The portrait of Sheridan, from Sir Joshua Reynolds, was Hall's first work, after I had been fixed with him. He published it himself, but it had little success. On its termination, Macklin, in my hearing, offered 450 guineas for the plate, but Hall stood out for 500 (observing that Macklin had given the larger sum for the portrait of Lord Mansfield, in the chalk manner, by Bartolozzi) and the negotiation went off, very unfortunately for Hall, as I do not believe it ever produced him half the money'. (*Memoirs and Recollections of the late Abraham Raimbach,* 1843, p. 19) Raimbach has further information about this print: 'Sheridan came twice or thrice . . . during the engraving of the portrait . . . I was however most struck with what seemed in such a man an undue and unbecoming anxiety about his good looks in the portrait to be executed. The efflorescence in his face had been indicated by Sir Joshua in his picture, not, it may be presumed, *à bon gré,* on · the part of Sheridan, and it was strongly evident that he deprecated its transfer to print. I need scarcely observe that Hall set his mind at ease on this point . . .' (op. cit. p. 9).

William Sharp

1749–1824

Began as a writing engraver, but in the 1780s earned a very high reputation, especially abroad, as an outstanding line-engraver. Sharp is also remembered as a religious enthusiast, and one of the loyalest followers of Joanna Southcott, whom he supported for a considerable time.

162 The Holy Family

1791
Line engraving 627 × 487 mm
Provenance Bequeathed by Felix Slade.
1868–8–22–1820
Literature Hamilton p. 150, finished state, with scratched lettering

Unlike Hall's print of Sheridan, which is a pure line-engraving, this is engraved over an etched foundation; the Department possesses an example of the etched state. This technique was developed in France in the late seventeenth century, but was established firmly in England by Woollett.

The painting of the *Holy Family,* which is now in the Tate Gallery, was commissioned from Reynolds by Macklin, the publisher. It was painted in 1788, but never exhibited at the Royal Academy. The print was published at the end of 1791, and so took over three years to engrave. (This explains why line engraving was such an expensive and risky procedure.) A newspaper cutting among the Whitley papers gives the information that Macklin paid Reynolds £500 and Sharp £700. Another press-cutting in the Victoria and Albert Museum albums is also interesting; after puffing the *Holy Family,* it continues: 'On inspection of the subscribers' list it will appear rather singular that foreigners, either in their own names, or that of their connections, are more numerous than can well be supposed–an ample testimony to the merit of the English School of Engraving'.

Prints after Gainsborough

Francesco Bartolozzi
(see 156)

163 Thomas Gainsborough (after a self-portrait)

1798
Stipple 253 × 202 mm
Provenance Transferred from the Department of Manuscripts. 1853-1-12-1936
Literature V and C 816

It appears that no portrait print was published of Gainsborough in his own lifetime. By contrast, at least half a dozen were published of Reynolds.

Thomas Major
1720-99

Worked in Paris under Le Bas from about 1745 to 1753. Most of Major's work is after the Old Masters or landscape paintings.

164 Landguard Fort, Suffolk

1754
Etching with engraving 402 × 618 mm
Provenance Transferred from the Department of Manuscripts. 1853-1-12-2335
Literature P. Thicknesse: *A Sketch of the life and paintings of Thomas Gainsborough, Esq.*, London, 1788, pp. 12-15

The painting was commissioned by Captain Philip Thicknesse, the Lieutenant-Governor of Landguard Fort and Gainsborough's first significant patron. Thicknesse's memoirs of Gainsborough tell us how the painting came to be engraved: 'The following winter I went to London, and I suspected . . . that my landscape had uncommon merit, I therefore took it with me, and as Mr Major the engraver, was then just returned from Paris, and esteemed the finest artist in London in his way, I showed it to him; he admired it so much, that I urged him for both their sakes as well as mine, to engrave a plate from it, which he seemed very willing to undertake, but doubted whether it would by its sale (as it was only a perspective view of the Fort) answer the expence; to obviate which, I offered to take ten guineas worth of impressions myself; he then instantly agreed to do it. The impression will show the merit of both artists, but alas! the picture, being left against a wall which had been made with salt water mortar, is perished and gone'. In Major's price list of 1754 the print is priced at 3s.

Francis Vivares
1716-80

Born in France; came to England in 1734. One of the founders of the English school of landscape engraving.

165 The Rural Lovers

1760
Etching with engraving 405 × 504 mm
Provenance Purchased from Mrs Judkin. 1872-1-13-852

According to Vivares' undated broadsheet catalogue of plates, an impression of which is in the Department, this print was published as a pair with *The Hop Pickers,* after a painting by George Smith, at a price of 7s. The catalogue is almost entirely of landscapes of many schools and periods, and is a remarkable document illustrating the surprising catholicity of English taste in landscape in this period.

The print is in reverse to the original (Waterhouse 1958, plate 40).

William Austin
1721-1820

Pupil of Bickham. Began as an engraver, but from the 1760s devoted most of his energies to his other activities as drawing master and print publisher.

166 Landscape

1764
Etching with engraving 390 × 542 mm (trimmed)
Provenance Purchased from Mr Daniell. 1867-3-9-964

The original painting is described by Waterhouse (No. 839) as 'very early work'.

William Woollett
1735–85

The greatest figure in the revival of English line-engraving after the mid-century. His earliest plates were mostly after landscape paintings, but he later turned to historical compositions.

167 Old peasant with a donkey

*c.*1754
Etching with engraving 273 × 232 mm
Provenance Purchased at the Palmer sale, Sotheby's, 18 May 1868, lot 108.
1868–8–8–3060
Literature L. Fagan: *Catalogue raisonné of the engraved works of William Woollett,* London, 1885, No. 10, second state

The print is made by Woollett's usual method of engraving over an etched foundation. The plate was republished in 1824 but the word 'proof' was still left on–in other words every published state carries the inscription 'proof'.

The plate is not dated; Fagan places it around 1754, which fits Waterhouse's dating of the picture (No. 816 a) in the early 1750s.

Valentine Green
(see 134)

168 David Garrick

1769
Mezzotint 615 × 385 mm
Provenance Purchased at the Brentano sale, Frankfurt, 16 May 1870, lot 780.
1870–6–25–629
Literature CS 46; W7, first state, with scratched lettering

The original painting was purchased by the Corporation of Stratford-on-Avon in 1769 after the Shakespeare Jubilee which Garrick had organised. It was destroyed by fire in 1946.

The provenance of this impression is of interest. It comes from the collection formed by Melchior von Birckenstock (1738–1809) between 1765 and his death. Birckenstock was an Austrian diplomat, who lived in Vienna, and collected a huge number of prints from all over Europe. The English prints in the 1870 sale make 236 lots; many are mezzotints, but most of these are of subject pictures rather than portraits.

John Dean
*c.*1750–after 1805

Pupil of Valentine Green; his prints all belong to the years 1776 to 1789, when a fire destroyed his stock and plates.

169 Mrs Elliot

1779
Mezzotint 618 × 382 mm
Provenance Horace Walpole; bequeathed by Lord Cheylesmore. 1902–10–11–638
Literature CS 9, second, published, state

The portrait was exhibited at the Royal Academy of 1778 and is now in the Metropolitan Museum in New York. The plate is a brilliant, but hardly successful, attempt to translate Gainsborough's manner into mezzotint.

The inscription on this impression is in the hand of Horace Walpole. Walpole's enormous collection of engraved British portraits, which served as a basis for his pioneering *Catalogue of Engravers,* was auctioned with the contents of Strawberry Hill in 1842. This mezzotint can be identified with one of the nineteen prints in lot 697, which made £1.

John Raphael Smith
(see 140)

170 George, Prince of Wales

1783
Mezzotint 650 × 452 mm
Provenance Purchased from Messrs Graves.
1859–8–6–417
Literature Russell 167, second state

The portrait was shown at the Royal Academy in 1782, and was later given by the Prince of Wales to Colonel St Leger. It is now at Waddesdon.

The plate is notorious among students of English mezzotints for the complication of its successive states. It was of such popularity that it was almost entirely re-engraved on four occasions (according to Russell's elucidation). On each re-engraving new proofs were issued, to make a total of ten states. What makes the sequence particularly amusing is that the figure of the Prince was brought up to date on each occasion; so we can trace his degeneration from the handsome 21-year-old youth in this version, to the bloated, side-whiskered 50-year-old in the final version of 1813.

171 Giovanna Baccelli

1784
Mezzotint 534 × 353 mm
Provenance Bequeathed by Lord Cheylesmore.
1902–10–11–2849
Literature CS 3, second, published, state

An Italian dancer and mistress of the Duke of Dorset. The original painting was recently acquired by the Tate Gallery. Very complete information is given in the booklet written by Elizabeth Einberg, published in 1976.

Gainsborough Dupont

1755–97

Gainsborough's nephew and pupil. After Gainsborough's death he set up on his own as a portrait painter and received Royal patronage, but died young. Thirteen mezzotints by him are known, all after Gainsborough's paintings. But it is interesting that only seven prints have publication lines, and only four of these were published before Gainsborough's death.

172 Lord Rodney

1788
Mezzotint 612 × 390 mm
Provenance Bequeathed by Lord Cheylesmore.
1902–10–11–866
Literature CS 9, second, published, state

Waterhouse dates the painting 1783–6. At this time Rodney had retired from the navy with a peerage and colossal wealth.

173 Queen Charlotte

1790
Mezzotint 632 × 382 mm
Provenance Bequeathed by Lord Cheylesmore.
1902–10–11–861
Literature CS 2, first state, before any inscription

The portrait, which was exhibited at the Royal Academy in 1781, is still in the Royal collection. It was painted as a pair with one of George III; both were engraved by Dupont two years after Gainsborough's death, and ten years after they were painted.

111
Reynolds as a collector

The collector's mark of Sir Joshua Reynolds, reproduced on this page (see left), is one of the best known stamps of its kind. Its frequent appearance on Old Master drawings and prints of varying quality has even aroused the suspicion that unscrupulous dealers have added it to drawings of unknown provenance to facilitate their sale. Apart from implying that Reynolds' taste should be universally admired, this rumour reflects the best known fact about his collection: it was vast, so large that its size surprised those responsible for dispersing the collection after his death.[1] Our most detailed record of its contents are catalogues compiled after Reynolds' death, and with these our investigation must begin.

On 26 May 1794, just over two years after Reynolds died, his Old Master drawings appeared on the open market for the first time.[2] This sale, organised by the dealer A. C. de Poggi at his New Bond Street premises, took the form of an exhibition which was to continue until all the drawings had sold. The sale did not include either paintings or prints, which were to be sold later. Prices were fixed, and admission cost one shilling. The catalogue was prefaced by a formal declaration, signed by Reynolds' three executors, Edmund Burke, Edmond Malone and Philip Metcalfe, 'that the WHOLE of the Collection was his entire Property'. A total of 2,253 drawings were for sale. Each one had been stamped by the executors with the collector's mark according to their presumed value: those priced at 2s. 6d. or more on the *recto,* the remaining 748 on the *verso,* 'as being of inferior merit; such, as all Collectors know, must be purchased at sales, in order to possess a good Drawing, which is lotted with Fifteen or Twenty of this description'. Poggi's catalogue is the most useful source of information about Reynolds' collection of drawings, although deficient in one important respect: it contains rather less than half the drawings he owned at the time of his death. Four years later, on 5 March 1798 and the seventeen following days, Philips auctioned over four thousand drawings from his collection, apart from any that Poggi had managed to sell.[3] The catalogue contained 2,001 lots, of which

836 were of drawings, the rest were of prints and books of prints, together with a few empty portfolios and cabinets. The drawing lots averaged about five sheets each, most of which were undescribed. To discover the character of the collection we must return to the 1794 catalogue, which includes an index showing how many drawings attributed to each artist were for sale, and an introduction by Poggi:

THE COLLECTION chiefly consists of the Works of the ITALIAN SCHOOL; and excepting Nicolo Poussin, Rubens, Van Dyck and Rembrandt, there are few of the French, Flemish or Dutch Masters to be found in it;[4] from whence it may be inferred, that the main object of SIR J. REYNOLDS, was to possess himself of the Works of *Michel-Angelo, Raffaelle, Coreggio, Titiano,* Lionardo da Vinci, Giulio Romano, Frate Bartolomeo, Andrea del Sarto, Daniel da Volterra, Parmigiano, Primaticcio, Polidoro da Carravaggio, Pellegrino Tibaldi, Perino del Vaga, Battista Franco, Baccio Bandinelli, Francesco and Giuseppe Salviati, Federico and Taddeo Zucchero, Paolo Veronese and Tintoretto, Orazio Samacchini, the *three Carracci,* and their Scholars, with many other great Masters, too numerous to mention here.

 Among them will be found Drawings by the above Masters, of the greatest beauty, both for genius and execution; others, which are sketches (or as the Italians call them, PRIMI PENSIERI,) may not have the same fascination for the general observer; but the well-informed connoisseur will easily discern, that if they possess not the same magical attraction to the eye, the mind is as much entertained, and oftentimes more powerfully instructed, by these performances, than by more laboured efforts.

Poggi's emphasis on the value of slighter sketches reflects Reynolds' own view, more elaborately expressed in Discourse XI:

Those who are not conversant in works of art, are often surprised at the high value set by connoisseurs on drawings which appear careless, and in every respect unfinished; but they are truly valuable; and their value arises from this, that they give the idea of an whole; and this whole is often expressed by a dexterous facility which indicates the true power of a Painter, even though roughly exerted: whether it consists in the general composition, or the general form of each figure, or the turn of the attitude which bestows grace and elegance . . . On whatever account we value these drawings, it is certainly not for high finishing, or a minute attention to particulars.[5]

Sketches of this kind, which reflect the artist's initial inspiration, seem indeed to have formed a major part of Reynolds' collection, and it appears that he even preferred them to all but the finest paintings. As he says in Discourse VIII:

From a slight undetermined drawing, where the ideas of the composition and character are, as I may say, only just touched upon, the imagination

supplies more than the painter himself, probably, could produce; and we accordingly often find that the finished work disappoints the expectation that was raised from the sketch; and this power of the imagination is one of the causes of the great pleasure we have in viewing a collection of drawings by great painters.[6]

Reynolds himself drew little, preferring to sketch his ideas straight onto the canvas like the Venetians. Yet both these quotations remind us of his fascination with the perennial question of 'invention', an interest above all complemented by the study of drawings. Northcote remembered Reynolds saying that 'the very foundation of the art of painting is invention; and he who excels in that high quality must be allowed to be the greatest painter'.[7]

The greater part of the drawings from Reynolds' collection in the Department fall into the category of *primi pensieri*; but many of these are too slight to include in an exhibition. Though the drawings that are exhibited may not represent this characteristic of the collection, they do illustrate one important fact about it: nearly all of them are figure studies. Landscape is rarely met with. Reynolds' biographers all say that he preferred the town to the country, and this preference is reflected in his taste and in his art. The landscape backgrounds in his portraits are adequate for their purpose, but they appear perfunctory beside those of his great rival, Gainsborough. As is clear from the Discourses, he followed the Academic tradition in believing landscape to be a secondary art form: 'perfection in an inferior style may be reasonably preferred to mediocrity in the highest walks of art. A landskip of Claude Lorrain may be preferred to a history by Luca Giordano'.[8] His taste as a collector reflects this attitude towards landscape, though there were a few exceptions. But when he urged his students to study nature, he was clearly referring above all to the human figure.

Van Dyck and Claude were exceptions to this general rule. He owned several landscape studies by the former, but these may have been bought in lots together with the portrait studies which he prized more highly.[9] Claude, as Northcote says, 'appears to have been a particular favourite in the estimation of Sir Joshua; as I have heard him say, that, in his opinion, the superiority of Claude in Landscape was so pre-eminently excellent, that we might sooner expect to see another Raffaelle than another Claude Lorrain'.[10] The exact number of Claudes Reynolds owned is unknown. They were not included in the sale catalogues, for he left 'the choice of his Claude Lorraines' to Sir Abraham Hume in his will.[11]

Only one Claude drawing is listed in the index of Poggi's catalogue, which includes altogether 234 artists, the majority, as one would expect, Italian of the sixteenth and seventeenth centuries. The Carracci were represented altogether by 61, 15 by

Agostino, 28 by Annibale, and 18 by Lodovico. Then there were Parmigianino (62), Correggio (54), Michelangelo (44), Giulio Romano (43), Tintoretto (32), Domenichino (31), Guercino (28), Raphael (24), Veronese (23), Polidoro (22), Maratta (17), Perino del Vaga (17), Pietro da Cortona (17), Donato Creti (16), Andrea del Sarto (15), Mola (15), Reni (13), Titian (13), Barocci (12), Bandinelli (12), Battista Franco (12), Leonardo (12), Lanfranco (10) and Fra Bartolommeo (9). Countless others were represented by one or two drawings. Of the non-Italians, Reynolds owned seventy by Van Dyck, followed by Rembrandt (49), Rubens (22), Poussin (13), Boucher (4) and Jordaens (4).

In some cases (e.g. Michelangelo, Correggio, Polidoro and Titian) these figures certainly included large numbers of school works and copies, many considered genuine in Reynolds' day. On the other hand his purchases would have been restricted by the availability of drawings by certain artists whom he greatly admired. It was not until after his death that the French Revolutionary wars and the Napoleonic wars threw a flood of works onto the market, from which a later President of the Royal Academy, Sir Thomas Lawrence, profited to amass an even finer collection. Reynolds' collection of paintings seems also to reflect what was available. Pictures were occasionally subjected in Italy to severe export restrictions[12] and in fact Reynolds' collection of paintings was richer in works by Northern artists, although he certainly preferred the Italian School to all others. In the three-day sale of his Old Master paintings at Christie's in 1795, about 430 paintings were sold in 411 lots. Ninety-two of the 154 artists represented were Dutch, Flemish, French, Spanish or German, responsible for just over half the total number of paintings. The balance of his collections can thus only be explained as a fair reflection of the state of the art market during the eighteenth century.[13]

He tirelessly sought out good works of any school within reach of his pocket, devoting a great deal of time and expense to collecting from quite early in his career. In so doing, he followed the example of several painters, including Sir Peter Lely and his pupil Prosper Lankrink, and Jonathan Richardson, senior, who from the mid-seventeenth century had successively assembled some of the first major collections of drawings formed in this country. Indeed Richardson described England as the world's 'Cabinet of Drawings'. Edmond Malone records Reynolds saying:

I considered myself as playing a great game, and, instead of beginning to save money, I laid it out faster than I got it, in purchasing the best examples of art that could be procured; for I even borrowed money for this purpose. The possessing [of] portraits by Titian, Van Dyck, Rembrandt and company, I considered as the best kind of wealth.[14]

This statement conveys something of Reynolds' evident enjoyment of the sale-rooms. He attended them from the moment he arrived in London, although at first he could not afford to buy much. His master, Thomas Hudson, who like his father-in-law, Jonathan Richardson, senior, was a collector of drawings on a large scale, probably introduced him to the auction rooms, where dealers and painters rubbed shoulders with noblemen and connoisseurs and other potential patrons or customers.[15]

The first auction he is recorded as attending was the Earl of Oxford's sale at Cock's of Covent Garden, which began on 8 March 1742.[16] On this occasion he bid on Hudson's behalf. The earliest auction when he is recorded as bidding for himself was at a Mr Glover's sale in 1745, when he bought a pair of Van Goyens, another pair by 'Dalens' and a *Boy's Head* by Rembrandt for a total of fifteen guineas.[17] But purchases in this decade must have been rare. Two years later, on 22 January 1747, began the greatest sale of Italian Old Master drawings to occur in Reynolds' lifetime, the dispersal of the collection formed by the painter Jonathan Richardson, senior. Northcote tells us that Reynolds and Richardson had met,[18] and the latter's *Essay on the Theory of Painting,* first published in 1715, is acknowledged by all Reynolds' earliest biographers to have been an important formative influence on him.[19] We can be confident that he would have bought at this sale if he possibly could, but his name does not appear as a purchaser in the Department's annotated copy of the catalogue. He did, however, on the seventeenth and penultimate night of the auction, buy a book of prints, a copy of Bartoli's *Admiranda Romanarum Antiquitatum.*[20] The main buyers included Hudson, John Barnard and Dr Richard Mead, at all of whose posthumous sales in later decades Reynolds was a purchaser to such an extent that of the 215 drawings in the Department that bear his stamp, no fewer than forty-eight also bear that of the elder Richardson.[21]

Reynolds' collecting began in earnest only when his finances had improved after his return from Italy in 1752, a journey he had undertaken with money borrowed from his sisters.[22] From the caricature groups he painted in Rome we know that he mixed with the most distinguished English connoisseurs, through whom he probably encountered the dealers and agents whose services he later employed.[23] No reliable evidence survives to suggest that he bought more than a few prints during his tour of Italy.[24] Information relating specifically to his purchases of drawings is scarce, because the sale catalogues rarely describe them individually. On the other hand, from his acquisition of paintings we can gain some indication of his activity as a collector.

By 1755, the year of Reynolds' first surviving sitter-book, his income had increased considerably. He was charging the same prices for portraits as his former master, Hudson, and on 14 April

noted in the book a 'Sale at Prestage's to be seen'.[25] On the accounts page for 12–18 May, he apparently calculates the profit he has made by selling some Old Master paintings for fifteen guineas. As we shall see, he seems to have supplemented his income by a moderate amount of dealing. In 1756 he bought paintings from at least five sales: that of James Gibbs, the architect, at Langford's 26–28 March; that of John De Pester, 1–2 April, at Prestage's, where Reynolds bought two Ruysdaels, a Van de Velde, a Lairesse and a Sebastiano Ricci for £113; Christopher Batt, 14–15 April, where he bought a Mola, a Rembrandt and a copy after Veronese for £22 12s. 6d.; and at Robert Bragge's and Mr Vandergucht's respective sales he acquired a Karel Du Jardin, a Carlo Maratta and an Agostino Carracci for a total of £34 7s. 6d. At Robert Bragge's sale the following year Reynolds laid out at least £83 19s. 6d., but at the George Vertue sale at Ford's from 17–19 May, he bought only one lot (No. 39 on the first day), and that not a painting, but 'An exceeding fine head of Milton, modelled from the life, in a glass case'.[26] Reynolds generally emerges as a selective buyer. At Sir Luke Schaub's sale at Langford's from 26–28 April 1758, he again bought just one lot, No. 39 on the first day, a *Landscape and Figures* by Paulus Potter, for £11 0s. 6d. To what extent Reynolds bought to sell in these years is hard to gauge. Only very few purchases he made in this period can be identified in his own posthumous sale of paintings in 1795; some of them, such as Poussin's *Landscape with Orion,* now at the Metropolitan Museum, New York, he certainly kept a long time. Reynolds bought this painting at the Duke of Rutland's sale in 1758, but in the spring of 1791 sold it to Charles Alexandre de Calonne, at whose sale in 1795 it reappeared.[27]

In 1760, Reynolds' financial situation had so improved that he was able to buy a new house in Leicester Square for £3000. In the same year he even outbid Hudson at the sale of Richard Houlditch's drawings at Langford's, from 12–14 February, on the second day securing eleven of the seventy lots offered. From now on Reynolds was constantly buying at auctions, generally in person but often through agents, particularly at day-time sales: his sitter books were full, and he was kept at his easel while daylight lasted. A list of some of the sales he definitely attended is appended to this catalogue.

Reynolds' pursuit of the best works on the market occasionally took him abroad to view the major sales on the continent. To this end he visited Paris twice, in 1768 and 1771. In 1768 no particular auction had drawn him,[28] but by his own admission he spent his time looking at 'Ta Bleas as they call them in their damn'd lingo, which by the by I cannot yet speak for my life though I have tried at it ever since I have been here'.[29] In 1771 he went to Paris specially to view the Thiers-Crozat sale, and was annoyed when

Catherine the Great 'bought the whole together for £18,000, which I think is not above half of what they would have sold for by auction'.[30] In 1781, on his journey to Flanders and Holland, he saw several private collections, noted paintings that were for sale and was always on the look-out for possible acquisitions.[31] In Amsterdam he contacted an agent, Pierre Yver, and a shipper, Henry Hope of the Amsterdam banking firm. Letters from both of them to Reynolds survive, relating to the packing and transport of paintings he had bought there.[32] Four years later, in 1785, Reynolds went to Brussels to view the paintings brought onto the market by the suppression of the monasteries under Emperor Joseph II. Reynolds, who obtained the catalogue before leaving, particularly wanted to buy a 'Rubens of a St Justus—a figure with his head and his hands after it had been cut off—as I wish to have it for the excellency of its painting; the oddness of the subject will, I hope, make it cheap'.[33] He was also acting as agent for the Duke of Rutland, to whom he complained on 22 August that the paintings were 'the saddest trash that ever were collected together',[34] but nevertheless Reynolds 'swept the country' for pictures and spent over £1000 at the sale through his agent, De Gree.[35]

Horace Walpole had an equally low opinion of these paintings, and in a letter to Lady Ossory from Strawberry Hill, dated 10 August 1785, expressed some surprise that 'Sir Joshua Reynolds is gone to see them; yet there are but three of Rubens, two of Van Dyck, one of Snyder, and half a dozen of Jordaens. The rest are of old Flemish masters . . .'.[36] He evidently did not consider that the sale warranted a journey abroad. On an earlier occasion Walpole had regretted not going; writing to Lady Ailesbury on 10 October 1761, he said: 'I wished for a thousand more drawings in that sale at Amsterdam, but concluded that they would be very dear; and not having seen them, I thought it too rash to trouble your Ladyship with a large commission'.[37] Individual drawings, it seems, were too commonplace to be worth mentioning. Even Reynolds could briefly pass over 'a large and choice collection of drawings, many of which were bought in England, as appears from the marks of Sir Peter Lely and Richardson'.[38] Sometimes news of an exceptional bargain became widely known, such as the portrait of Milton by Cooper which Reynolds bought in 1784, 'from a common furniture broker'.[39] That Reynolds at·this date had bothered to visit the broker implies an exceptional degree of enthusiasm. But not all his finds turned out to be masterpieces. In 1786 something of a stir was created by his apparent discovery of another miniature by Cooper, this time of Cromwell. *The Morning Herald* of 28 October agreed it was genuine,[40] but Walpole had this to say: 'Sir Joshua himself has bought a profile of Oliver Cromwell, which he thinks the finest miniature by Cooper he ever

saw. But all his own geese are swans, as the swans of others are geese. It is most clearly a copy, and not a very good one'.[41] On occasions Reynolds' judgement verged on the ridiculous. Of the paintings in his collection he valued three above all others: Correggio's *Mystic Marriage of St Catherine,* Michelangelo's *Leda and the Swan,* and Leonardo's *Mona Lisa.* For the first he apparently paid a considerable sum at the sale of Dr Newton, Bishop of Bristol, even though he knew there was another version at Naples.[42] The *Leda* he obtained from Earl Spencer, who parted with it after his young daughter had asked embarrassing questions about its subject-matter; the *Mona Lisa* he was given by the Duke of Leeds. All three paintings were copies,[43] but Reynolds produced elaborate arguments in their favour, mainly on the basis of provenance. In the case of the 'Mona Lisa' he even found a Frenchman to declare that the painting in the Louvre was a copy, while his own version, in which the hands 'were probably finished by Raphael', was the original.[44]

Despite judgements like these, Reynolds was a sophisticated connoisseur. Collectors as distinguished as Sir William Hamilton sought his advice, as we know from a letter of 28 March 1769, concerning 'a small Picture of Paolo Veronese' of *Mary Magdalene washing Christ's Feet,* which Reynolds thought worth 'at least a hundred pounds'.[45] On 5 July 1785, Reynolds wrote to the Duke of Rutland to recommend the purchase of Poussin's first set of the *Seven Sacraments* from the Boccapaduli Palace in Rome:[46] 'Though two thousand pounds is a great sum, a great object of art is procured by it, perhaps a greater than any we have at present in this nation'.[47] Reynolds' knowledge of works in his own collection could be impressive. In the Prince of Orange's gallery at The Hague, he came across

a study of a Susanna, for the picture by Rembrandt, which is in my possession: it is nearly the same action, except that she is here sitting. This is the third study I have seen for this figure. I have one myself, and the third was in the possession of the late Mr Blackwood. In the drawing which he made for the picture, which I have, she is likewise sitting; in the picture she is on her legs, but leaning forward. It appears very extraordinary that Rembrandt should have taken so much pains and have made at last so very ugly and ill-favoured a figure; but his attention was principally directed to the colouring and effect, in which it must be acknowledged he has attained the highest degree of excellence.[48]

His notes consistently reveal a keen aesthetic response, supported by a wide knowledge of every school of painting.

Other well-informed connoisseurs of the period accused Reynolds of borrowing motifs from Old Master engravings in his collection, and using them in his own paintings.[49] His collection of

drawings sometimes also supplied him with ideas. The British Museum's drawing by Lucas van Leyden of *A nude woman holding a mirror* (see 269) provided Reynolds with the pose of the figure of Prudence in his design for the window of New College, Oxford. Reynolds clothed the nude, at the same time turning her a little more towards the spectator, but otherwise left her almost unchanged.[50] Secondly, a drawing by Raphael from his collection, later owned by Frits Lugt and now in the Fondation Custodia in Paris, formed the basis of the portrait of Thomas Pelham, which Reynolds exhibited in 1759.[51] These examples seem to be exceptional where drawings are concerned, and Reynolds' portfolios of engravings must have been a larger and more easily referred to source of motifs.[52]

If Reynolds considered great works of art 'as models you are to imitate, and at the same time as rivals you are to combat',[53] he also viewed them as a source of income. His activities as a *marchand amateur* began early, as we have seen from the first sitter book of 1755. His most open admission of buying to sell occurs in a letter to the Duke of Rutland of 7 September 1786:

I have likewise made a great purchase of Mr Jenkins [a notoriously dishonest agent in Rome][54]–a statue of Neptune and a Triton grouped together, which was a fountain in the Villa Negroni [formerly Montalto]. It is near eight feet high, and reckond Bernini's greatest work. It will cost me about 700 guineas before I get possession of it. I buy it upon speculation, and hope to be able to sell it for a thousand.[55]

In this particular case Reynolds never received an offer he considered satisfactory. According to *The World* of 9 June 1787, Reynolds had been 'offered £700 for his Bernini Neptune, and he has refused it. Mr Townley and Lord Pembroke both are talked of for it'.[56] In 1791 Reynolds was asking 1500 guineas but failed to sell it, and it was bought two years after his death by Lord Pelham, later Lord Yarborough, for £500.[57] Other ventures were evidently more successful. Most of the documentary material concerning his sales of Old Masters dates from after about 1770, when his collection had been expanded by his purchases in London and Paris.

In the Fitzwilliam account book for the period December 1769 to June 1770, Reynolds noted with satisfaction: 'Sent a bill to Lord Carlisle for pictures sold £493 10s. and paid the same day. Sold a picture of Rubens to ditto, 300 guineas, likewise paid'. Reynolds often sold to his sitters and combined both transactions: 'I have a small bill on you for your own Picture and the Pieta of Palma Giovane the first was twelve Guineas the other twenty'.[58] Sometimes he sold through the auction rooms, as we know from a

letter dated 17 March 1775, written by Reynolds' nephew to his sister: 'I am just come from Leicester Square [i.e. Reynolds' house] where I have dined to-day and shall dine tomorrow in order to go with my Aunt to look at a Sale of Pictures in which she has three and my Uncle many, but not in his own name'.[59] We can only speculate on Reynolds' reasons for wishing to preserve his anonymity in dealings of this kind. Perhaps he felt such trans-actions to be beneath the dignity of the President of the Royal Academy. On the other hand, his friendship with the dealer, Poggi, whom he knew by 1779,[60] went beyond a formal business relationship and in 1781 Reynolds even helped publicise an exhibition of Poggi's own fan paintings by writing an introduction for the catalogue.[61] In fact, Reynolds seems to have been buying and selling paintings increasingly towards the end of his life. In the mid-1780s, apart from helping the Duke of Rutland acquire the Poussins, he placed orders on the Duke's behalf with his own agent, De Gree, at the Brussels sale of 1785 and the following year 'took care to obey your Grace's orders about the Velasques [*sic*] and Van der Meulen when they arrive'.[62] When the Poussins eventually landed in England, Reynolds had them restored, exhibited them at the Academy, and when sending them to the Duke in 1787 wrote to him saying: 'I have been often angry with myself for having declined parting with the portrait of Albert Durer, as your Grace wished to have it in your collection . . . I shall therefore take the liberty of sending it with the Poussins'.[63]

During the same period Reynolds concluded a number of contracts with a second dealer, Noël Desenfans. On 27 April 1786, the *Morning Herald* reported that 'out of the ten pictures of Berchem which are in Mr Desenfans collection, that which attracts the most universal attention is the view of Tivoli. It was formerly imported from abroad by the Hon. Mr Walpole, at whose sale it was purchased by Sir Joshua Reynolds, and from thence came in the possession of Mr Desenfans'.[64] This relationship worked both ways, for in 1789 Reynolds 'agreed to copy his Picture of Mrs Siddons (as the Tragic Muse); his payment, a Rubens, valued at £500' from Desenfans.[65] In the same year Reynolds negotiated a similar deal with Lord Farnborough, who exchanged 'a little bit of Julio Romano which I gave a few sequins for at Bologna . . . for a fancy of his own that I like extremely'.[66] Reynolds also exchanged a *Head of the Hon. Mrs Stanhope* with another collector, Dr Charles Chauncey (1706–77), for 'pictures valued at £300'.[67] One purchaser managed to escape without paying. Reynolds noted in his ledger for April, 1790: 'Lord Darnley, for a Head of Inigo Jones by Van Dyck £52. 10. 0. . . . for a Sketch of Rubens of 'Little Boys Reaping' £26. 5. 0. He set out for Ireland on 30th July, 1791, not paying for the picture'.[68]

Only one scrap of evidence survives to suggest that Reynolds sold drawings from his own collection.[69] William Young Ottley, who owned Michelangelo's study for the figure of Adam on the Sistine ceiling (see 217), stated that it came from Reynolds' collection. But the drawing does not bear Reynolds' mark and therefore was presumably not in either posthumous sale. He most probably sold it to Ottley before the latter's departure for Italy in 1791. Ottley was only twenty at the time, but he had already laid the foundation of his collection by buying the contents of the studio of his master, John Brown.[70] It does not necessarily follow from the lack of evidence that Reynolds only sold drawings very rarely. The likelihood is that he treated them in much the same way as his paintings. Of course, within certain limits, selling works of art to buy others has always been a perfectly normal activity among collectors. Reynolds was too preoccupied as a painter to be a full-time dealer. So far as we know, he never sold very much at a time. Indeed, only the highest prices seem to have tempted him to part with his possessions. The *Morning Herald* implies as much in its report of 15 June 1789, that 'Rembrandt's celebrated picture of *Vertumnus* and *Pomona,* for which the late Mr Rigby gave 700 guineas to Sir Joshua Reynolds, was lately sold for £350 at Christie's . . .'[71] A further incentive to sell may have arisen after July 1789 when he tragically went blind in his left eye, and was forced to end his painting career. Yet even in April 1790, the Baron de Brabech could write to Reynolds for his advice, both as a 'connoisseur consomé . . . et pas negotiant de Tableaux lui meme'.[72] Reynolds does not emerge as a dealer on a large scale, and none of his early biographers bother to mention the sale of paintings in his collection except in reference to two events of 1791.

The first was his offer to sell his entire collection to the Royal Academy. Few details of this affair are known, but he apparently asked a modest price on condition that the Academy would purchase the Lyceum in the Strand to house the collection.[73] The offer was refused and Reynolds then organised an exhibition, advertised in *The World,* 2 April 1791: 'Ralph's Exhibition of pictures will open to the public on Monday next, the fourth of April, at No. 28 Haymarket. Admission one shilling'.[74] A manuscript first published by Leslie and Taylor was evidently drawn up as an introduction to the catalogue:

As many people may not know what exhibition it is which has been advertised to be seen in the Haymarket, called 'Ralph's Exhibition', it may be necessary to inform our readers that Sir Joshua Reynolds, intending to dispose of his collection of pictures, has sent as many as this room will contain to be exhibited for the advantage of his old servant, Ralph, and at the same time to give an opportunity of their being seen by collectors and lovers of pictures. The person who receives the money has a catalogue

marked with the prices of each picture, to the reservation of three only, which are not to be sold, viz., the Marriage of St Catherine by Correggio; the Joconde of Leonardo da Vinci; and the Leda of Michaelangelo. The statue of Neptune, by Bernini, in the middle of the room, is valued at 1500 guineas.[75]

Only one or two drawings were included in the exhibition, which was not a financial success. The dealer, Whitefoord, refers to the exhibition in an undated and unaddressed letter: 'Sir Joshua is also exhibiting his old mended pictures at a shilling a head, but I am told he has not sold one. Desenfans has just given notice that he means to sell his whole collection by private sale'.[76] This is the last we hear of the collection before Reynolds' death. With few exceptions, its contents were left in his will to his niece, Miss Palmer, later Marchioness of Thomond, who instructed the executors to sell. They hoped at first that Catherine the Great might purchase the whole collection, and they wrote to her to this effect on 17 January 1793:

. . . this great man has left behind him a considerable number of pictures and drawings, the result of his researches during 35 years, which his heirs wish to dispose of. As we presume . . . that this collection, acquired at great expense, deserves a place in the rich and beautiful gallery of Yr. Imperial Majesty, we humbly make to her the first offer.[77]

This evidently also came to nothing, and a year later, as we have seen, Poggi opened his exhibition. He found the drawings slow to sell, only managing to get rid of £570 12s. 6d. worth.[78]

The major sales of the paintings and drawings took place in 1795 and 1798 respectively. The combination of a depressed economy and a slump in the art market after the French Revolution forced prices down. Several lots at both sales were bought in, and eventually dispersed at Christie's after Lady Thomond's death in 1821. This sad episode closes the history of the collection on which Reynolds had lavished so much time and energy. 'It has been the business of my life', he wrote 'and I have had great opportunities'.[79]

MARTIN ROYALTON-KISCH

Notes to Introduction

My thanks are due to Brian Allen of the Mellon Center for Studies in British Art and Messrs. Christie, Manson and Woods for allowing me to study their sale catalogue archives, and my colleagues in the Department for their helpful advice and suggestions.

1 George Redford, *Art Sales,* 1888, vol. 1, p. 53, quotes a letter written by Edmund Burke soon after Reynolds' death: 'We do not know his circumstances exactly, because we have not been able to estimate the immense collection of pictures, drawings and prints. They stood him in more than twenty thousand pounds'. Reynolds' mark was occasionally forged; in the case of a drawing in

the Department by Sebastiano del Piombo, the mark of Prince Esterházy was carefully modified to look like Reynolds' (see P and G 279). A forged Reynolds stamp had been put on a drawing in the style of Rembrandt sold at the Robert von Hirsch sale, Sotheby's, 20 June 1978, lot 47.

2 A few drawings were included in 'Ralph's exhibition' in 1791.

3 The Philips catalogue is also prefaced by a declaration signed by the executors (except Burke, who died in 1797), that all the drawings were in Reynolds' collection. It does not mention whether any were stamped with Reynolds' mark on the *verso*. After several recounts, Mr Terry Blackman, my wife Marlies and I agreed that a total of 4,034 drawings were listed in the catalogue.

4 Poggi could have added the German School, which hardly features at all.

5 Discourse XI, p.198.

6 Discourse VIII, pp. 163–4.

7 Northcote, II, p. 58.

8 Discourse VII, p. 130. An unusual example of a pure landscape by Reynolds is represented in the exhibition by a mezzotint (see 151).

9 H. Vey, in *Die Zeichnungen Anton Van Dycks*, Brussels, 1962, catalogues twenty-eight Van Dyck drawings with a Reynolds provenance, of which three are landscape studies. The latter are, of course, much rarer.

10 Northcote, II, p. 271.

11 Northcote, II, p. 299. M. Röthlisberger, in his Claude catalogues, found a Reynolds provenance for three paintings and four drawings. Reynolds also owned a copy of Earlom's engraved *Liber Veritatis*, now in the Yale Art Gallery, New Haven. Hume's collection later passed to the Brownlow family, in whose sales a number of Claudes were included.

12 See Brinsley Ford's articles on Thomas Jenkins and James Byres in *Apollo*, XCIX, 1974, pp. 416–425 and 446–461; A. Bertolotti, 'Esportazione di oggetti di belle arti da Roma per l'Inghilterra', *Archivio Storico Artistico . . . di Roma*, IV, 1880, pp. 74–90; Lesley Lewis, *Connoisseurs and Secret Agents*, London, 1961; O. Sitwell, 'The Red Folder', *Burlington Magazine*, LXXX, 1942, pp. 85ff. and 115ff.

13 There were also more non-Italian paintings at the sale of Reynolds' heiress, Lady Thomond, at Christie's, 16–17 May 1821. Many of them had been 'bought in' at the 1795 sale. Most of the eighteenth-century sale catalogues I have studied contained more Northern than Italian paintings. For Reynolds' sale, see *Burlington Magazine*, 1945, pp. 133 ff; 211 ff; 263 ff.

14 Malone, I, p.li. Reynolds' father apparently had a small collection of prints and was 'fond of drawings'—see Northcote, I, p. 12 and F. W. Hilles (ed.), *Portraits by Sir Joshua Reynolds*, 1952, pp. 20–22.

15 Reynolds could have met Horace Walpole, an inveterate sale-goer, in this way.

16 Hilles, *op. cit.*, p. 22. Reynolds said he met Pope at the sale, but neither he, Hudson nor Reynolds are recorded as buyers. The British Library's copy of the catalogue gives Captain Keppel, who later took Reynolds to Italy, as the purchaser of a sea-piece at the sale (third day, lot 17).

17 The copy of the catalogue in the Victoria and Albert Museum Library is only partly annotated with buyers' names. See Appendix, p. 90.

18 Northcote, II, p. 39.

19 In a chapter of his *Essay* devoted to drawings, Richardson describes the pleasure he takes in them in terms similar to those used by Reynolds in the quotations from the Discourses cited above (see in particular pp. 151–152 of Richardson's *Essay*, 2nd ed., 1725).

20 Lot 34. Hudson's presence at the sale on the same night is recorded by his purchases, including lots 12 and 43. Thus he and Reynolds were not buying on each other's behalf. Bartoli's book was easily obtainable (nearly every library catalogue of the period seems to include a copy) and the *Admiranda* was a well-known source of illustrations after the antique.

21 L 2183 and 2184.

22 See Cotton, 1859, p. 11; Leslie and Taylor, I, p. 39. In a letter to Miss Weston from Port Mahon, dated 10 December 1749, Reynolds seems pleased that the riding accident he suffered allowed him time to paint 'as many pictures as will come to a hundred pounds' (Reynolds Letters, p. 5).

23 See Denys Sutton, 'The Roman Caricatures of Reynolds', in *Country Life Annual*, 1956, pp. 113–116.

24 Reynolds' Venice note-book (published in full by Leslie and Taylor, I, pp. 67–84) contains constant references to engravings after Veronese, Titian etc., which he presumably bought. The only reference I have found which suggests that Reynolds bought drawings in Italy occurs in the sale catalogue of James Stewart, Sotheby, 17 May 1839 (Whitley Papers, in an envelope at the end of vol. II), which describes an album of drawings mostly by Reynolds: 'The drawings not Sir Joshua's in this volume are remarkably choice specimens of early Italian art, collected by himself when in Italy'.

25 Walpole Society, XLI, 1968, p. 124.

26 The copy of this catalogue in the Department says the lot was bought by 'Reynolds Ye Painter', leaving no doubt about his identity. I have found no reason to suppose that any other purchasers named Reynolds attended the auction rooms in Sir Joshua's lifetime.

27 Anthony Blunt, *The Paintings of Nicolas Poussin, A Critical Catalogue*, London, 1966, No. 169. The Duke of Rutland's sale was presumably that of John, 3rd Duke.

28 Unless it was the de Merval sale, (Lugt, *Ventes*, No. 1681) which included two paintings by Claude later owned by Reynolds (see M. Röthlisberger, *Claude Lorrain, The Paintings*, London, 1961, Nos. 103, 109).

29 Published by F. W. Hilles, 'Horace Walpole and the Knight of the Brush', in *Horace Walpole, Writer, Politician and Connoisseur*, ed. Warren Hunting Smith, New Haven and London, 1967, p. 153. Reynolds' journal of his Paris trip, where he constantly notes pictures and dealers he has seen, is published in part by Leslie and Taylor, II, pp. 285–290.

30 See F. W. Hilles, *op. cit.*, pp. 155f.

31 Malone, II, p. 269, noted that Reynolds saw two Rubens sketches in Mr Orion's collection in Brussels which Reynolds later acquired. They were sold on the fourth day of Reynolds' own sale in 1798, lot 68.

32 The texts of these letters have not, to my knowledge, been published. They were included in *An Exhibition of Books, Manuscripts and Prints pertaining to Sir Joshua Reynolds,* at Yale University Library, New Haven, 1973, Nos. 30 and 31.

33 From a letter to the 4th Duke of Rutland, 19 July 1785 (Reynolds Letters, p. 129f); catalogues of major foreign sales seem to have been readily available in London, and were advertised in the English press. The Duke had been appointed Lord Lieutenant of Ireland in 1784.

34 Reynolds Letters, pp. 134f.

35 De Gree's name occurs in Reynolds' letters to the Duke of Rutland after the sale (Reynolds Letters, pp. 138f). Northcote (II, pp. 124f) says that Reynolds met De Gree in Antwerp in 1781. The figure of £1,000 is taken from Northcote, II, pp. 213f.

36 Walpole's Letters, ed. Paget Toynbee, XIII, pp. 304f.

37 *Ibid.,* V, pp. 130f.

38 This was the Greffier collection at The Hague (Malone, II, p. 352).

39 Northcote, II, p. 198.

40 Whitley Papers, I, p. 67.

41 *Ed. cit.,* XIII, p. 423 (Letter to the Countess of Ossory, 1 December 1786).

42 The Naples version is referred to in a rough manuscript for Discourse VI in the Royal Academy (see F. W. Hilles, *The Literary Career of Sir Joshua Reynolds,* Cambridge, 1936, p. 225). Reynolds probably acquired his version at the Newton sale of 1788, not of April 1790, as he inscribed a note on the back of the panel two weeks before the latter sale began (see Appendix, List of sales). The catalogue of 'Ralph's exhibition' says that Reynolds bought the picture 'at the sale of the cabinet of Dr Newton' (Graves and Cronin, IV, p. 1607).

43 I have only seen one of them, the *Leda,* now in the National Gallery, where tentatively attributed to Rosso. The Correggio is in the Duke of Northumberland's collection, but the whereabouts of this 'Mona Lisa' are unknown to me. It was bought at Reynolds' sale by Sir Abraham Hume, whose collection later passed to the Brownlow family.

44 See the Catalogue of 'Ralph's Exhibition', reprinted in Graves and Cronin, IV, pp. 1595–1608.

45 Reynolds Letters, pp. 21f.

46 See Anthony Blunt, *op. cit.,* pp. 73ff.

47 Reynolds Letters, pp. 125f.

48 Malone, II, pp. 344f. The painting, now at Berlin, is No. 516 in Bredius' catalogue; the drawing, now in the Louvre, is No. 609 in Benesch's. Both were exhibited by Reynolds in 'Ralph's' Exhibition, Nos. 46 and 66 respectively (Graves and Cronin, IV, p. 1603).

49 The best known attack on this pretext occurred in 1775, when Nathaniel Hone submitted a satire on Reynolds' borrowings, a painting called *The Conjuror,* to the Academy. See Martin Butlin, 'An Eighteenth Century Art Scandal, Nathaniel Hone's *The Conjuror', Connoisseur,* May 1970, pp. 1–9.

50 The drawing is reproduced by J. K. Rowlands in *Master Drawings,* X, 1972, pp. 284ff; the engraving by Earlom after the New College window is fig. 8 in Waterhouse, 1973, opposite p. 32.

51 Waterhouse, 1941, p. 46, under 1759; the drawing is No. 177 in Fischel, *Raphaels Zeichnungen.* As Mr J. A. Gere, Keeper of the Department, was the first to notice, a drawing in the Department by Nathaniel Dance (1735–1811) is closely based on Raphael's study (1898–7–12–70).

52 Some of the more 'Antique' poses may have been inspired by casts after the Antique in his collection. These were sold off at Greenwoods in Leicester Square soon after his death, beginning 16 April 1792.

53 Northcote, II, p. 276. Reynolds also lent and borrowed works from his own and other collections (see Northcote, II, p. 180). He wrote to Richard Cosway, saying 'If you will trust me with your sketch of Rubens of Jupiter & Venus for a few days, I shall take it as a great favour'. This letter is dated only 'April 22' (see Reynolds Letters, p. 189).

54 See Brinsley Ford, 'Thomas Jenkins, Banker, Dealer and Unofficial English Agent' in *Apollo,* XCIX, 1974, pp. 416–425.

55 Reynolds Letters, pp. 161f.

56 Whitley Papers, I, p. 73.

57 W. T. Whitley, *Artists and their Friends in England,* London, 1928, vol. II, pp. 181f; Whitley Papers, II, p. 25. The sculpture is now in the Victoria and Albert Museum.

58 Reynolds Letters, pp. 31f.

59 Susan M. Radcliffe (ed.), *Sir Joshua's Nephew,* London, 1930, p. 86.

60 Poggi is noted in Reynolds' pocket book of February (Graves and Cronin, IV, p. 1545).

61 Leslie and Taylor, II, p. 320, say that Reynolds provided designs for Poggi's fans. See also W. T. Whitley, *Artists and their Friends in England,* II, p. 111. An undated catalogue of an exhibition organised by Poggi 'at the Great Room, late Royal Academy' in Pall Mall provides proof that Poggi the dealer and Poggi the fan painter are the same person: the exhibition includes fan paintings by Poggi himself (cat. in Victoria and Albert Museum Library).

62 Reynolds Letters, p. 148.

63 *Ibid.,* p. 177. In the same letter Reynolds describes a Van Dyck 'sketch which I bought, with a view of offering it to your Grace at the price it cost me'.

64 Whitley Papers, I, p. 63. The sale was possibly that of Thomas Walpole, presumably the second son of the first Lord Walpole, which took place in 1782 (Lugt, *Ventes,* 3394). The final lot of Reynolds' own sale in 1795 was a Poussin, now at Dulwich and considered a copy, which was said to have been in the possession of Sir Edward Walpole.

65 *Stuart's Star,* 15 April 1789 (Whitley Papers, I, p. 89); *The World,* 15 April 1794 says that Sir Joshua 'sold it for 1,000 guineas worth of other pictures to Desenfans, and Desenfans sold it to Calonne' (Whitley Papers, II, p. 13). The painting is now at Dulwich.

66 Letter from Lord Farnborough to George Cumberland, British Library, Department of Manuscripts, Add. MS 36496, 26 September (Whitley Papers, I, p. 88).

67 *The World,* 3 April 1790 (Whitley Papers, I, p. 97). The portrait of the Hon. Mrs Stanhope was lot 86 on the second day of Chauncey's sale at Christie's, 26–27 March 1790.

68 Walpole Society, XLII, 1968–70, p. 150. In the earlier Fitzwilliam ledger (*ibid.,* p. 146) Reynolds notes a more successful deal in which he sold £150 worth of Old Master paintings to 'Mr Bromel'.

69 At least, the only evidence I have found. Plenty more is likely to exist.

70 On Ottley as a collector, see J. A. Gere in *The British Museum Quarterly,* XVIII, 1953, No. 2, pp. 44–52.

71 Whitley Papers, I, p. 91.

72 The Baron had been approached by two Englishmen wishing to buy his whole collection. See Cotton, 1859, p. 68.

73 Northcote, II, p. 275. The Lyceum was burnt in 1830, and replaced by the present theatre, which opened in 1834.

74 Whitley Papers, II, (envelope inside back cover).

75 Leslie and Taylor, II, p. 604.

76 British Library, Department of Manuscripts, Add. MS 36595, 256 (Whitley Papers, II, envelope inside back cover). Rumours that Reynolds had restored the paintings in his collection were widespread. According to the *Literary Gazette* of 1822, p. 103, Reynolds bought a Rubens from Whitefoord for £300 sometime after he had become blind in one eye. 'When he got it home he found it was a copy: "That man", he said, "has taken me in" and from that hour he was always denied to Mr Whitefoord, who it is to be presumed only erred in judgement. The original picture is at Munich' (Whitley Papers, II, p. 25).

77 Whitley Papers, II, p. 21. The original is among the Malone papers presented to the Bodleian, 1878.

78 Edward Edwards, *Anecdotes of Painters,* London, 1808, p. 207.

79 F. W. Hilles, *The Literary Career of Sir Joshua Reynolds,* Cambridge, 1936, p. 185.

Luca Signorelli

Cortona *c.*1441–Cortona 1523

201 Dante and Virgil with Count Ugolino

Black chalk. 312 × 256 mm
Provenance N. Hone (L 2793); Sir J. Reynolds (L 2364); Sir T. Lawrence (L 2445); S. Woodburn; W. Russell (L 2648); Thibaudeau. 1885-5-9-41
Literature P and P 241

The scene is that described by Dante (*Inferno,* xxxii, 124–39; xxxiii, 1–90) in which Count Ugolino, pointing to the half-eaten head of Archbishop Ruggieri, relates his story to Dante and Virgil. The drawing was possibly made as a design for one of the circular monochrome scenes in the chapel of the Madonna di S. Brizio in the Duomo at Orvieto, which Signorelli agreed to decorate on 27 April 1500.

Domenico Ghirlandaio

Florence? *c.*1449–Florence 1494

202 The Birth of the Virgin

Pen and brown ink. 215 × 285 mm
Provenance J. Richardson, sen. (L 2183); J. Barnard (L 1419); Sir J. Reynolds (L 2364); W. Esdaile (L 2617); T. Thane (L 2461); Rev. Dr H. Wellesley. 1866-7-14-9
Literature P and P 69

A composition study, with considerable variations, for the fresco in the lowest tier of the left wall of the choir of S. Maria Novella, Florence. In 1485 Giovanni Tornabuoni commissioned Domenico and Davide Ghirlandaio to decorate the choir with stories mainly of the Madonna and of St John the Baptist. The cycle must have been completed in 1490 when the choir was reopened.

Leonardo Da Vinci

Vinci 1452–Amboise 1519

203 Study of drapery for a kneeling woman

Brush drawing in brown and white on brown linen. 283 × 193 mm (top corners cut)
Provenance J. Richardson, sen. (L 2184); Sir J. Reynolds (L 2364); Sir T. Lawrence (L 2445); King of Holland; Malcolm. 1895-9-15-489
Literature P and P 95

The figure seems to be a study for a Madonna in an *Annunciation* or a *Nativity*. This is probably a youthful work as the influence of Leonardo's master, Andrea del Verrocchio (1436–88), is strong.

Follower of Fra Angelico
Florence? 1387–Rome 1455

204 A Pope (Clement V), with a hawk on his fist, riding away from a Woman (Holy Church)

Pen and brown wash. 160 × 155 mm (top right corner made up)
Provenance Resta-Somers (L 2981:*g.3*);
Sir J. Reynolds (L 2364); C. M. Metz;
W. Y. Ottley; Sir T. Lawrence (L 2445);
S. Woodburn; Sir J. C. Robinson (L 1433);
Malcolm. 1895–9–15–470
Literature P and P 3

Inscribed at the bottom to the left in a contemporary hand: *D. beltrand (us) Ghuasco dictus \overline{pp} clemens quintus.*

 The subject alludes to the transference of the papacy to Avignon by Clement V (Bertrand de Goth), d. 1314. Its treatment is based on an illustration in a cycle of illustrations which had a wide circulation in the fifteenth century: Abbot Joachim's *Prophecies of the Popes.*

Francesco Da San Gallo
Florence 1494–Florence 1576

205 Head of a dead man (Cardinal Leonardo Buonafede)

Red chalk. 262 × 322 mm
Provenance Sir J. Reynolds (L 2364);
Sir T. Lawrence (L 2445); Phillipps-Fenwick.
1946–7–13–5

Apparently a study for the tomb of Cardinal Leonardo Buonafede in the Certosa di Val d'Ema, outside Florence.

Pietro Perugino
Città della Pieve *c.*1445-Fontignano, nr. Perugia 1523

206 Head of a young woman

Metal-point and faint wash on grey prepared surface. 377 × 243 mm
Provenance J. Richardson, sen. (L 2184);
A. Pond; Sir J. Reynolds (L 2364; sale,
H. Phillips, 1798, 23 March, lot 1683 as
Domenico Ghirlandaio); R. Payne Knight
Bequest. Pp. 1–26
Literature P and P 191

The attribution is based above all on the drawing's resemblance to two paintings by Perugino datable

from his middle period: the *Portrait of a Youth* in the Uffizi, and the *Magdalen* in the Pitti, Florence.

Fra Bartolommeo Della Porta
Florence 1472–Pian' di Mugnone 1517

207 The Virgin and Child with the infant St John the Baptist and an angel

Pen and brown ink with some (oxidised) white heightening. 187 × 155 mm
Provenance Sir J. Reynolds (L 2364); R. Payne Knight Bequest. Pp. 1–52.
Literature BB 405

After Fra Bartolommeo Della Porta
208 St Mark seated in a niche

Pen and brown ink; the outlines of the architecture drawn first with a stylus.
252 × 166 mm
Provenance Sir J. Reynolds (L 2364); R. Payne Knight Bequest. Pp. 1–56
Literature BB 402

Inscribed in a sixteenth-century hand in ink in the lower left-hand corner: *frater Bartholomeo.*

 Generally believed to be a preparatory study for the *St Mark* in the Pitti Gallery, Florence, which was apparently painted in 1514 for the church of S. Marco. Berenson described it as 'Summary and rough, but good'. On the other hand, a note on the Department's draft catalogue entry for the drawing records Philip Pouncey's view that it is a copy.

Raphael (Raffaello Santi)
Urbino 1483–Rome 1520

209 Three standing nude men

Pen and brown ink. 243 × 148 mm
Provenance J. Richardson, sen. (L 2183);
Sir J. Reynolds (L 2364; in his possession by
1763, see No. 210); Mackintosh (according to
JCR); Malcolm. 1895–9–15–628
Literature P and G 16

The style of this rather damaged drawing accords well with other studies of the nude made by Raphael during his years in Florence, *c.*1504–8.

William Wynne Ryland
London 1732–London 1783

210 Three standing nude men, after Raphael

Etching. 241 × 148 mm (excluding simulated mount)
Presented anonymously. 1949–5–23–3
Inscribed: *Raffaëlle del'.* and *W. W. Ryland sc'. 1763,* and below: *In the Collection of Mr Reynolds. CR edid'.* The date shows that Reynolds had acquired the drawing by then.

The volume, entitled *A Collection of Prints, in Imitation of Drawings,* was published by Charles Rogers (1711–84) in 1778. He was no doubt encouraged in the enterprise by his friend Arthur Pond (*c.*1705–58), who had produced a similar series of facsimiles in the 1730s. The frontispiece is a mezzotint, also by Ryland, of Reynolds' portrait of Rogers painted in 1777.

Giulio Romano
Rome *c.*1499–Mantua 1546

211 Allegory of the Virtues of Federico Gonzaga

Pen and brown ink over red and black chalk. 220 × 294 mm
Provenance N. Lanière (L 2886); unidentified collector (L 2883ª); J. Richardson, jun. (L 2170); Sir J. Reynolds (L 2364); Malcolm. 1895–9–15–642
Literature P and G 79

Study for the ceiling-octagon of the Sala d'Attilio Regolo in the Casino della Grotta in the Garden of the Palazzo del Te in Mantua. This was probably begun *c.*1529.

Giovanni Da Udine
Udine 1487–Rome 1561/64

212 A cock-pheasant

Watercolour, heightened with white, over red chalk. The smaller bird in black chalk. 163 × 348 mm
Provenance Unidentified collector (L 474); J. Richardson, sen? (inscription on back of mount: *O 43. L 423.8*); Sir J. Reynolds (L 2364 on back of mount); C. S. Bale (L 640); J. P. Heseltine (L 1507); H. Oppenheimer. 1936–10–10–19
Literature P and G 153.

In general appearance the drawing is very like the birds in Giovanni's frescoes in Raphael's *Logge* in

the Vatican of *c.*1518, and seems certainly to date from the first half of the sixteenth century.

Reynolds' executors applied his mark on the back of drawings they considered to be worth less than 2s. 6d. (see p. 61).

Polidoro Da Caravaggio
Caravaggio (Lombardy) 1490/1500–Messina 1543?

213 Studies for a *Transfiguration*

Pen and brown ink, touched with red chalk. 210 × 155 mm
Provenance N. Lanière (L 2886); J. Richardson, sen. (L 2183. Inscribed on fragment of his mount: *Zn.39.P.34.E.17.R.69 li*); Sir J. Reynolds (L 2364); T. Banks (L 2423); Sir E. J. Poynter, Bt (L 874); H. Oppenheimer. 1936–10–10–3
Literature P and G 218

Polidoro painted a picture of this subject for S. Maria del Carmine at Messina; it no longer exists in the church and was probably destroyed in the earthquake of 1783.

Reynolds' stamp appears on the *verso,* probably because it has almost equal claim to be called the *recto,* rather than for the reasons given under No. 212.

Mounted with the drawing is a fragment of Richardson's mount, inscribed in ink: *These Ornam.ᵗˢ just the same as are painted throughout in the Vatican.*

214 Studies for a Christ in a *Transfiguration*

Pen and brown ink. 219 × 159 mm
Provenance N. Lanière (L 2886); J. Richardson, sen. (L 2183); Sir J. Reynolds (L 2364); Baron D. Vivant Denon (L 779); Sir E. J. Poynter, Bt (L 874); presented by Sir O. Beit, Bt. 1918–6–15–2
Literature P and G 217

Related to the studies shown in No. 213.

215 Priest celebrating Mass, with kneeling monks and other figures

Red chalk. 232 × 202 mm
Provenance J. Richardson, sen. (L 2184); Sir J. Reynolds (L 2364). 1963–4–20–5

216 A schoolmistress with her pupils, and other studies

Pen and brownish-grey ink, with wash of the same colour in the upper right-hand group.
214 × 328 mm
Provenance Sir P. Lely (L 2092); Sir J. Reynolds (L 2364); Phillipps-Fenwick. 1946–7–13–463
Literature P and G 212

Michelangelo Buonarroti
Caprese, nr. Sansepolcro 1475–Rome 1564

217 Study for Adam on the Sistine Chapel ceiling

Red chalk. 193 × 259 mm
Provenance J. Richardson, sen.?; Sir J. Reynolds (according to Ottley); W. Y. Ottley;
Sir T. Lawrence (L 2445); Locker-Lampson. 1926–10–9–1
Literature W. Y. Ottley, *The Italian School of Design,* London, 1823, pp. 28/29; Wilde 11

For the figure in the *Creation of Adam.* The pose of Adam as painted in the fresco is substantially that of the present sheet.

Probably sold to Ottley by Reynolds before 1791, when Ottley went to Italy. This would explain the absence of Reynolds' collector's mark, which was applied by his executors to all the drawings in his collection at his death (see p. 71).

After Michelangelo Buonarroti
218 Head of a warrior (Count Canossa)

Black chalk. 410 × 263 mm (the upper corners made up)
Provenance Sir J. Reynolds (L 2364);
Sir T. Lawrence (L 2445); Sir J. C. Robinson (L 1433); J. Malcolm (L 1489). 1895–9–15–492
Literature Wilde 87

Probably considered an original by Reynolds. The drawing is traditionally known as *'The Count of Canossa'.* The crest on the helmet, a dog (*cane*) gnawing a bone (*osso*), may be construed as a punning allusion to the name Canossa. Michelangelo supposed himself to be descended from the family of the Count according to the artist's biographer, Condivi.

Michelangelo Buonarroti
219a Two studies of a sleeping figure

Black chalk. 660 × 101 mm
Provenance Sir J. Reynolds (L 2364); F. Cheney. 1885–5–9–1894
Literature Wilde 79

219b Nude man in violent motion

Black chalk. 102 × 60 mm
Provenance As 219a. 1885–5–9–1893
Literature Wilde 73

A figure close to the two studies in 219a was used for a sleeping apostle in a painting of the *Agony in the Garden* by Marcello Venusti of which several versions exist, the best being in the Doria Gallery in Rome. On the basis of the painting, the drawing is datable 1555–60.

No. 219b may be a study for the angel in the altarpiece of the *Annunciation* painted by Venusti for S. Giovanni in Laterano a few years earlier, and for which Michelangelo had been persuaded to provide designs.

Nos. 219a and 219b are mounted with Wilde 74, 68 and 80.

Daniele (Ricciarelli) Da Volterra
Volterra *c.*1509–Rome 1566

220 Bearded man on a ladder

Black chalk. 208 × 122 mm
Provenance Sir P. Lely (L 2092); Sir J. Reynolds (L 2364); Sir T. Lawrence (L 2445);
Phillips-Fenwick. 1946–7–13–326
Literature S. Levie, *Album Discipulorum . . . Prof. dr. J. G. van Gelder,* Utrecht, 1963, p. 57

Probably an early study for the figure descending a ladder in the background of the altarpiece of the *Descent from the Cross* in S. Trinita dei Monti in Rome.

Rosso Fiorentino
Florence 1495–Paris 1540

221 Reclining nude woman

Red chalk. 126 × 244 mm
Provenance N. Hone (L 2793, almost completely erased); Sir J. Reynolds (L 2364); R. Payne Knight Bequest. Pp. 5–132
Literature BB 2444

Inscribed, lower right: *Rosso.*

It has been suggested that this may have been a study for a figure in Rosso's fresco of the *Fountain of Youth* in the Gallery of Francis I at Fountainebleau.

Baccio Bandinelli

Florence *c.* 1493–Florence 1560)

222 Two standing figures: a bearded man in a cloak, and a youth leaning on a stick

Black chalk. 275 × 211 mm
Provenance J. Richardson, sen. (L 2183);
Sir J. Reynolds (L 2364); J. Barnard (L 1419);
Sir T. Lawrence (L 2445); Phillipps-Fenwick.
1946–7–13–19
Literature U. Middeldorf, *Rivista d'Arte*, XIV, 1932, pp. 483 ff.

Barnard's inscription on the back of the old mount correctly identifies these two figures in an engraving of the *Martyrdom of St Lawrence,* after Bandinelli, by Marcantonio Raimondi (B. xiv, p. 89, 104). The bearded man appears in the background standing on a ledge over an arch to the left, to the right of a group of figures; the youth stands to the extreme right on a ledge over the arch to the right.

Jacopo Carrucci Da Pontormo

Pontormo 1494–Florence 1556/7

223 Seated woman

Red chalk. 289 × 202 mm
Provenance N. Hone (L 2793); Sir J. Reynolds (L 2364). 1933–8–3–13
Literature J. Cox-Rearick, *The Drawings of Pontormo,* Cambridge, Mass., 1964, No. 252

The style suggests the period 1523–8, when the painter was working at the Certosa del Galluzzo, outside Florence.

Domenico Beccafumi

Nr. Siena 1486–Siena 1551

224 Standing saint or prophet holding a book

Brush drawing in brown wash and white heightening, over black chalk. 206 × 122 mm
Provenance Sir P. Lely (L 2092); J. Richardson, sen. (L 2183); Sir J. Reynolds (L 2364).
1938–6–11–6
Literature D. Sanminiatelli, *Domenico Beccafumi,* Milan, 1967, p. 152, No. 70

Battista Franco

Udine 1510–Venice 1561

225 St Jerome in penitence

Pen and brown ink. 268 × 217 mm (lower left corner cut)
Provenance J. Richardson, sen. (L 2184);
Sir J. Reynolds (L 2364); C. M. Cracherode Bequest. Ff. 1–24

Inscribed in ink in the lower right corner in a contemporary hand, possibly that of the artist: *Batista franco.*

226 A seated nude youth

Black chalk. Somewhat stained and spotted.
366 × 274 mm
Provenance Sir P. Lely (L 2092); W. Gibson (inscribed in ink on backing: *6.3* [30s] altered from *1.4* [20s]: see L 2885 and *Supplément*);
Sir J. Reynolds (L 2364); R. Payne Knight Bequest. Pp. 2–123

In the nineteenth century, and perhaps also in Reynolds' day, this drawing was believed to be Michelangelo's study for the figure of Jonah on the Sistine Ceiling. It was later attributed to Raphael, but Popham's attribution to Franco was confirmed by the discovery that it is a study for the figure of Jupiter in a painting of *Venus, Mercury and Jupiter* in the Museo de Arte at Ponce, Puerto Rico (repr.: *Apollo,* LXXXV, 1967, p. 184).

227 Design for a ceiling octagon with Jupiter, Mercury and other figures

Pen and brown wash, heightened with (partly oxidised) white. 154 × 156 mm
Provenance J. Richardson, sen. (according to manuscript Payne Knight inventory of 1845 in the Department. The back of the mount is inscribed in ink *Z.72/E.* Numbers of this type are often found on the mounts of drawings from his collection); Sir J. Reynolds (L 2364); R. Payne Knight Bequest. Pp. 2–122

The type of ceiling suggests Venice, where Franco was active in his last years.

Taddeo Zuccaro

Sant' Angelo in Vado, nr. Urbino 1529–Rome 1566

228 Sibyl in the left-hand side of a lunette

Pen and brown wash, heightened with white, on blue paper. The rough sketch for the figure, top left, in black chalk. 234 × 233 mm

Provenance Resta-Somers (L 2981: *59.n*);
Sir J. Reynolds (L 2364); R. Payne Knight
Bequest. Pp. 2–127
Literature J. A. Gere, *Taddeo Zuccaro: his
Development studied in his Drawings,* London,
1969, No. 98

A study, with variations, for the Sibyl on the left
of the lunette above the altar in the Mattei
Chapel in S. Maria della Consolazione, Rome.

229 Soldier in armour descending a step
and holding a staff

Red chalk. 358 × 135 mm
Provenance Sir J. Reynolds (L 2364); W. Mayor
(L 2799); J. Malcolm. 1895–9–15–814
Literature J. A. Gere, *Taddeo Zuccaro: his
Development studied in his Drawings,* London,
1969, No. 102

Inscribed in pencil along lower edge: *Fra
Sebastiano del Piombo.* Despite the traditional
attribution, this is a typical chalk study, probably
from the life, by Taddeo Zuccaro. The style
suggests a late date, *c.*1560, or later.

Polidoro Da Caravaggio

230 Two women carrying a body

Pen and brown ink and wash. 169 × 179 mm
Provenance Sir P. Lely (L 2092); W. Gibson?
(inscribed in ink on *verso*: Polidoro *1.3.* [5s],
altered from *4.1.* [4s]: see L 2885 and
Supplément); Sir J. Reynolds (L 2364);
Sir T. Lawrence (L 2445); Phillipps-Fenwick.
1946–7–13–461
Literature P and G 200

Presumably a fragment of a design for a façade
painting in simulation of an antique relief.
Polidoro specialised in façade decoration during
his years in Rome, before 1527.

An alternative possibility is that the drawing is
an early work by Taddeo Zuccaro who carried on
in the 1550s, the tradition of façade decoration
still in the manner of Polidoro.

Francesco Primaticcio
Bologna 1504–Paris 1570

231 The Flaying of Marsyas

Red chalk. 331 × 282 mm
Provenance N. Lanière? (L 2908 and
Supplément); J. Richardson, sen. (L 2184);
Sir J. Reynolds (L 2364); Sir T. Lawrence
(L 2445); Phillipps-Fenwick. 1946–7–13–42

Jacopo Palma, called Palma Il Giovane
Venice 1544–Venice 1628

232 Diana and a nymph

Pen and brown ink. 219 × 184 mm
Provenance J. Richardson, jun. (L 2170);
Sir J. Reynolds (L 2364); R. Payne Knight
Bequest. Pp. 3–195

Lodovico Cardi, called Il Cigoli
Castelvecchio, nr. Empoli 1559–Rome 1613

233 The Holy Family with the infant
St John

Pen and brown ink and brown wash.
256 × 203 mm
Provenance Sir J. Reynolds (L 2364 *verso*);
W. Y. Ottley (his mount); Sir T. Lawrence
(L 2445); Phillipps-Fenwick. 1946–7–13–318

234 Study of a project for St Peter's; above,
two cartouches with inscriptions

Pen and brown ink. 248 × 245 mm
Provenance F. Baldinucci; Sir J. Reynolds
(L 2364); T. Banks (L 2423); Sir E. Poynter
(L 874). 1916–5–3–1

According to an old inscription on the back of the
mount, this drawing represents Cigoli's own design
for St Peter's. However, the drawing seems to be
little more than a copy of Michelangelo's project
for the basilica. In 1605, Paul v commissioned
Cigoli to submit a design for the façade of St
Peter's in competition with Maderna, who won
the contest.

Giovanni Lorenzo Bernini
Naples 1598–Rome 1680

235 Plan and elevation of a semi-circular
colonnade: design for the colonnade of
St Peter's

Pen and brown wash over black chalk; the
outlines indented. 523 × 844 mm
Provenance Joseph Smith? (his sale, Christie's,
1776, 27 April, lot 77: *Colonade of St Peter's, by
Barnini,* bt *Beauvais, 12s.-6d*); Sir J. Reynolds
(L 2364); R. Payne Knight Bequest. Oo. 3–5
Literature H. Brauer and R. Wittkower, *Die
Zeichnungen des Gianlorenzo Bernini,* Berlin,
1931, p. 81 (as studio)

Inscribed in brown ink in the lower left-hand
corner with the permission for the design to be
printed: *Incidatur f. (?) Horatius Carnesechius*

socius R[everendissi]mi P[atris] M[agistri] S[acri] P[alatii] A[postolici]. Extensively inscribed in pencil to the left and right of the sheet with explanations of the plan.

This is a study in reverse for an engraving made in 1659 by Giovanni Battista Bonacina (described by Brauer and Wittkower, *op. cit.*, p. 81, note 4). The print published the project for the most ambitious of Bernini's many architectural commissions for Pope Alexander VII (Chigi): the oval colonnade of the Piazza di S. Pietro, in front of the basilica.

Jacopo Robusti, called Il Tintoretto
Venice 1518–Rome 1594

236 A standing man with raised arms

Black chalk, heightened with white, on blue paper; squared in black chalk. 353 × 240 mm
Provenance Sir J. Reynolds (L 2364, sale, Phillips, 1798, 24 March, lot 1798 with 20 others; in numbered sale wrapper when acquired). 1913-3-31-189
Literature P. Rossi, *I Disegni di Jacopo Tintoretto*, Florence, 1975, p. 42 and pl.62

Inscribed in brown ink in an old hand, bottom right-hand corner: *Giacomo Tintoretto*.

A study for the figure of a man standing in the centre of the painting, the *Finding of the Body of St Mark* (Milan, Brera; reproduced: H. Tietze, *Tintoretto*, London, 1948, pl. 112), one of three scenes from the legend of St Mark commissioned from Tintoretto by Tommaso Ragone of Ravenna for the Scuola Grande di S. Marco in 1562. In the picture the man holds a candle in his right hand while directing the removal from the tomb of the Saint's body.

Jacopo Da Ponte Bassano
Bassano *c.*1510–Bassano 1592

237 Reclining man: study for a figure of St John the Evangelist

Black and coloured chalks on blue paper. 262 × 369 mm
Provenance J. Richardson, jun. (L 2170); Sir J. Reynolds (L 2364); E. Rose. 1943-11-13-2

W. R. Rearick in a letter to the Department pointed out that this is for the figure of St John the Evangelist in the ceiling fresco of the Cappella del Rosario in the Chiesa Parrocchiale at Cartigliano, near Bassano (reproduced: M. Muraro, *Arte Veneta*, vi, 1952, p. 43). In the painting the Saint

holds to his left his symbol, the eagle. The ceiling was probably completed by 1575, the date inscribed on one of the painted walls below.

Titian
Venice 1477?–Venice 1576

238 Study of a man looking up

Black chalk heightened with white on blue paper. 157 × 135 mm
Provenance Sir J. Reynolds (L 2364); Sir T. Lawrence (according to JCR); W. Esdaile (L 2617); Malcolm. 1895-9-15-823
Literature K. Oberhuber, *Disegni di Tiziano e della sua Cerchia*, exhibition catalogue, Fondazione Cini, Venice, 1976, No. 26

Generally believed to be Titian's study for the seated figure of St Peter in Titian's famous altarpiece of the *Assumption of the Virgin* painted in 1516–8 for the church of the Frari in Venice.

Paolo Farinati
Verona 1524–Verona 1606

239 Tamerlane mounting his horse from the back of a conquered king

Pen and brown wash over black chalk, heightened with white, on blue paper. 211 × 226 mm
Provenance Sir J. Reynolds (L 2364); Sir T. Lawrence (L 2445); Phillipps-Fenwick. 1946-7-13-26

Tamerlane, or Timur i Leng (1336–1405), was a famous Tartar conqueror who was notorious for his cruelty. Petrus Perondinus, in *Magni Tamerlanis Scytharum Imperatoris Vita*, Florence, 1553, p. 30, describes the incident shown in this drawing of King Bajazeth submitting to his victor.

Attributed to Giuseppe Porta, called Il Salviati
Castelnuovo di Garfagnana *c.*1520–Venice? *c.*1575

240 The discovery of Callisto's shame

Pen and brown ink and brown wash, heightened with white, on blue paper. Some black chalk underdrawing. 207 × 327 mm
Provenance Sir P. Lely (L 2092); Sir J. Reynolds (L 2364); R. Payne Knight Bequest. Pp. 3-194

Callisto was an Arcadian nymph beloved by Jupiter. According to one legend, Jupiter assumed the form of Diana to deceive Callisto, who was one of Diana's nymphs. When bathing, Callisto's pregnancy was discovered by the nymphs, and Diana, who turned her into a bear.

Antonio Allegri, called Il Correggio
Correggio between 1489 and 1494–Correggio 1534

241 The Virgin in an *Assumption*

Red chalk with traces of white heightening.
278 × 238 mm
Provenance J. Richardson, sen. (L 2184);
T. Hudson (L 2432); Sir J. Reynolds (L 2364);
Sir T. Lawrence (L 2445); William II of Holland
(according to JCR); G. Leembruggen; Malcolm.
1895–9–15–720
Literature Popham 13

A study for the Virgin in the *Assumption* in the
cupola of Parma Cathedral, for which Correggio
received a final payment in 1530. The study
corresponds with the painted figure in the upper
part of the body but differs from it in the position
of the legs.

*242 Study for a figure of Eve

Red chalk. 183 × 130 mm
Provenance Sir P. Lely (L 2092); Earl of
Cholmondeley (L 1149); Sir J. Reynolds (L 2364);
R. Ford (L 2209); J. H. Hawkins (according to
JCR); Malcolm. 1895–9–15–738
Literature Popham 12

Like the preceding drawing, this is a study for the
cupola fresco of Parma Cathedral. The apple held
by the attendant angel establishes the identity of
the figure.

Francesco Mazzola, called Il Parmigianino
Parma 1503–Casalmaggiore 1540

243 A man standing in profile, with his
left arm extended

Black chalk and brown wash on brown paper,
heightened with white. 273 × 179 mm
Provenance Mitelli; Resta-Somers (L 2981:
k.86); T. Hudson (L 2432); Sir J. Reynolds
(L 2364); Miss J. Sharpe. 1946–4–13–206
Literature Popham 94*

Inscribed in ink in lower left-hand corner by Padre
Sebastiano Resta: . . . *dal Sg Mitelli Bolognae . . .
ne in Roma 1688. Xbre.*

 This is a study for the figure of St Joseph of
Arimathaea who stands to the left in Par-
migianino's etching of the *Entombment* (B xvi, p.
8, 5), which probably dates from the painter's
Roman period (1523/4–7).

244 Two angels supporting a column

Pen and brown ink and brown wash, over black
chalk. 252 × 171 mm
Provenance T. Hudson (L 2432); Sir J. Reynolds
(L 2364); Prof. W. Bateson. 1900–5–10–1
Literature Popham 122

245 Studies of St John the Baptist preaching

Pen and brown ink and brown wash, heightened
with white, over black chalk and stylus
underdrawing. 155 × 209 mm
Provenance Cavaliere F. Bajardi (see below);
M. Cavalca (see below); J. Richardson, sen.
(L 2184); N. Hone (L 2793); Sir J. Reynolds
(L 2364); R. Payne Knight Bequest. Pp. 2–131
Literature Popham 82

Popham traced the early provenance of this
drawing. He noted that a description of it occurred
in an inventory of the effects of Francesco Bajardi
drawn up probably shortly after the latter's death
in 1561. Vasari relates that the drawings in his
collection were inherited by Bajardi's grandson,
Marcantonio Cavalca.

 There is a possible connexion between this and
the *Madonna and Child with Sts John the Baptist
and Jerome* in the National Gallery, London.

Lelio Orsi
Novellara? *c.*1511–Novellara 1587

246 A man holding a rearing horse

Pen and brown ink. 227 × 177 mm
Provenance Sir J. Reynolds (L 2364);
W. Y. Ottley; Sir T. Lawrence (L 2445);
Phillipps-Fenwick. 1946–7–13–38
Literature Popham 51

This corresponds closely to the group of a man
and a rearing horse in a miniature on parchment
by Orsi of the *Conversion of St Paul* in the
Galleria Estense, Modena. The motif is based on
that in Michelangelo's fresco of the *Conversion* in
the Capella Paolina in the Vatican, Rome
(1546–50). The drawing would appear to date
from the mid-to-late 1550s.

Jacopo Zanguidi, called Il Bertoja
Parma 1544–Parma 1574

247 Studies of nude women and a man's
head

Pen and brown ink. 271 × 170 mm
Provenance N. Lanière (L 2886 and *Supplément*);
J. Richardson, sen. (L 2183); Sir J. Reynolds
(L 2364); R. Payne Knight Bequest. Pp. 2–181
Literature Popham 233

Inscribed in the lower right-hand corner of the *recto* in brown ink, in the hand believed to be Lanière's: *F. Parmagiano*. There can be little doubt, however, that this drawing is by Bertoja.

248 The Coronation of the Virgin

Pen and brown ink and wash, heightened with (partly oxidised) white. 345 × 242 mm (lower left corner made up)
Provenance Sir P. Lely (L 2092); Sir J. Reynolds (L 2364); Sir G. Clausen (L 539). 1943–7–10–17
Literature D. DeGrazia Bohlin, *Master Drawings,* xii, 1974, pp. 363 f.

The old attribution to Niccolò dell' Abbate is not implausible.

Annibale Carracci

Bologna 1560–Rome 1609

249 The Holy Family

Pen and brown ink. 246 × 194 mm
Provenance Resta-Somers (L 2981: *h.147*); Dr R. Mead; Sir J. Reynolds (L 2364); C. M. Cracherode Bequest. Ff. 2–122
Literature D. Posner, *Annibale Carracci,* I, London, 1971, p. 84 and p. 166, note 47

Engraved in reverse by Arthur Pond while in the collection of Dr Richard Mead.

The composition, with several differences is that of a painting in the Durazzo-Pallavicini Collection in Genoa, traditionally attributed to Annibale, but which Posner is inclined to give to Agostino, Annibale's brother.

250 A man with his left arm outstretched, holding a vessel in his left hand

Red chalk and stumping. 244 × 275 mm (lower left corner made up)
Provenance Sir J. Reynolds (L 2364); R. Payne Knight Bequest. Pp. 3–14

Inscribed indistinctly in red chalk, lower left: *Ann Carazzi* (?).

Probably an early drawing, made before the painter's transfer to Rome in 1595.

Federico Barocci

Urbino *c.*1535–Urbino 1612

251 Head of a man looking up: study for a head of Christ

Black and coloured chalks. 326 × 231 mm
Provenance J. Richardson, sen. (L 2184); J. Richardson, jun. (L 2170); Sir J. Reynolds (L 2364); R. Payne Knight Bequest. Pp. 3–199

Literature H. Olsen, *Federico Barocci,* Copenhagen, 1962, p. 203; *Mostra di Federico Barocci,* Bologna, 1975, No. 236

Study for the head of Christ in the *Last Supper* painted in 1590–9 for the Cathedral at Urbino.

This sheet may have been No. 55 in 'Ralph's' Exhibition, 1791 (Graves and Cronin p. 1600; see p. 71).

Domenico Zampieri, called Il Domenichino

Bologna 1581–Naples 1641

252 A man on all fours

Red chalk. 213 × 250 mm
Provenance T. Hudson (L 2432); Sir J. Reynolds (L 2364). 1905–8–10–1

In spite of the traditional attribution to Domenichino, the style of this drawing suggests those in the same medium made by Annibale and Lodovico Carracci in Bologna in the late 1580s and early '90s.

Pier Francesco Mazzucchelli, called Il Morazzone

Morazzone, nr. Varese 1571 or 1573–Piacenza *c.*1626

253 The Vision of St John the Evangelist

Pen and brown ink and brown wash, heightened with white, over black chalk, on (faded) blue paper. 271 × 332 mm
Provenance Sir J. Reynolds (L 2364); R. Payne Knight Bequest. Pp. 4–45

Enea Salmeggia, called Il Talpino

Salmeggia, nr. Bergamo *c.*1558– Bergamo 1626

254 The Marriage of the Virgin

Pen and brown ink and brown wash, heightened with white. 321 × 177 mm
Provenance Sir P. Lely (L 2092); J. Richardson, sen. (L 2183); Sir J. Reynolds (L 2364); Lucas. 1917–12–8–2

A painting of this subject by Salmeggia, but horizontal rather than upright in composition, is in the Villa d'Este at Tivoli.

Domenico Cresti, called Il Passignano

Passignano, nr. Perugia *c.*1560–Florence 1636

255 The entry of Margaret of Austria into Ferrara

Pen and brown wash over red chalk (or reddish underdrawing made with the point of the brush). 326 × 409 mm
Provenance Sir J. Reynolds (L 2364);
G. T. Clough. 1912–2–14–1

Inscribed in ink in an old hand near lower edge to the right: *Passignano.*

This is a design for one of the scenes at the obsequies of the Queen of Spain celebrated in S. Lorenzo in Florence. It was etched in reverse, with minor differences, by Jacques Callot (1592–1635) to illustrate Giovanni Altoviti's *Essequie della Sacra Cattolica e real maestà di Margherita d'Austria regina di Spagna,* Florence, 1612.

Vitzthum suggested (orally) that the drawing could be by Antonio Tempesta, an attribution which has much to recommend it.

Giovanni Francesco Barbieri, called Il Guercino

Cento 1591–Bologna 1666

256 A fortress under siege

Pen and brown ink. 130 × 297 mm
Provenance J. Richardson, sen. (L 2184);
Sir J. Reynolds (L 2364); C. M. Cracherode Bequest. Ff. 2–145

Lieven Mehus

Oudenaerde 1630–Florence 1691

257 Pan reclining with nymphs and a satyr

Pen and brown ink and wash over black chalk. Squared in red chalk. 206 × 244 mm
Provenance Sir J. Reynolds (L 2364); R. Payne Knight Bequest, 1824. Pp. 5–118

Faintly inscribed in brown ink, lower right: *di Livio Mehus;* numbered in red chalk: *26.*

In style this is close to the drawings by the Florentine painter Baldassare Franceschini, called il Volterrano, by whom Mehus, a Fleming whose career was spent in Florence, was much influenced. The inscription is in the same hand as that on other drawings by him.

Pier Francesco Mola

Coldrerio, nr. Como 1612–Rome 1666

258 Head of a man wearing a hat

Black and red chalks. 253 × 216 mm
Provenance J. Richardson, sen. (L 2184);
J. van Rijmsdijk (L 2167); Sir J. Reynolds (L 2364); R. Payne Knight Bequest. Pp. 4–89

The partly erased inscription in brown ink in the lower right-hand corner is now indecipherable.

With the difference that the man wears a wide-brimmed hat, the head resembles in reverse that of Nicodemus in Barocci's *Entombment* in S. Croce, Senigallia; in Barocci's painting Nicodemus wears a turban.

Carlo Maratta

Camerano, the Marches 1625–Rome 1713

259 A caricature head of a man with glasses, seen in profile

Red chalk. 186 × 154 mm
Provenance R. Houlditch (L 2214);
Sir J. Reynolds (L 2364); C. M. Cracherode Bequest. Ff. 3–206

Engraved in reverse by Arthur Pond while in the collection of Richard Houlditch. Reynolds owned another almost identical but weaker version of the drawing which was sold at Christie's, 30 March 1976, lot No. 61.

* **260** St John the Evangelist

Red chalk on blue paper. 394 × 256 mm
Provenance Sir J. Reynolds (L 2364).
1938–6–11–7

For the figure of St John the Evangelist who appears standing to the left in the altarpiece, *St John the Evangelist disputing the subject of the Immaculate Conception of the Virgin with the Church Fathers, Sts Gregory, John Chrysostom and Augustine,* painted in 1686 for the Cappella Cybò in S. Maria del Popolo, Rome. The pose corresponds almost exactly with that of the figure in the painting.

261 Four studies of cherubs' heads

Red chalk on blue paper. 237 × 237 mm
Provenance J. van Haecken (L 2517);
T. Hudson (L 2432); Sir J. Reynolds (L 2364).
1872–10–12–3295

262 Study of a draped and bearded man carrying wood

Red chalk, heightened with white, on blue paper.
405 × 234 mm
Provenance J. Richardson, sen. (L 2183);
J. Barnard (L 1419); Sir J. Reynolds (L 2364).
1938–6–11–8

A study for the figure entering the room carrying fire-wood to the far right of the *Death of the Virgin* in the Villa Albani, Rome, which Maratta painted in *c.*1686.

Giovanni Battista Marcola

Verona 1711–Verona 1780

263 The Nativity

Pen and brown ink and wash over black chalk.
386 × 277 mm (arched top)
Provenance Sir J. Reynolds (L 2364);
Sir G. Clausen (L 539). 1943–7–10–11
Literature A. Bettagno, *Disegni di una Collezione veneziana del Settecento,* exhibition catalogue, Fondazione Cini, Venice, 1966, No. 128

Inscribed, lower left, in the 'reliable Venetian hand': *Giambatista Marcola Veronese.*

Domenico Piola

Genoa 1627–Genoa 1703

264 St Luke painting the Virgin

Black chalk, pen and brown ink and wash, heightened with white, on blue paper.
253 × 382 mm (arched top)
Provenance J. Richardson, sen. (L 2184);
T. Hudson (L 2432); Sir J. Reynolds (L 2364);
R. Payne Knight Bequest. Pp. 4–50
Literature M. Newcome, *Genoese Baroque Drawings,* exhibition catalogue, University of New York at Binghamton, 1972, under No. 89

A study for the apse fresco in the church of S. Luca, Genoa. Another study for the whole composition, but less finished, is in the Cooper-Hewitt Museum, New York.

Antonio Guardi

Venice 1698–Venice 1760

265 Allegory of Venice

Pen and brown ink with grey wash and yellow watercolour. Traces of red chalk underdrawing.
252 × 174 mm (oval)
Provenance Sir J. Reynolds (L 2364);
A. M. Champernowne (L 153, *recto*).
1910–10–13–6
Literature A. Morassi, *Tutti i Disegni di Antonio, Francesco e Giacomo Guardi,* Venice, 1975, No. 48

Though at first attributed to Francesco, it is now generally agreed that this is by his elder brother Antonio.

School of Antwerp, Early XVI Century

266 Allegory of Charity

Pen and black ink and red wash, some areas in brown ink. 277 × 174 mm
Provenance Sir J. Reynolds (L 2364);
W. Esdaile (L 2617); F. D. Harford.
1911–4–12–2
Literature P. anon. 33

Inscribed on left tablet in Greek capitals. In translation: 'You will live rightly, nursing your parents in their old age'. On the right tablet in Latin. In translation: 'This is my commandment, that ye love one another as I have loved you' (John xv 12).
 The drawing was attributed to Dürer when in Esdaile's collection and possibly also when owned by Reynolds. Popham considered it to be the work of an Antwerp artist who had visited Italy, and dated it about 1530.

Pieter Pourbus

Gouda *c.*1510–Bruges 1584

267 Design for a triptych with scenes from the legend of St Barbara

Pen and black ink over red chalk. 174 × 292 mm
Provenance Sir J. Reynolds (L 2364).
1951–7–14–324

Lucas Van Leyden

Leyden 1494–Leyden 1533

268 The Circumcision

Drawn with the point of the brush in black ink.
197 × 139 mm
Provenance Sir J. Reynolds (L 2364); H. B. Ray.
1856–7–12–991
Literature P. 5

269 Two studies of a nude woman holding a mirror

Silverpoint on light cream prepared paper, with some pen and brown ink around the hips of the figure on the right. 335 × 220 mm
Provenance Sir J. Reynolds (L 2364 *verso*); Sir T. Lawrence (L 2445); Sir J. C. Robinson (L 1433 *erased*); Malcolm. 1895–9–15–979
Literature J. K. Rowlands, *Master Drawings*, x, 1972, pp. 284–286

In the nineteenth century, and possibly also in Reynolds' day, the present drawing was attributed to Dürer. The pose of the nude was closely followed by Reynolds in his figure of Prudence in his design for the window of New College, Oxford (see p. 69).

Sir Peter Paul Rubens

Siegen, Westphalia 1577–Antwerp 1640

270 A sheet of studies: below, a dragon struggling with animals; above a lion hunt

Pen and brown ink. Traces of black chalk underdrawing. 574 × 485 mm
Provenance P. H. Lankrink (L 2090); Sir J. Reynolds (L 2364);? Sir T. Lawrence; P. L. Huart; W. Russell. 1885–5–9–51
Literature Hind 1; D. Rosand, *Art Bulletin*, LI, 1969, pp. 31f.; J. K. Rowlands, *Rubens*, exhibition catalogue, British Museum, 1977, No. 89

The sketches on the lower half of the sheet are connected with the *Fall of the Damned* in Munich of 1621. The studies of a *Lion Hunt* seem to derive from a painting, now lost, executed *c*.1615–6 for the Elector of Bavaria.

The *verso* contains studies for the *Assumption of the Blessed*, a painting entirely executed by Rubens' studio and now in Munich.

271 Portrait of Hendrik van Thulden

Black chalk. 374 × 262 mm
Provenance J. Richardson, sen. (L 2184); T. Hudson (L 2432); Sir J. Reynolds (L 2364). 1845–12–8–5
Literature Hind 44 (as Van Dyck); J. S. Held, *Rubens–Selected Drawings*, 1959, No. 86; L. Burchard and R. A.-d'Hulst, *Rubens Drawings*, 1963, No. 109; J. K. Rowlands, *Rubens*, exhibition catalogue, British Museum, 1977, No. 78

A study for the portrait in Munich. The sitter was pastor at St Joris, Antwerp, from 1613 to his death in 1617.

Sir Anthony Van Dyck

Antwerp 1599–London 1641

272 Portrait of John, Count of Nassau-Siegen

Black chalk, heightened with white, on grey-blue paper. 514 × 388 mm
Provenance J. Richardson, sen. (L 2184); T. Hudson (L 2432); Sir J. Reynolds (L 2364). 1845–12–8–3
Literature LB 34; Hind 41; H. Vey, *Die Zeichnungen Anton Van Dycks*, 1962, No. 201

A study for the portrait in the Liechtenstein collection. On the *verso* are two portrait studies of Cesare Alessandro Scaglia, abbot of Staffarda near Saluzzo in Piedmont.

273 Portrait of a lady

Black chalk, heightened with white, on blue-grey paper. 528 × 343 mm
Provenance J. Richardson, sen. (L 2184); T. Hudson (L 2432); Sir J. Reynolds (L 2364). 1845–12–8–6
Literature LB 62; Hind 71; H. Vey, *Die Zeichnungen Anton van Dycks*, 1962, No. 219

274 Portrait of John, Count of Nassau-Siegen

Black chalk, heightened with white, on blue-grey paper. 455 × 313 mm
Provenance J. Richardson, sen. (L 2184); T. Hudson (L 2432); Sir J. Reynolds (L 2364). 1845–12–8–4
Literature LB 32; Hind 40; H. Vey, *Die Zeichnungen Anton Van Dycks*, 1962, No. 199

A study for the family portrait of the Count in the collection of Lady Gage, Firle Place, Sussex.

275 Study of a man

Black chalk on grey paper. 413 × 254 mm
Provenance P. H. Lankrink (L 2090); J. Richardson, sen. (L 2184); T. Hudson (L 2432); Sir J. Reynolds (L 2364); E. Prentis. 1850–4–13–129
Literature LB 56; Hind 36; H. Vey, *Die Zeichnungen Anton Van Dycks*, 1962, No. 194

Inscribed, lower left: *A. v. Dyck.*
Binyon took the inscription to be a signature. On the *verso* are studies of hands and drapery.

276 Drapery study; Lord Bernard Stuart

Black chalk, heightened with white, on blue-grey paper. 430 × 287 mm (corners cut)

Provenance J. Richardson sen. (L 2184);
T. Hudson (L 2432); Sir J. Reynolds (L 2364).
1845–12–8–10
Literature LB 53; Hind 65; H. Vey, *Die
Zeichnungen Anton van Dycks,* 1962, No. 231

A study for the double portrait of Lord Bernard
Stuart and his older brother, John, in the col-
lection of Lady Mountbatten.

277 A design for ornament

Pen and brown ink and brown wash, heightened
with (partly oxidised) white, on grey-brown
paper. 136 × 173 mm
Provenance N. A. Flinck (L 959);
Sir J. Reynolds (L 2364); R. Payne Knight
Bequest. Oo. 9–51
Literature LB 16; Hind 29

The design was engraved in reverse by Lucas
Vorsterman.

278 A study of trees

Pen and brown ink and brown wash with green
watercolour. 195 × 237 mm
Provenance J. Richardson, sen. (L 2183);
Sir J. Reynolds (L 2364); R. Payne Knight
Bequest. Oo. 9–50
Literature LB 71; Hind 82; H. Vey, *Die
Zeichnungen Anton Van Dycks,* 1962, No. 303

Attributed to Jacob Jordaens
Antwerp 1593–Antwerp 1678

279 A nude man seated

Black chalk, heightened with (partly oxidised)
white on blue-grey paper. Touched with red
chalk. 264 × 329 mm
Provenance Sir J. Reynolds (L 2364); R. Payne
Knight Bequest. Oo. 9–62
Literature Hind 12

Cornelis Schut
Antwerp 1597–Antwerp 1655

280 The Rape of Europa

Pen and black ink and brown wash. Touched
with red chalk and grey bodycolour.
180 × 262 mm
Provenance J. Richardson, sen? (L 2184, written
by hand); Sir J. Reynolds (L 2364); E. Rose.
1943–11–13–67

Two other versions of this subject by Schut are
known, but have little connection with the present
drawing. The artist was a pupil of Rubens and a
prolific print-maker.

Rembrandt van Rijn
Leyden 1606–Amsterdam 1669

281 Titus Manlius having his son executed

Pen and brown ink and wash. 197 × 221 mm
Provenance Sir J. Reynolds (L 2364); G. Salting
Bequest. 1910–2–12–178
Literature Hind 91; O. Benesch, *The Drawings
of Rembrandt,* 1954–7, No. 1382

This drawing was considered by Benesch to be the
work of a pupil of Rembrandt, to which the
master himself had added the two boys bearing the
train of Titus Manlius' mantle.

282 The Lamentation at the Foot of the Cross

Pen and brown ink and wash with grey oil
colours over red and black chalks. 216 × 254 mm
(The sheet has been cut and reassembled several
times.)
Provenance J. Richardson, jun. (L 2170);
Sir J. Reynolds (L 2364); R. Payne Knight
Bequest. Oo. 9–103
Literature Hind 60; O. Benesch, *The Drawings
of Rembrandt,* 1954–7, No. 154; A. Harris,
*Master Drawings,*VII, 1969, pp. 158–164

Inscribed on a piece of paper evidently once on the
old mount (this is now laid down on the back of
the present mount) in the hand of Jonathan
Richardson, jun.: *'Rembrandt has Labour'd this
Study for the lower part of his famous Descent
from the Cross, grav'd by Picart, and had so often
chang'd his Mind in the Disposition of the
Clair-Obscur, which was his Point Here, that my
Father and I counted, I think, seventeen different
pieces of Paper'.*

A study for the painting of this subject in the
National Gallery, London, which was also in
Reynolds' collection. Northcote (vol I, pp. 261 f.),
remembered bidding for this drawing at the
younger Richardson's sale in 1772: 'I attended
every evening of the sale, by Sir Joshua's desire,
and much to my own gratification, as I had never
before seen such excellent works. I purchased for
Sir Joshua those lots which he had marked, con-
sisting of a vast number of extraordinary fine
drawings and prints by and from old masters;
which greatly increased his valuable collection.
One drawing in particular I remember, a descent
from the cross by Rembrandt, in which were to be
discovered sixteen alterations, or *pentimenti,* as
the Italians term it, made by Rembrandt, on bits

of paper stuck upon the different parts of the drawing, and finished according to his second thoughts'.

School of Rembrandt van Rijn

283 Landscape with a wood

Pen and brown ink with brown and grey wash. Some reddish brown wash. 143 × 221 mm (arched top)
Provenance N. Lanière? (L 2908 and *Supplément*); J. Richardson, sen. (L 2184); Sir J. Reynolds (L 2364); R. Payne Knight Bequest. Oo. 10–125
Literature Hind 163

Jan Erasmus Quellinus
Antwerp 1634–Mecheln 1715

284 A classical scene within an architectural framework

Pen and brown ink with watercolours and oil colours. 305 × 251 mm
Provenance Sir J. Reynolds (L 2364); R. Payne Knight Bequest. Oo. 10–223
Literature Hind 1

David Teniers the Younger
Antwerp 1610–Antwerp 1690

285 Eight studies of a soldier

Pencil. 239 × 375 mm
Provenance Sir J. Reynolds (L 2364); E. Prentis. 1850–4–13–125
Literature Hind 1

Claude Gellée le Lorrain
Chamagne 1600–Rome 1682

286 Landscape with St Eustace

Pen and brown ink and brown wash, heightened with (much oxidised) white. 196 × 260 mm
Provenance Sir J. Reynolds (L 2364); R. Payne Knight Bequest. Oo. 8–248
Literature A. M. Hind, *British Museum: Drawings of Claude*, 1926, No. 307; M. Röthlisberger, *Claude, the Drawings*, 1968, No. 1025

Follower of Nicolas Poussin
Villiers, nr. Les Andelys 1594–Rome 1665

287 The sacrifice at Lystra

Black chalk and grey-brown wash. Perspective lines marked with the stylus. 260 × 357 mm
Provenance J. Richardson, sen. (L 2184); T. Hudson (L 2432); Sir J. Reynolds (L 2364); Malcolm. 1895–9–15–925
Literature JCR 472; W. Friedländer (ed.), *The Drawings of Nicolas Poussin*, vol. 1, No. B19

François Boucher
Paris 1703–Paris 1770

288 A woman, seated, with a basket

Black chalk, heightened with white, on blue paper. 308 × 218 mm
Provenance Sir J. Reynolds (L 2364); W. Mayor (L 2799); presented by J. E. Taylor. 1868–6–12–1868
Literature A. Ananoff, *François Boucher*, 1976, No. 350/8, fig. 1026

The pose of the woman is similar to that of a figure in Boucher's painting of the *Rape of Europa* in the Louvre and in a tapestry, *Le Marchand d'Oeufs,* in the Metropolitan Museum of Art, New York.

 A drawing by Boucher in the Museum of Fine Arts, Boston, has on the *verso* an inscription: *Given me by Boucher. J. Reynolds,* (cf. Regina Shoolman Slatkin, *Burlington Magazine,* CXV, 1973, p. 676). In the Twelfth Discourse delivered in 1784 Reynolds describes a visit he had made to Boucher's studio in Paris 'some years since' (Discourses, pp. 224–5). It is most likely that this had been in 1768.

Alphabetical Index of Artists

Name	Cat. No.	Name	Cat. No.	Name	Cat. No.
Anon. School of Antwerp	266	Ghirlandaio, D.	202	Pontormo	223
Abbate, N. dell'	248	Giovanni da Udine	212	Pourbus, P.	267
Angelico, Fra	204	Giulio Romano	211	Poussin (school)	287
Bandinelli, B.	222	Guardi, A.	265	Primaticcio	231
Barocci, F.	251	Guercino	256	Quellinus, E.	284
Bartolommeo, Fra	207, 208	Jordaens	279	Raphael	209
Bassano, J.	237	Leonardo	203	Rembrandt	281–283
Beccafumi	224	Lucas van Leyden	268, 269	Rosso	221
Bernini, G. L.	235	Maratta, C.	259–262	Rubens	270, 271
Bertoja	247, 248	Marcola	263	Ryland	210
Boucher	288	Mehus	257	Salmeggia	254
Carracci, Annibale	249, 250	Michelangelo	217–219	Salviati, G.	240
Cigoli	233, 234	Mola, P. F.	258	San Gallo, F. da	205
Claude	286	Morazzone	253	Schut, C.	280
Correggio	241, 242	Orsi, L.	246	Signorelli	201
Daniele da Volterra	220	Palma Giovane	232	Teniers the Younger	285
Domenichino	252	Parmigianino	243–245	Tintoretto	236
Dyck, A. van	272–278	Passignano	255	Titian	238
Farinati	239	Perugino	206	Zuccaro, T.	228, 229
Franco, B.	225–227	Piola	264		
		Polidoro	213–216, 230		

Appendix: List of Auctions and Sales where Reynolds is recorded.

Note: the abbreviations are the same as those in Lugt, *Ventes.* I have occasionally given the shelf-mark of catalogues not in Lugt. This list has no claim to be complete, and should be seen, rather, as a starting point.

TABLE I: Sales where Reynolds is recorded as a Purchaser

Date	Location	Provenance	Lugt No.	Copy consulted. Comments
1742, 8–13 March	Cock	Edward, Earl of Oxford	553	BML (see p. 65)
1745	Unknown	Mr Glover	–	VAL (ref. RC.S.1) (see p. 65)
1747, 22 Jan–10 Feb	Cock	J. Richardson, sen.	653	BMPL (see p. 65)
1756, 26–28 March	Langford	James Gibbs	912	VAL (ref. RC.S.2)
1756, 1–2 April	Prestage	J. de Pester	916	VAL (see p. 66)
1756, 14–15 April	Langford	C. Batt	919	VAL (ref. RC.S.1) (see p. 66)
1756	Unknown	Dr Robert Bragge	–	VAL qq. n. (see p. 66)
1756	Unknown	'Vandergucht'	–	VAL (ref. RC.S.1) qq. n. (see p. 66)
1757, 23 March	Langford	Moses Hart	951	VAL (ref. RC.S.1)
1757, 17–19 May	Ford	George Vertue	964	BMPL (see p. 66)
1757	Unknown	'Mr Bagnal and Lady Arthur'	–	VAL (ref. RC.S.1) qq. n.
1757	Unknown	Dr Robert Bragge	–	VAL (ref. RC.S.1) qq. n. (see p. 66)

Date	Location	Provenance	Lugt No.	Copy consulted. Comments
1757	Unknown	Mr Kent	–	VAL (ref. RC.S.1) qq. n.
1757	Unknown	'Rongent'	–	VAL (ref. RC.S.1) n.
1758, 17 Jan, etc.	Langford	Alexander Van Haecken	984	VAL (ref. RC.S.2) n.
1758, 17–18 March	Prestage	Dr Robert Bragge	–	VAL (ref. RC.S.2) q.q.n.
1758, 26–28 April	Langford	Sir Luke Schaub	1004	VAL: BML; BMPL. n. (see p. 66)
1758	Unknown	Fouquier	–	VAL (ref. RC.S.2) n.
1758	Unknown	'Mr Furnsese'	–	VAL (ref. RC.S.2) qq. n.
1758	Unknown	'Rongent'	–	VAL (ref. RC.S.2) n.
1758	Unknown	Duke of Rutland	–	VAL (ref. RC.S.2) n. inc. (see p. 66)
1758	Unknown	Lord Southwell	–	VAL (ref. RC.S.2) qq. n.
1759, 25 April–3 May	Langford	Arthur Pond	1048	VAL (ref. RC.S.2) inc.
1759	Unknown	Dr Robert Bragge	–	VAL (ref. RC.S.2) n.
1760, 12–14 February	Langford	Richard Houlditch	1078	COL (BMPL typescript copy) qq. n.
1763, 16–19 November	Prestage	Earl of Waldegrave	1328	See Reynolds' own sale, Christie's, 13 March 1795, lot 92; A. Blust, Poussin, A Critical Catalogue, 1966, under No. 185
1764, 10 May	Langford	Lady Sidney Sherrard	1385	PKA (photocopy in Mellon Centre) qq. n.
1772, 5 February	Langford	J. Richardson, jun.	–	BMPL; VAL. (see 282)
1773, 31 March–3 April	Langford	James West	2152	BML; qq. n.
1774, 22–23 April	Christie	Sir George Colebrook	2275	CL. (no lots bt Reynolds, see Leslie and Taylor, II, p. 81)
1779, 15 March, etc.	Langford	Thomas Hudson	2972	BMPL
1784, 15–22 March	Christie	Nathaniel Hiller	3691	CL. Reynolds bt 4 lots, and left unsuccessful bids with the auctioneer for 9 others
1785, 7–15 February	Hutchins	Nathaniel Hone	3824	BMPL. Reynolds himself is not recorded, but many drawings from his collection bear Hone's mark
1785, 28 February, etc.	Hutchins	Peter Romilly	3836	BMPL
1786, 15 February, etc.	Hutchins	William Woollett	3985	BMPL
1787, 16 February, etc.	Greenwood	John Barnard	4145	BMPL; VAL
1787, 26–27 April	Christie	Sir John Taylor	4176	CL
1787, 9–10 May	Christie	'A Man of Fashion'	4185	CL
1788, 17–22 March	Christie	Comte D'Adhemar	4285	CL. 2 lots bt Reynolds, both reappear in his own sale
1790, 13 February	Christie	Peter Delme	4527	CL. Reynolds bt through his agent, Grozier, a study of horses attributed to Van Dyck, now in the National Gallery
1791, 9 and 11 April	Christie	Richard Dalton	4704	CL. Reynolds bought 4 lots through his agent, Grozier, which reappear in his own sale

TABLE II: Other sales apparently attended by Reynolds or one of his Agents

Date	Location	Provenance	Lugt No.	Copy consulted Source of Information
1768	Paris	de Merval	1681	(See p. 73, n. 28)
1769	Paris	Unknown	–	See Northcote, I, p. 202
1770	Langford	Lady Elizabeth Germain	1806	See Reynolds Letters p. 27
1770	Christie	Count Brühl	1813	See Reynolds own sale of 1795, 4th day, lot 93
1771	Paris	Thiers-Crozat	–	(See pp. 66f.)
1775	Christie	Hon. Felton Hervey	2352	CL. Reynolds may have bt through Northcote, who bt 3 lots (see 282)
1775	London	Unknown	2376?	See Susan M. Radcliffe, *Sir Joshua's Nephew,* 1930, p. 86
1776	Christie	Consul Jos. Smith	2534	(See 235)
1777	Christie	Lord Cholmondeley	2640	See Reynolds' own sale of 1795, 3rd day, lot 96
1779	Squibb	Unknown	–	Reynolds' Pocket Book, 28 April: '12 Auction at Squibbs' (Whitley Papers, I, p. 28)
1780	Squibb	Lord Ossory	–	Reynolds' Pocket Book, 13 May (Graves and Cronin, p. 1546)
1786	Skinner	Portland Museum	4028	Walpole letter, 18 June (Paget-Toynbee ed., vol. XIII, p. 388)
1787	Greenwoods	Unknown	–	Pocket Book 23 March (Whitley Papers, I, p. 71)
1787	Unknown	Lord Northington	–	Reynolds Letters, pp. 175f.
1787	Christie	Matthew Duane	4181	BMPL. Reynolds may have bought through Grozier
1788	Pall Mall	Dr Newton, Bishop of Bristol	–	VAL (ref. 23PP). Lot 123 is Correggio's *Marriage of St Catherine* (see p. 68)
1789	Greenwoods	Unknown	–	Pocket Book, 10 March (Whitley Papers, I, p. 88)
1790	Christie	Chauncey	4556	See Reynolds' own sale of 1795, 4th day, lot 79
1790	Unknown	Unknown	–	See Whitley Papers, I, p. 97

TABLE III: Sales at which Reynolds' Collections of Paintings and Drawings were dispersed

Date	Paintings/ Drawings	Location	Lugt No.	Copy consulted. Comments
1794, 26 May, etc.	Drawings	Poggi	–	BMPL. Total realised: £570 12s. 6d. (see pp. 61f.)
1795, 11–14 March	Paintings	Christie	5284	BMPL. *Burlington Magazine,* 1945. Total realised: £10,319 2s. 6d. (see p. 64)
1795, 27 April, etc.	Paintings	Bryan	–	BMPL. Fifteen paintings from Reynolds' collection were included. Twelve of these reappear at Lady Thomond's sale, 1821
1798, 5–26 March	Drawings	Phillips	5722	BMPL. Total realised: £1,903 16s. 6d. (see pp. 61f.)
1798, 8–9 May	Paintings A few drawings	Phillips	5755	Graves and Cronin, IV, pp. 1645ff. Includes some paintings 'bought in' in 1795 (Lugt 5284)
1821, 16–17 May*	Drawings	Christie	10039	BMPL. 1,595 Drawings were sold in multiple lots. Many of these had no doubt been 'bought in' in 1798 (Lugt 5722)
1821, 18–19 May*	Paintings	Christie	10042	Graves and Cronin, IV, pp. 1655ff.
1821, 26 May*	Drawings	Christie	10045	Graves and Cronin, IV, pp. 1665ff. Included 390 Old Master drawings

*The sales of 1821 took place after the death of Lady Thomond, who had inherited Reynolds' collections at his death.

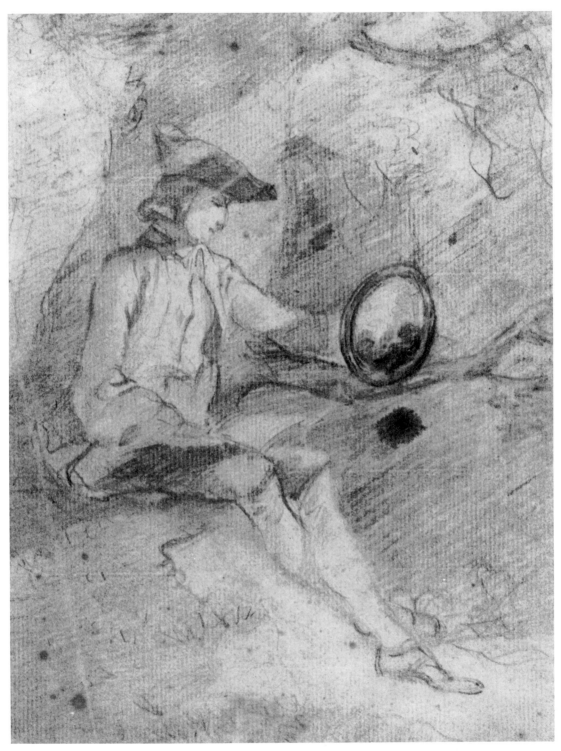

14 *Gainsborough* Man with a Claude glass

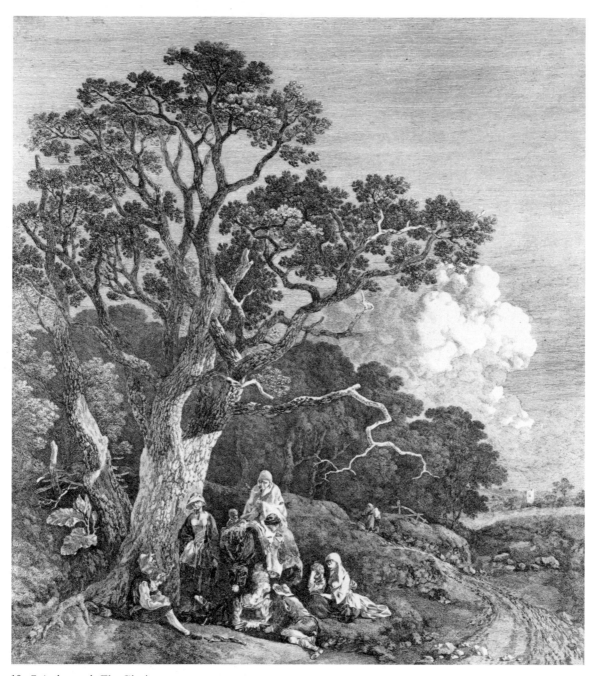

10 *Gainsborough* The Gipsies

right above **18** *Gainsborough* Willows

right below **19** *Gainsborough* Trees with a pool

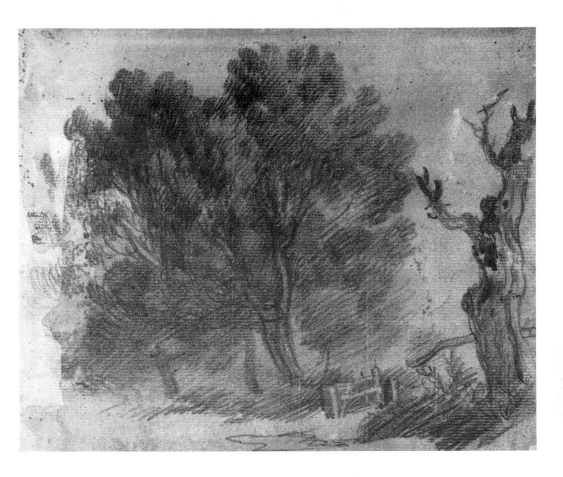

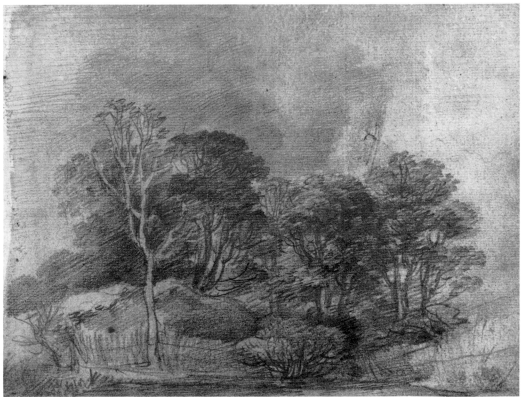

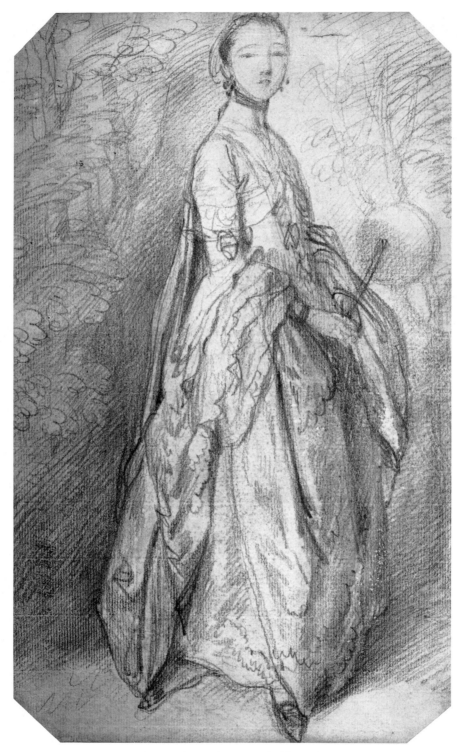

23 *Gainsborough* Woman holding a fan

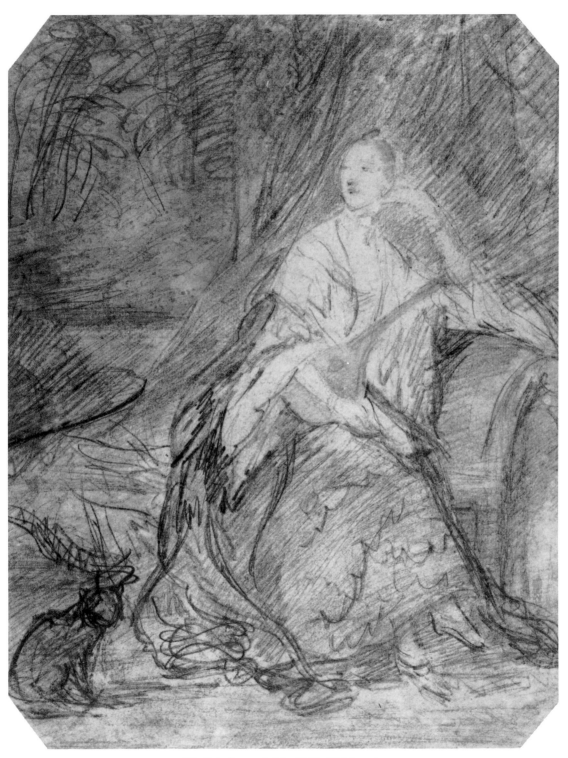

25 *Gainsborough* Mrs Philip Thicknesse

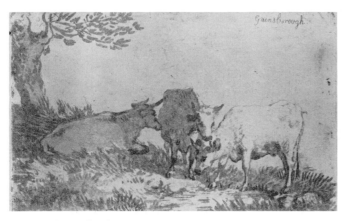

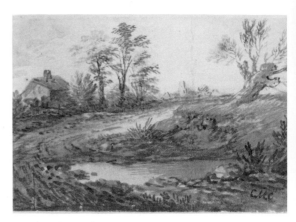

28 *Gainsborough* Three cows

26 *Gainsborough* Landscape with track and cottage

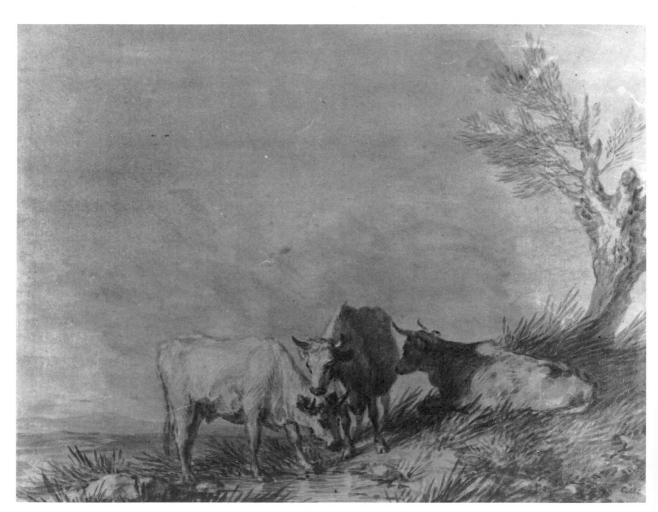

27 *Gainsborough* Open landscape with cows

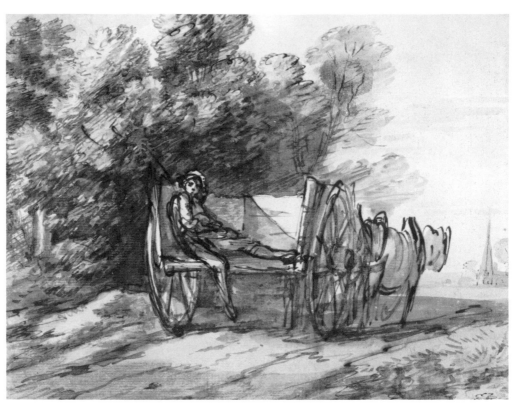

35 *Gainsborough* Boy reclining in a cart

34 *Gainsborough* Landscape with carts and figures

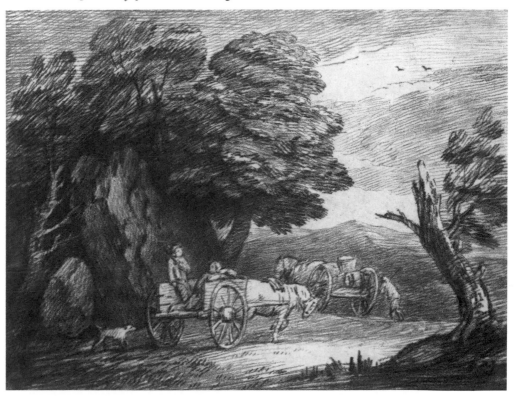

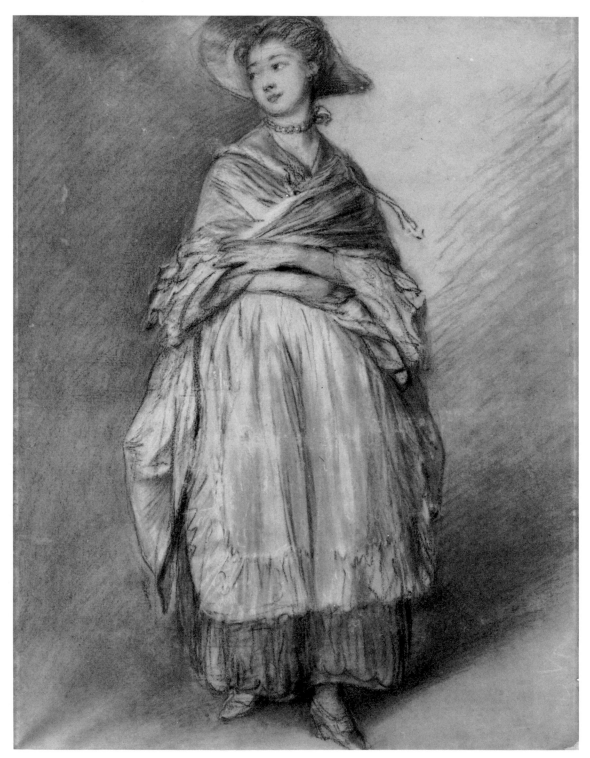

30 *Gainsborough* Mary Gainsborough

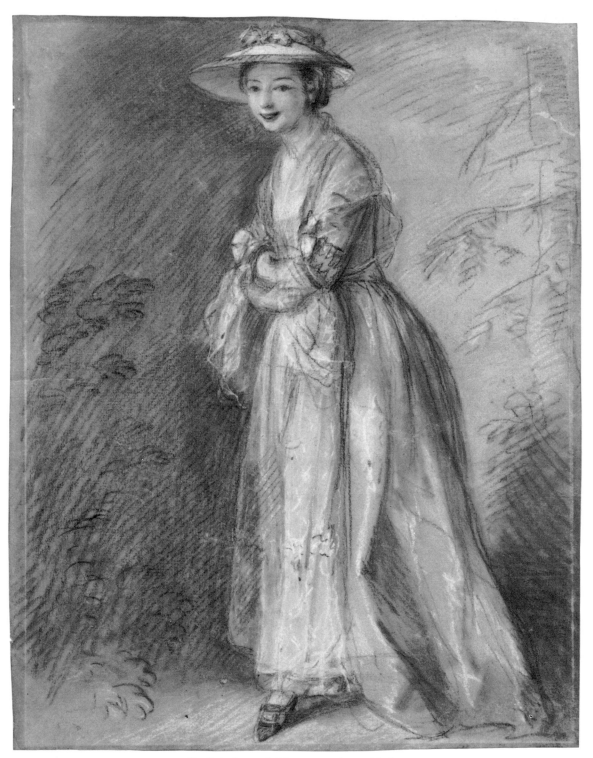

29 *Gainsborough* Woman wearing a chip hat

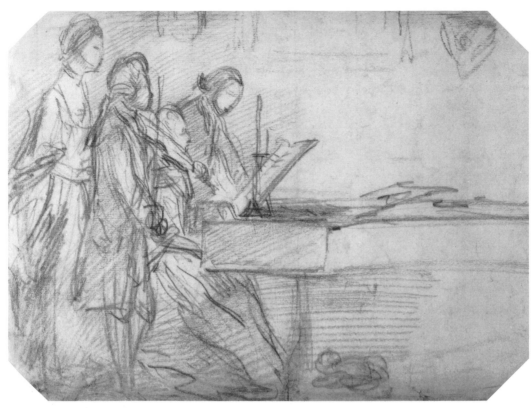

37 *Gainsborough* A music party

43 *Gainsborough* Coast scene with boats

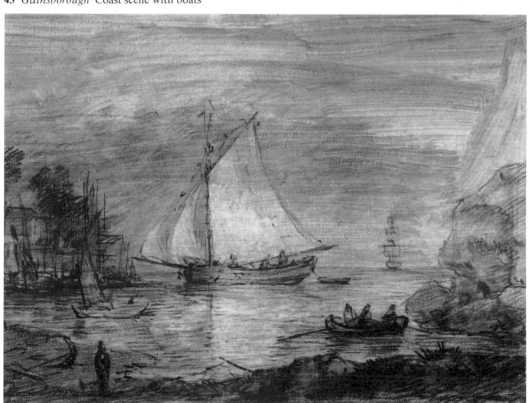

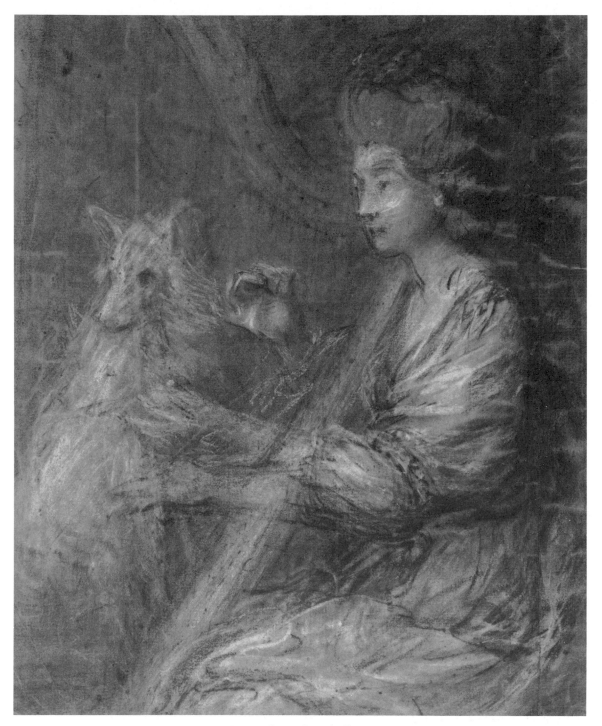

38 *Gainsborough* Lady Clarges

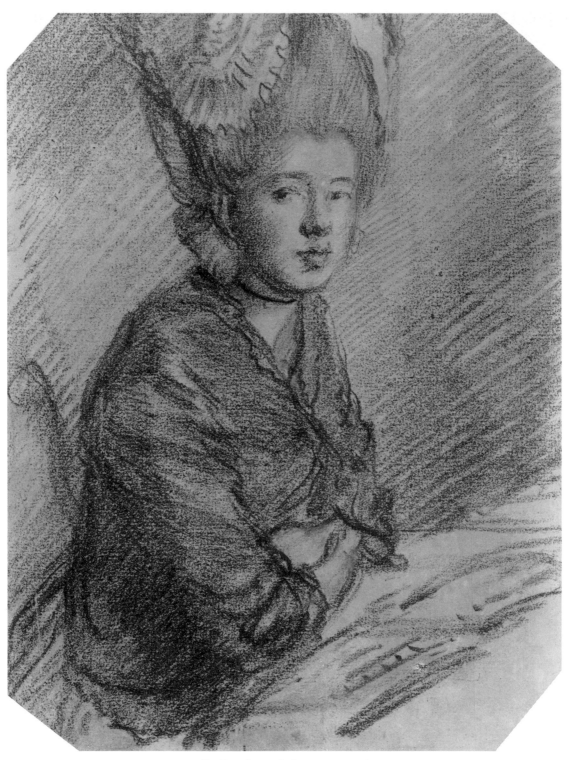

42 *Gainsborough* A woman seated

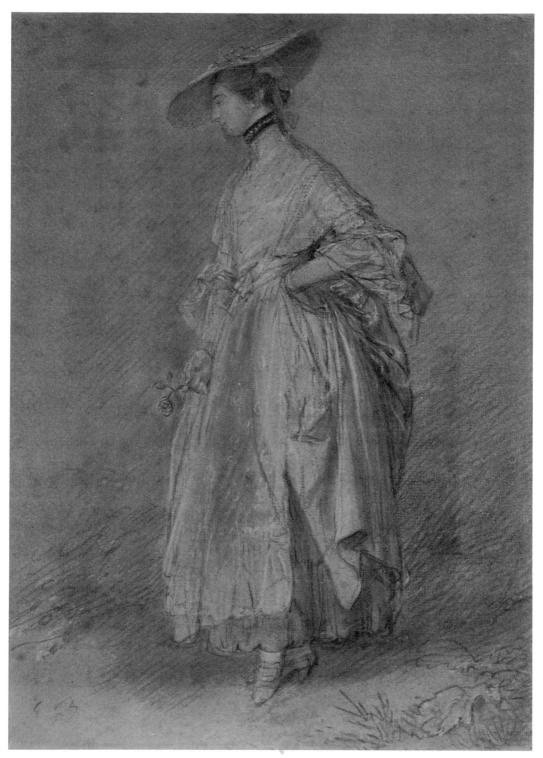

41 *Gainsborough* A woman with a rose

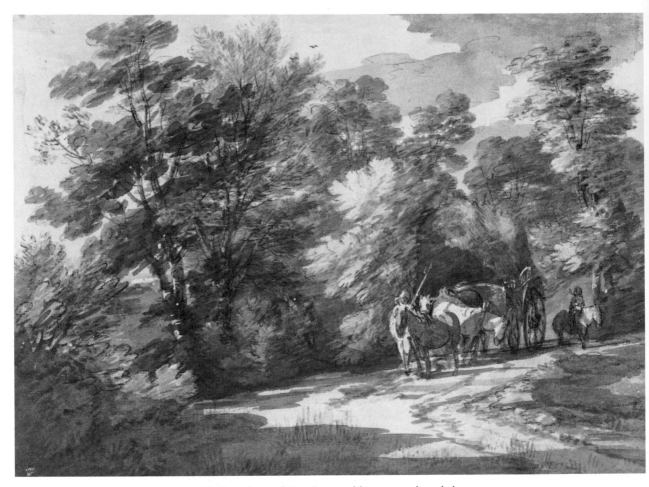

54 *Gainsborough* Landscape with a waggon in a glade

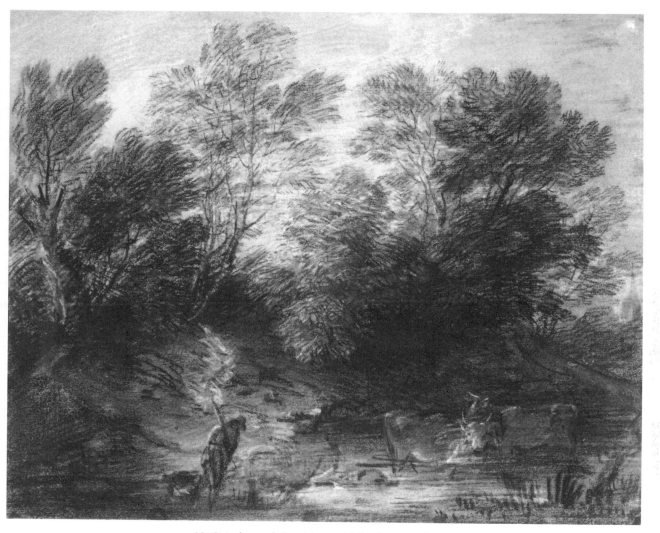

46 *Gainsborough* Landscape with herdsman and cows

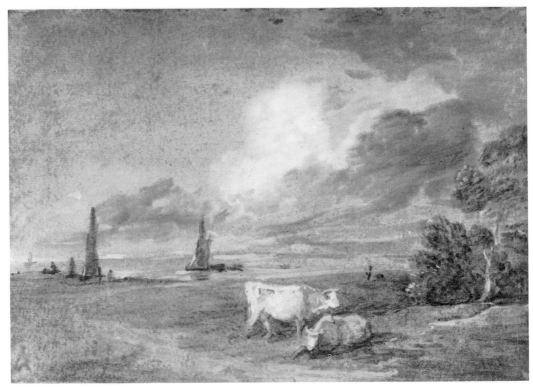

64 *Gainsborough* Coast scene with shipping and cows

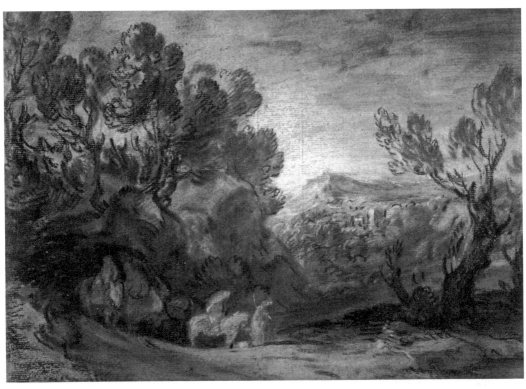

67 *Gainsborough* Rocky landscape with figures on horseback

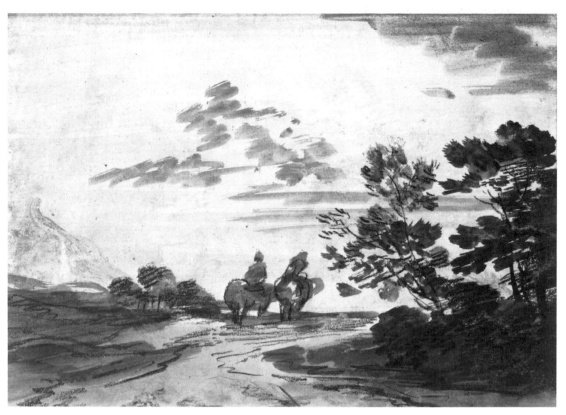

68 *Gainsborough* Open landscape with figures on horseback

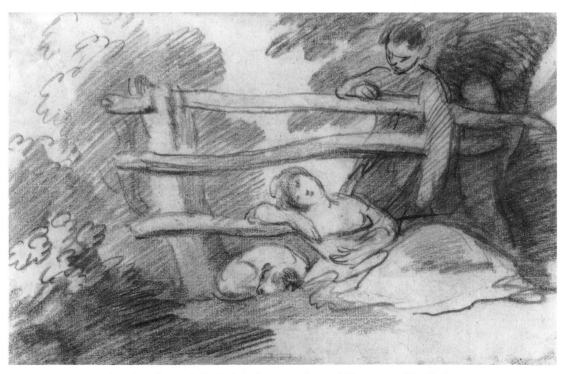

71 *Gainsborough* Study for *The Haymaker and Sleeping Girl at a Stile*

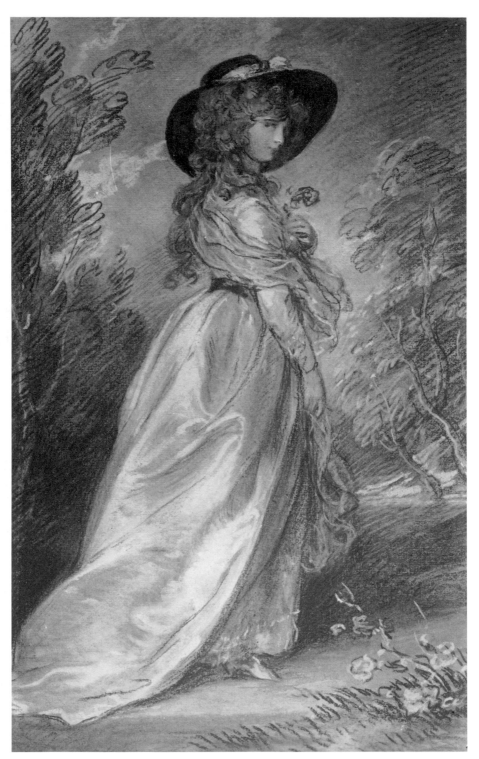

72 *Gainsborough* A lady walking to the right

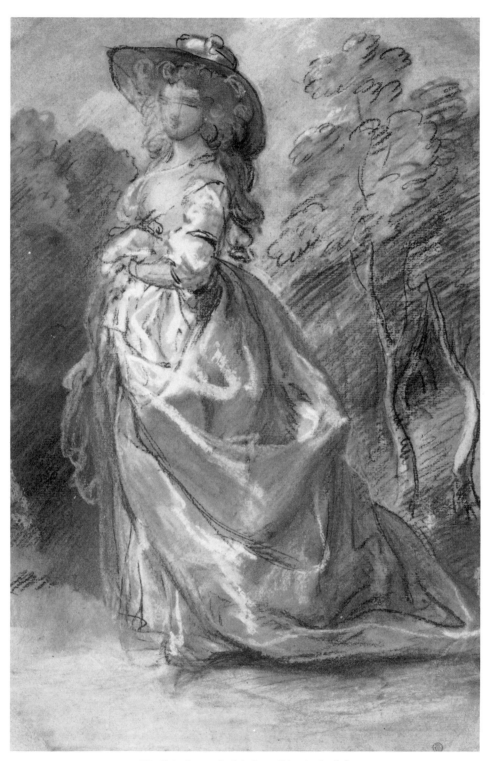

73 *Gainsborough* A lady walking to the left

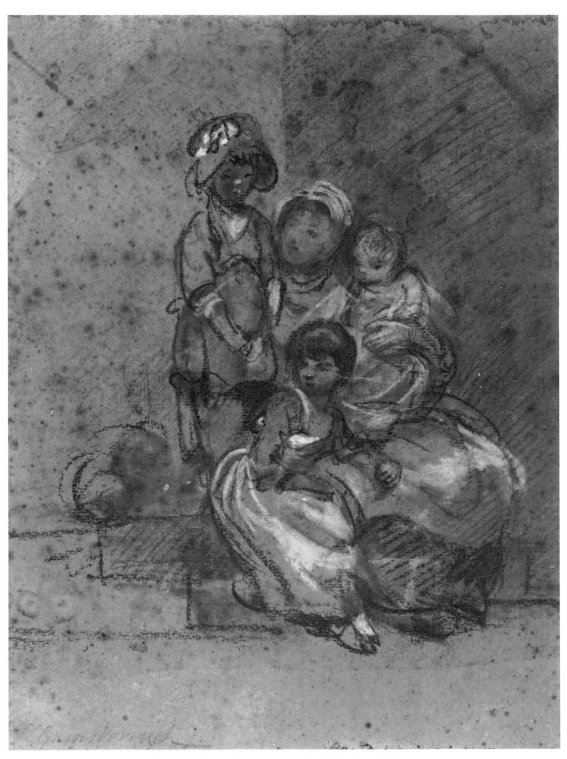

70 *Gainsborough* A woman seated with three children

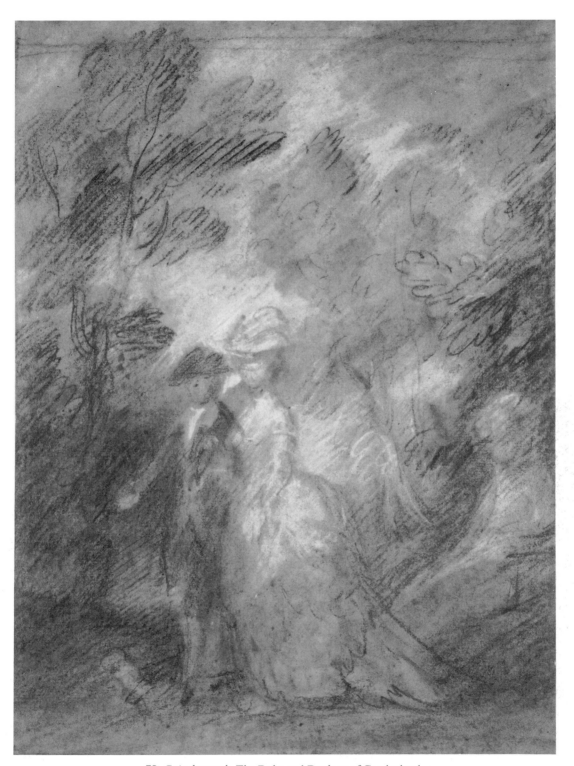

78 *Gainsborough* The Duke and Duchess of Cumberland

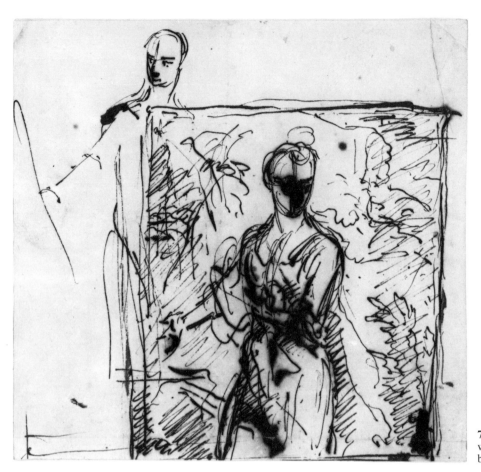

79 *Reynolds* Artist's studio with a painter (?) standing behind a female portrait

82 *Reynolds* A recumbent lady, after Kneller

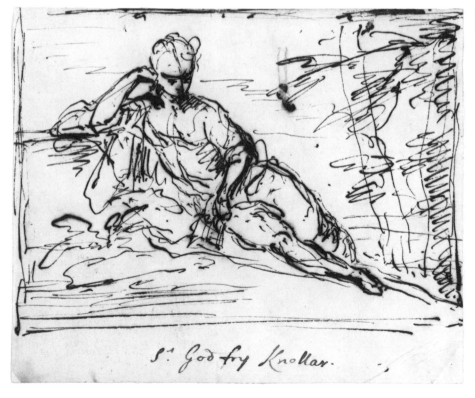

S͟r Godfry Knollar.

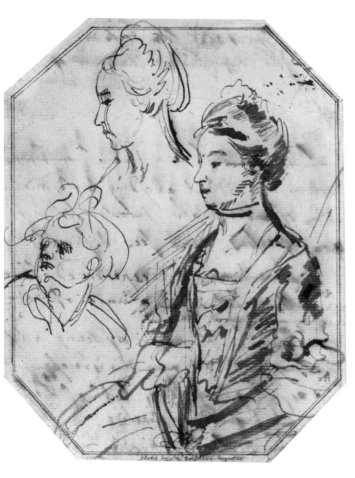

88 *Reynolds* Studies of heads

84 *Reynolds* A woman tying her garter

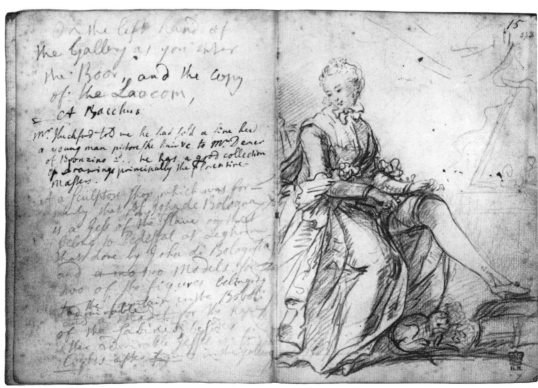

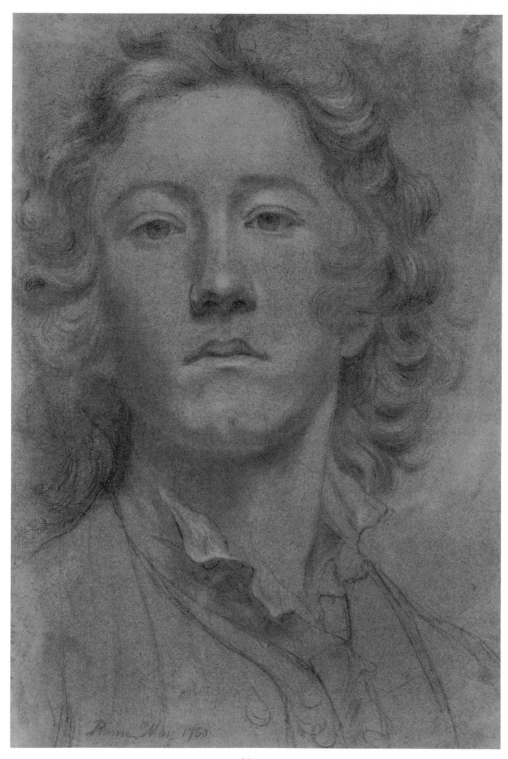

83 *Reynolds* Self-portrait

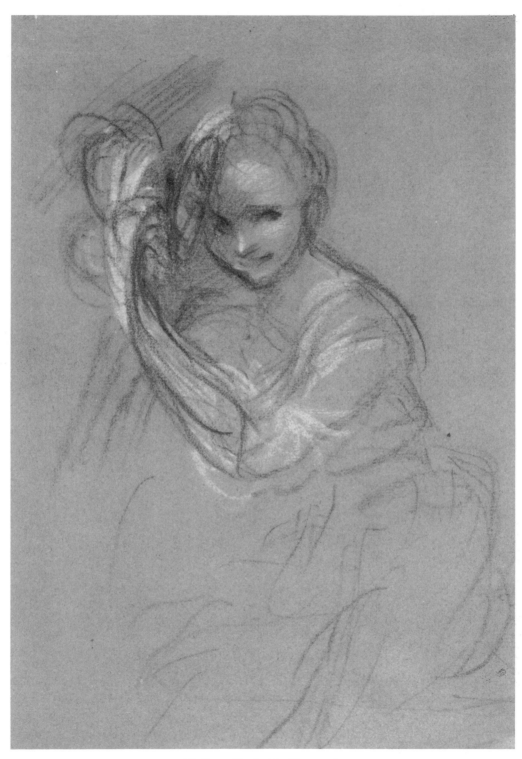

92 *Reynolds* A girl with a mask

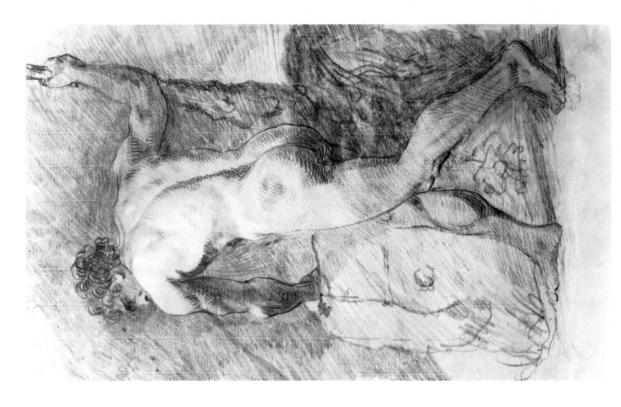

90 *Reynolds* Academic study of *Hercules*

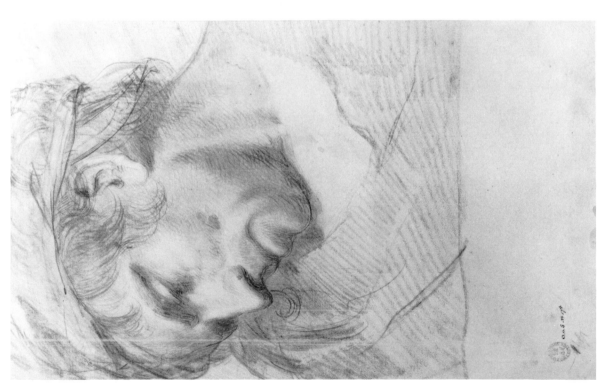

89 *Reynolds* A man's head

95b *Reynolds* Study for *The Infant Hercules*

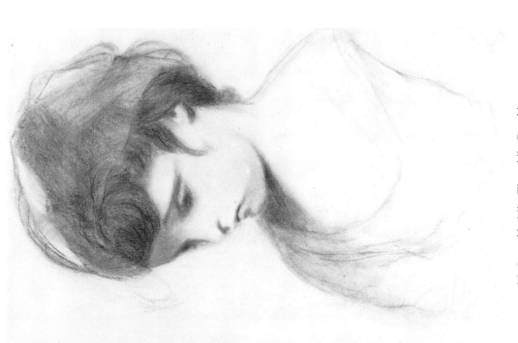

96 *Reynolds* Miss Theophila Gwatkin

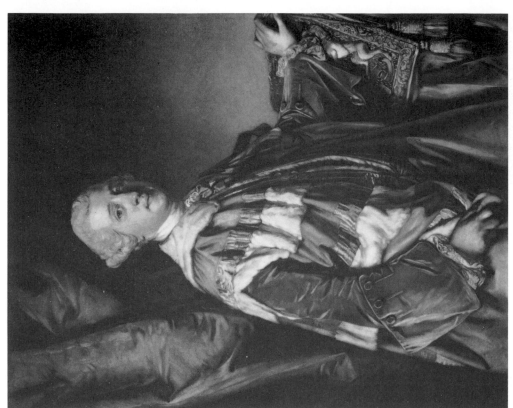

115 *Edward Fisher* after *Reynolds* Earl Gower

137 *Valentine Green* after *Reynolds* Sir Joshua Reynolds

109 *James Watson* after *Reynolds* Nelly O'Brien (corrected proof)

101 *James McArdell* after *Reynolds* Lady Charlotte Fitzwilliam

152 *Charles Hodges after Reynolds* Countess Spencer

144 *J. R. Smith after Reynolds* Mrs Carnac

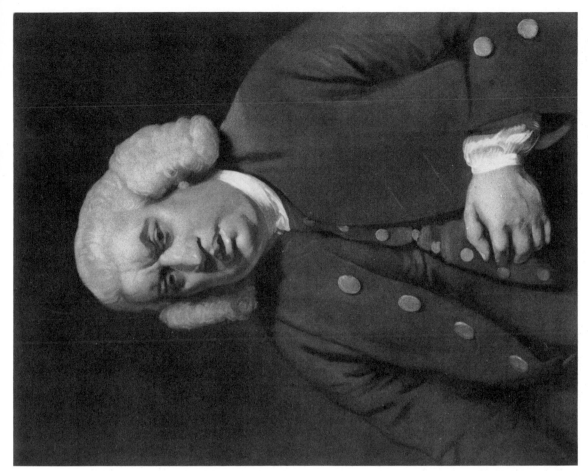

131 *William Doughty after Reynolds* Dr Johnson

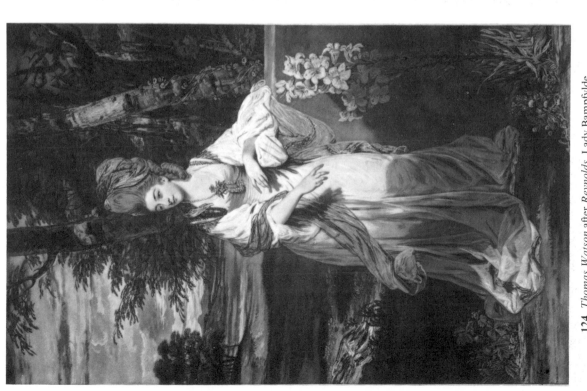

124 *Thomas Watson after Reynolds* Lady Bampfylde

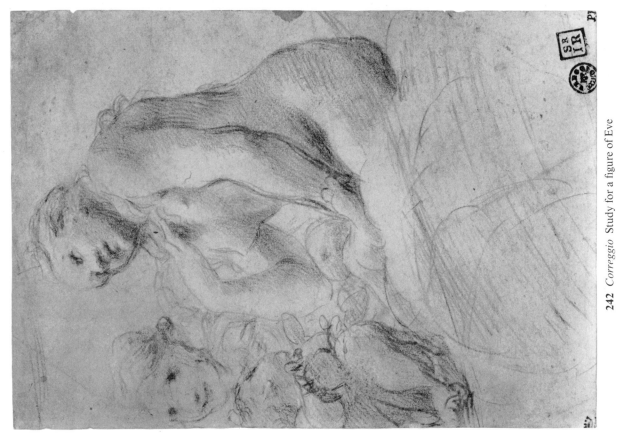

242 *Correggio* Study for a figure of Eve

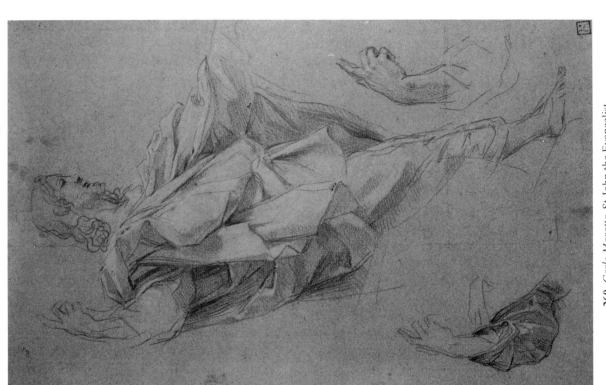

260 *Carlo Maratta* St John the Evangelist